To

From

Date

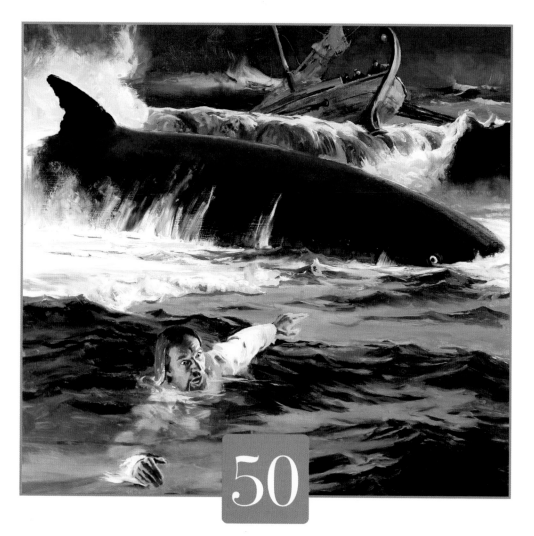

50
BIBLE STORIES
Every Adult Should Know

Volume 1: Old Testament

MATTHEW LOCKHART

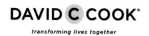

DAVID C COOK
transforming lives together

50 BIBLE STORIES EVERY ADULT SHOULD KNOW
Published by David C Cook
4050 Lee Vance Drive
Colorado Springs, CO 80918 U.S.A.

Integrity Music Limited, a Division of David C Cook
Brighton, East Sussex BN1 2RE, England

The graphic circle C logo is a registered trademark of David C Cook.

Library of Congress Control Number 2020949415
ISBN 978-0-8307-8274-1

The Team: Michael Covington, Stephanie Bennett, Judy Gillispie, James Hershberger

Printed in China
First Edition 2021

1 2 3 4 5 6 7 8 9 10

120420

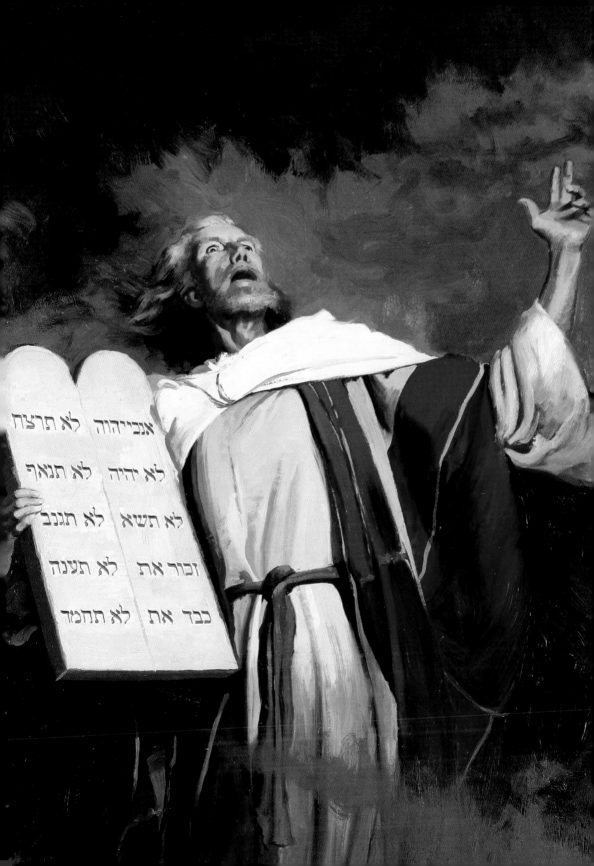

CONTENTS

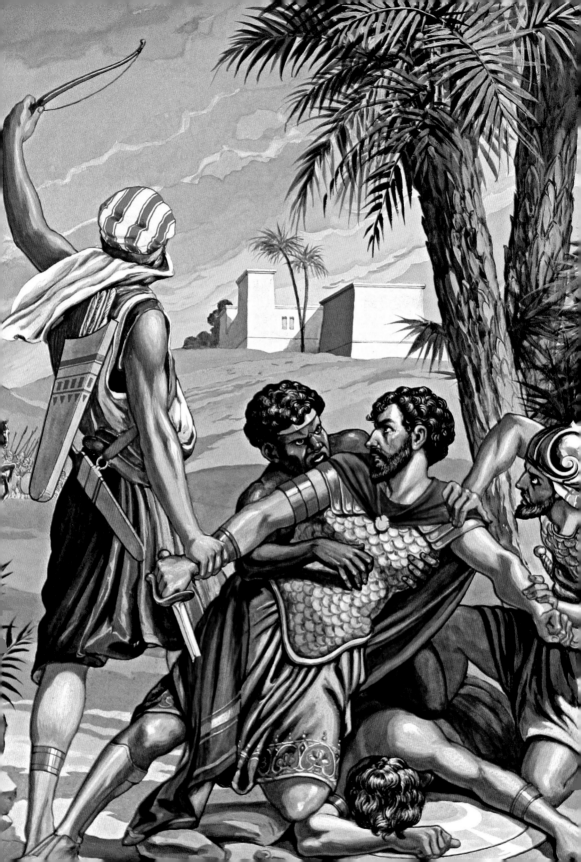

FOREWORD

I loved this idea the minute I saw it, even though it's aimed at readers who may not be familiar with Bible stories. Being one of those proverbial raised-in-the-church people, I know well all these stories and yet found myself cherishing them anew.

Such tales never grow old because, naturally, we believe they're more than tales. They're true stories within the love letter God wrote to us, the Bible.

In enjoying them again, I was reminded how much they have informed my own storytelling over the decades. Much of my fiction is set in Bible times, and the heroic deeds of the patriarchs resound in my mind down through the ages as I write.

This book will prove a feast, especially for those being exposed to many of these stories for the first time. It makes a perfect gift and one sure to be passed down through many generations.

JERRY B. JENKINS
Bestselling novelist and writer of *The Left Behind* series

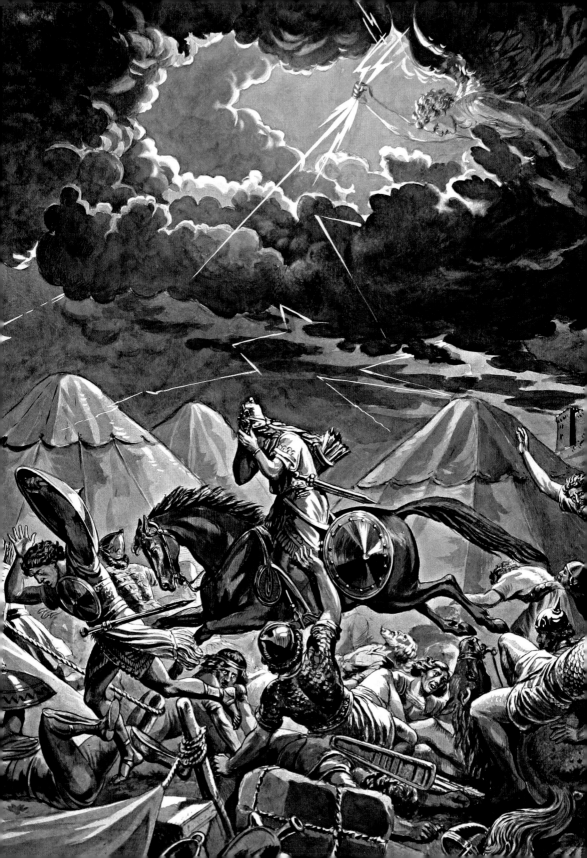

ACKNOWLEDGMENTS

In compiling this book of Bible stories, I couldn't help reflecting on the small army of people, beyond my own parents, who taught many of the stories included in this volume to me as a child. More than that, they set a good example and helped to instill within me a love of God and an appreciation for the wisdom and truth found in the Bible.

In no particular order, I dedicate this volume to the following faithful:

Roy and Janet Miller	Ray and Ann Counts	Pastor George
Jack and Alma Davis	Mr. and Mrs. Dabney	Pastor Farrell
Grandma Tommy	Gary and Jo Tallman	Tom and Melissa Lokey
Mary Robertson	Tom and Barb Coffan	Mark and Wanda Crane
Mary Ann Wetzler	Gilbert and Evelyn Davidson	Mrs. Wulbrandt
Al and Jackie Morley	Ron and Lee Shaffer	Pastor Hill
Mr. Rick	Mr. and Mrs. Grebe	Pastor Elliff
Mr. Digby	Bay and Peg Forrest	Gene and Betty Lawson
Mr. Beasley	Russ McKendry	Miss T
Pete and Naomi Fast	Mr. and Mrs. Brownrigg	Lee and Esther Walker
Fred and Sabra Ladd	J. R. and Connie Ford	Pat Miller
Don and Jeri Davis	Luther and Betty Mann	Cherie Noel

My memory was taxed trying to recall as many of the wonderful Sunday school teachers, Training Union and Royal Ambassadors leaders, children's choir directors, vacation Bible school volunteers, pastors, and children's and youth group teachers and leaders who gave generously of themselves. Mom and Mark, thanks for the assist. There's a host of saints I've neglected to mention by name, though I am comforted with the knowledge that they are known to God.

Praise unto the Lord, and a heartfelt thank-you—to those named and unnamed.

INTRODUCTION

If you didn't grow up attending Sunday, Sabbath, or Hebrew school and missed the childhood rite of passage of attending vacation Bible school at the local church in your neighborhood, you may be at a literary disadvantage when it comes to the most quoted book of all time. If that describes you, this book of Bible stories for adults is especially for you.

It may also be that you simply wish to brush up on your Bible knowledge or enjoy a good collection of short stories. Whatever the case may be, this volume will help unveil the abundant world of biblical allusions and references which are rife throughout literature, music, and pop culture.

While the Bible can be an intimidating read, this book provides you with selected stories from the Hebrew Bible (Christian Old Testament) that every adult should know. Inside each of these fast-moving chapters is a Bible story, along with vintage art illustrating the stories. In addition, brief introductions help provide historical context and commentary follows the biblical narrative that highlights a relevant moral principle. The material is presented in good humor and contains a number of informative and entertaining related facts, quotes, and asides.

The fifty stories curated here relate to some of the most important and historical events recorded in the Bible. Furthermore, this book will introduce, or reintroduce, you to both noble and notorious men and women of the Bible—some well-known, and others more obscure. Included within this highlight reel of popular stories, you may recognize ones such as Creation, Adam and Eve, Noah's Ark, and Moses and the Ten Commandments.

In addition to these golden stories, this collection contains a healthy dose of lesser-known Bible narratives which are often excluded from children's Bible storybooks due to their mature content. These stories include lurid tales of palace intrigue, lust, betrayal, deception, revenge, and death. Included among these are the stories of Jael and Sisera, the Destruction of Sodom, and the Sin of Achan, to name a few.

Each of the stories is presented as told in the Bible, compiled from reliable modern translations. In the interest of length, some of the Scripture passages have been abridged to tell these stories in shortened form. The Bible books and chapters from which the stories have been taken are noted as part of each story, and you are encouraged to read the stories for yourself in their full context in the translation of your choice. If you don't have a Bible, a number of good online Bible apps feature trustworthy translations.

In a book of this nature, you may have interest in knowing the perspective of the compiler. I hold a high view of Scripture and have approached this project personally from a Christian viewpoint. Whether you share my perspective or not, it is my firm conviction that the amazing stories from the Bible hold elemental value for believer and skeptic alike.

It is my hope and prayer that you will discover truth within these pages and that you will enjoy familiarizing yourself with some of the greatest stories ever told!

Shalom,
Matt Lockhart

P.S. For additional information, see the About the Art and the About the Author pages in the back of the book.

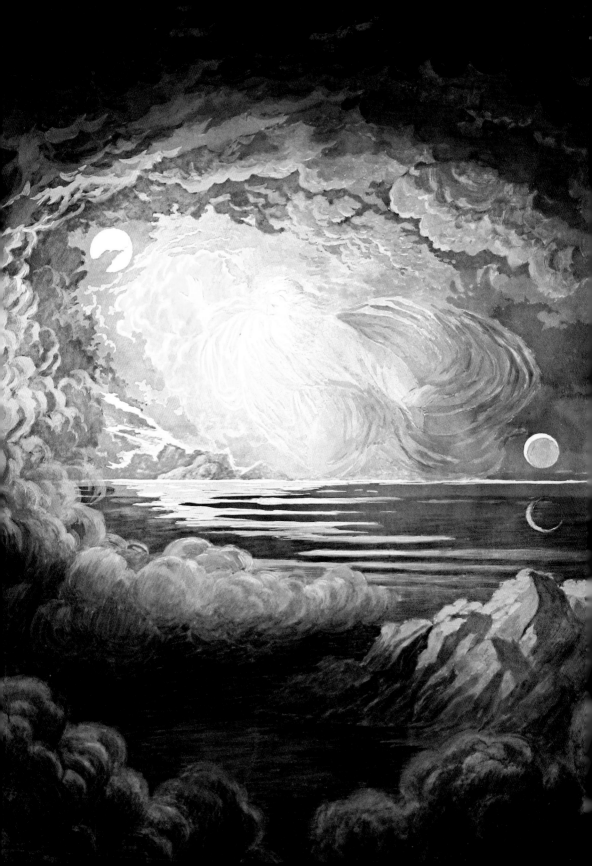

IN THE BEGINNING

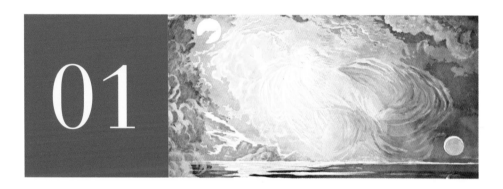

SETTING THE SCENE

Ex Nihilo: Out of nothing.
Time and space as we know it didn't exist.
A barren planet, devoid of life.
And then, God spoke.

Imago Dei

FROM GENESIS 1

In the beginning God created the heavens and the earth. The earth was barren, with no form of life; it was under a roaring ocean covered with darkness. But the Spirit of God was moving over the water.

THE FIRST DAY

God said, "I command light to shine!" And light started shining. God looked at the light and saw that it was good. He separated light from darkness and named the light "Day" and the darkness "Night." Evening came and then morning—that was the first day.

THE SECOND DAY

God said, "I command a dome to separate the water above it from the water below it." And that's what happened. God made the dome and named it "Sky." Evening came and then morning—that was the second day.

THE THIRD DAY

God said, "I command the water under the sky to come together in one place, so there will be dry ground." And that's what happened. God named the dry ground "Land," and he named the water "Ocean." God looked at what he had done and saw that it was good.

God said, "I command the earth to produce all kinds of plants, including fruit trees and grain." And that's what happened. The earth produced all kinds of vegetation. God looked at what he had done, and it was good. Evening came and then morning—that was the third day.

THE FOURTH DAY

God said, "I command lights to appear in the sky and to separate day from night and to show the time for seasons, special days, and years. I command them to shine on the earth." And that's what happened. God made two powerful lights,

the brighter one to rule the day and the other to rule the night. He also made the stars. Then God put these lights in the sky to shine on the earth, to rule day and night, and to separate light from darkness. God looked at what he had done, and it was good. Evening came, then morning—that was the fourth day.

THE FIFTH DAY

God said, "I command the ocean to be full of living creatures, and I command birds to fly above the earth." So God made the giant sea monsters and all the living creatures that swim in the ocean. He also made every kind of bird. God looked at what he had done, and it was good. Then he gave the living creatures his blessing—he told the ocean creatures to increase and live everywhere in the ocean and the birds to increase everywhere on earth. Evening came and then morning—that was the fifth day.

THE SIXTH DAY

God said, "I command the earth to give life to all kinds of tame animals, wild animals, and reptiles." And that's what happened. God made every one of them. Then he looked at what he had done, and it was good.

God said, "Now we will make humans, and they will be like us. We will let them rule the fish, the birds, and all other living creatures."

So God created humans to be like himself; he made men and women (CEV).

TRUTH FOR TODAY

The Creator spoke the world into existence. What was formless and void took shape, came to life, and "it was good." Whether acknowledged or not, the earth is God's creation and humanity is crafted in the image of God.

Life comes from the Creator,
and all people are created in God's image.

FYI

The Bible describes the creation of man and woman (Adam and Eve) in greater detail in the second chapter of Genesis.

The earth is the LORD's, and everything in it. The world and all its people belong to him. For he laid the earth's foundation on the seas and built it on the ocean depths.
PSALM 24:1-2

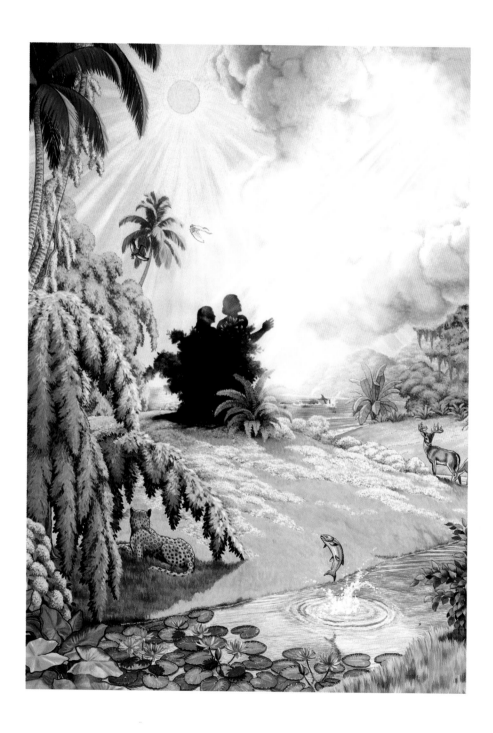

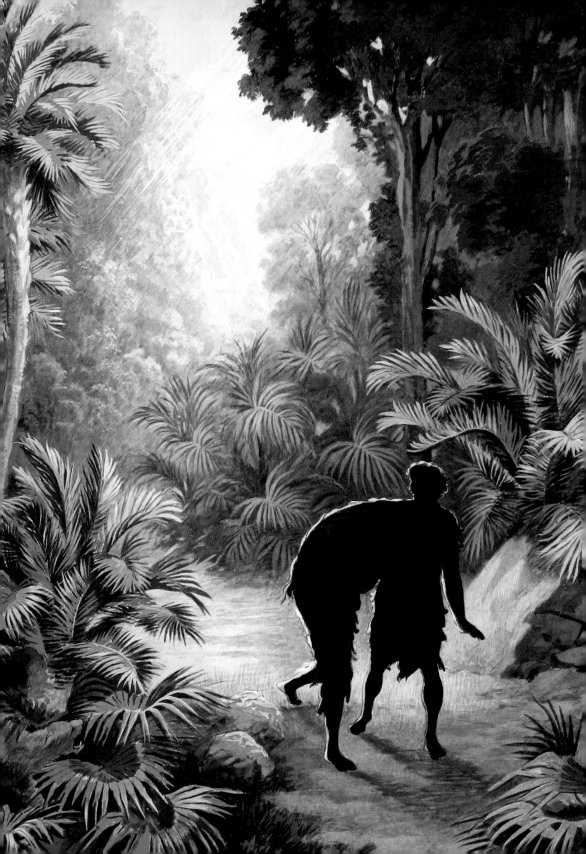

ADAM AND EVE

SETTING THE SCENE

After forming man from the dust of the earth and breathing life into him, God declared, "It is not good for the man to be alone" (Genesis 2:18).

In everything that had been created, there wasn't another creature deemed a suitable companion for man. So the Lord put Adam under and, taking a rib from the man's side, created a woman. When Adam awoke and saw the woman he said, "This at last is bone of my bones and flesh of my flesh" (Genesis 2:23, ESV). And together Adam and Eve made their home in Eden—until one fateful day.

Paradise Lost

FROM GENESIS 3

Now the snake was the most cunning animal that the Lord God had made. The snake asked the woman, "Did God really tell you not to eat fruit from any tree in the garden?"

"We may eat the fruit of any tree in the garden," the woman answered, "except the tree in the middle of it. God told us not to eat the fruit of that tree or even touch it; if we do, we will die."

The snake replied, "That's not true; you will not die. God said that because he knows that when you eat it, you will be like God and know what is good and what is bad."

The woman saw how beautiful the tree was and how good its fruit would be to eat, and she thought how wonderful it would be to become wise. So she took some of the fruit and ate it. Then she gave some to her husband, and he also ate it. As soon as they had eaten it, they were given understanding and realized that they were naked; so they sewed fig leaves together and covered themselves.

That evening they heard the LORD God walking in the garden, and they hid from him among the trees. But the LORD God called out to the man, "Where are you?"

He answered, "I heard you in the garden; I was afraid and hid from you, because I was naked."

"Who told you that you were naked?" God asked. "Did you eat the fruit that I told you not to eat?"

The man answered, "The woman you put here with me gave me the fruit, and I ate it."

The LORD God asked the woman, "Why did you do this?"

She replied, "The snake tricked me into eating it."

And he said to the woman, "I will increase your trouble in pregnancy and your pain in giving birth. In spite of this, you will still have desire for your husband, yet you will be subject to him."

And he said to the man, "You listened to your wife and ate the fruit which I told you not to eat. Because of what you have done, the ground will be under a curse. You will have to work hard all your life to make it produce enough food for you. It will produce weeds and thorns, and you will have to eat wild plants. You will have to work hard and sweat to make the soil produce anything, until you

go back to the soil from which you were formed. You were made from soil, and you will become soil again."

And the LORD God made clothes out of animal skins for Adam and his wife, and he clothed them.

Then the LORD God said, "Now these human beings have become like one of us and have knowledge of what is good and what is bad. They must not be allowed to take fruit from the tree that gives life, eat it, and live forever." So the LORD God sent them out of the Garden of Eden and made them cultivate the soil from which they had been formed (GNT).

TRUTH FOR TODAY

The offense: Adam and Eve trespassed against God, willfully partaking of the forbidden fruit.

The immediate result: a loss of innocence and banishment from Eden.

The long-term impact: a world beset and marred by sin.

At its essence, sin is rebellion against God. From a child taking another's toy, to road rage, to a couple engaged in a "harmless" affair, to acts of terror, there's ample evidence that we live in a fallen world.

A failure to recognize and acknowledge our need for God on a personal basis leaves us more susceptible to our own inherent selfish and destructive desires. However, as with Adam and Eve, God doesn't want to leave us unclothed and exposed—despite our sin.

Apart from God, humanity has a natural bent toward sin.

FYI

That a creature in the garden was able to speak didn't seem to come as a surprise to Eve. Though strange to us, perhaps talking animals were not an unusual occurrence in Eden.

The Christian doctrine of original sin has its origin in the events of Genesis 3, which is also referred to as "The Fall." In a nutshell, the basic tenet is that people have a sin nature. This teaching was advanced by early church leaders, including the apostle Paul, Saint Irenaeus, and Saint Augustine. It is also echoed elsewhere in Scripture, notably by the Lord in Genesis 8:21, "I will never again curse the ground because of the human race, even though everything they think or imagine is bent toward evil from childhood."

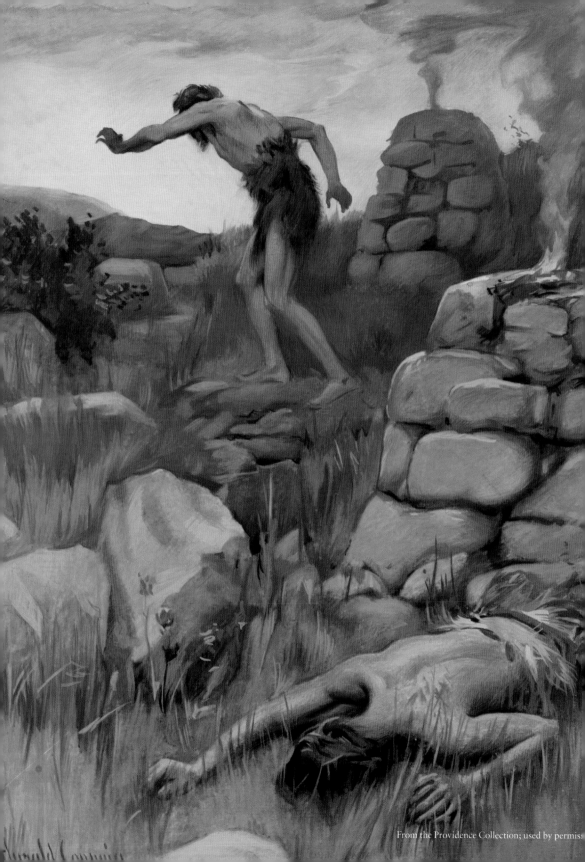

CAIN AND ABEL

SETTING THE SCENE

It appears that Adam and Eve didn't reside long in the Garden of Eden before their banishment. It wasn't until after they had left that Eve gave birth to two sons, Cain and Abel. These were the first of several children born to Adam.

Just as it hadn't taken long for Adam and Eve to rebel against God, it didn't take long for brother to turn on brother.

My Brother's Keeper
FROM GENESIS 4

Now Adam knew Eve his wife, and she conceived and bore Cain, saying, "I have gotten a man with the help of the LORD." And again, she bore his brother Abel. Now Abel was a keeper of sheep, and Cain a worker of the ground. In the course of time Cain brought to the LORD an offering of the fruit of the ground, and Abel also brought of the firstborn of his flock and of their fat portions. And the LORD had regard for Abel and his offering, but for Cain and his offering he

had no regard. So Cain was very angry, and his face fell. The Lord said to Cain, "Why are you angry, and why has your face fallen? If you do well, will you not be accepted? And if you do not do well, sin is crouching at the door. Its desire is contrary to you, but you must rule over it."

Cain spoke to Abel his brother. And when they were in the field, Cain rose up against his brother Abel and killed him. Then the Lord said to Cain, "Where is Abel your brother?" He said, "I do not know; am I my brother's keeper?" And the Lord said, "What have you done? The voice of your brother's blood is crying to me from the ground. And now you are cursed from the ground, which has opened its mouth to receive your brother's blood from your hand. When you work the ground, it shall no longer yield to you its strength. You shall be a fugitive and a wanderer on the earth."

Then Cain went away from the presence of the Lord and settled in the land of Nod, east of Eden (ESV).

TRUTH FOR TODAY

The Lord was pleased with Abel and his offering, but not so with Cain. Instead of humbling himself before God, Cain grew indignant and let his brooding anger grow into a murderous rage. Evidence of Cain's hardened and unrepentant heart comes through in his shockingly impudent and snarky reply to the Lord: "Am I my brother's keeper?"

As the Lord said to Cain, "Sin is crouching at the door.... but you must rule over it." While none of us are immune to feelings of anger or jealousy, it is incumbent upon us to guard against obsessively holding onto and fostering negative emotions that can give rise to grievous sin.

Anger unchecked gives rise to hateful thoughts and actions.

FYI

According to Genesis 5:4, Adam lived another 800 years and had other sons and daughters before returning to dust around the age of 930.

In the Sermon on the Mount, Jesus compares holding anger against another to murder (Matthew 5:21–22).

"My brother's keeper" is but one of many common expressions that have their origin in the Bible. Here are a few other popular sayings that also come from the Old Testament:

"How the mighty have fallen" (from 2 Samuel 1:27)

"At their wits' end" (from Psalm 107:27)

"Your sin will find you out" (from Numbers 32:23)

"Nothing new under the sun" (from Ecclesiastes 1:9)

"Skin of my teeth" (from Job 19:20)

"For everything there is a season" (from Ecclesiastes 3:1)

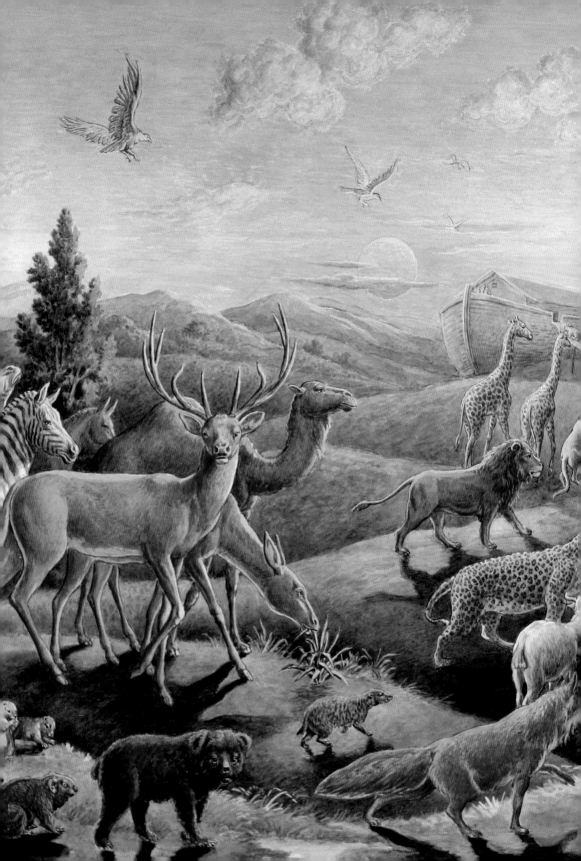

NOAH'S ARK

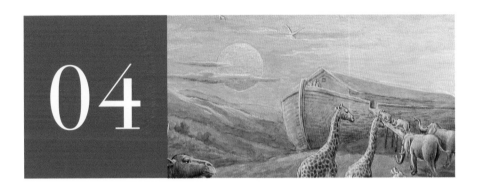

SETTING THE SCENE

Based on the antediluvian genealogy recorded in Genesis 5, there were ten generations between Adam and Noah, which encompassed 1,056 years. Sometime after Noah was 500 years old (not a typo), God revealed to him the coming judgment that was about to be visited upon the earth. Since "the fall" (Genesis 3), humankind had increasingly rejected God and had sunk further into depravity.

Raindrops Keep Fallin' on My Head

FROM GENESIS 6–8

The LORD saw how bad the people on earth were and that everything they thought and planned was evil. He was very sorry that he had made them, and he said, "I'll destroy every living creature on earth! I'll wipe out people, animals, birds, and reptiles. I'm sorry I ever made them."

But the LORD was pleased with Noah, and this is the story about him. Noah was the only person who lived right and obeyed God.

God knew that everyone was terribly cruel and violent. So he told Noah:

Cruelty and violence have spread everywhere. Now I'm going to destroy the whole earth and all its people. Get some good lumber and build a boat. Put rooms in it and cover it with tar inside and out. Make it four hundred fifty feet long, seventy-five feet wide, and forty-five feet high. Build a roof on the boat and leave a space of about eighteen inches between the roof and the sides. Make the boat three stories high and put a door on one side.

I'm going to send a flood that will destroy everything that breathes! Nothing will be left alive. But I solemnly promise that you, your wife, your sons, and your daughters-in-law will be kept safe in the boat.

Bring into the boat with you a male and a female of every kind of animal and bird, as well as a male and a female of every reptile. I don't want them to be destroyed.

They took along every kind of animal, tame and wild, including the birds. Noah took a male and a female of every living creature with him, just as God had told him to do. And when they were all in the boat, God closed the door.

For forty days the rain poured down without stopping. And the water became deeper and deeper, until the boat started floating high above the ground.

God did not forget about Noah and the animals with him in the boat. So God made a wind blow, and the water started going down. God stopped up the places where the water had been gushing out from under the earth. He also closed up the sky, and the rain stopped.

Noah wanted to find out if the water had gone down, and he sent out a dove. Deep water was still everywhere, and the dove could not find a place to land. So it flew back to the boat. Noah held out his hand and helped it back in.

Seven days later Noah sent the dove out again. It returned in the evening, holding in its beak a green leaf from an olive tree. Noah knew that the water

was finally going down. He waited seven more days before sending the dove out again, and this time it did not return (CEV).

TRUTH FOR TODAY

Although this is one of the most popular children's Bible stories and has inspired adults to adorn many a home and church nursery with cute animals, it reflects one of the darkest times in the history of mankind. One bright spot: Noah.

Because the story itself is larger than life, it's easy to overlook Noah himself. However, Noah stands alongside Abraham and Moses as a spiritual giant within the pages of the Old Testament. It is said of Noah that he "found favor in the eyes of the LORD" (Genesis 6:8, ESV). We also know him to be "a righteous man, blameless among the people of his time, [who] walked faithfully with God" (Genesis 6:9, NIV). And last but not least, "he did all that God commanded him" (Genesis 6:22, ESV).

As with anyone, Noah wasn't perfect; however, his example demonstrates that it's possible to live in obedience to God and swim against the tide of a hostile culture. Because of the content of his character, Noah and his family (Mrs. Noah, his three sons, and three daughters-in-law) were saved from the cataclysmic flood.

By daring to stand apart from the crowd, you may eventually find yourself as the only one left standing.

FYI

While there have been various attempts to reproduce the ark, one of the more recent, better-funded, and well-researched efforts is an attraction in Williamstown, Kentucky, that is known as Ark Encounter. In addition to building a full-size replica, the owners seek to address questions like this: "How many animals were on the ark?" See www.arkencounter.com for more information.

In the biblical era before the flood, some recorded lifespans ran quite long. There are seven people mentioned who lived for more than 900 years; Noah's grandfather, Methuselah, holds the record at 969 years.

Once Noah and his family were safely in the ark, God miraculously shut the door (Genesis 7:16), sealing them and the animals in what would be their home for over a year.

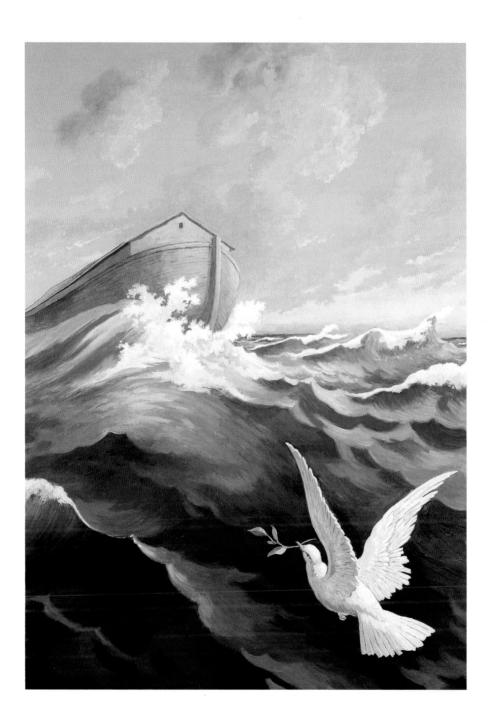

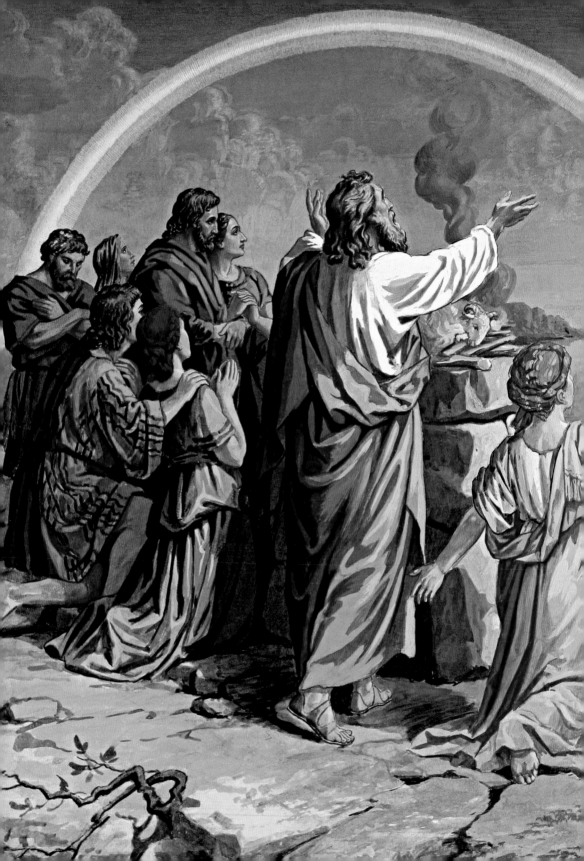

RAINBOW OF PROMISE

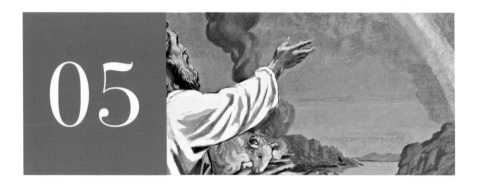

SETTING THE SCENE

After five months of water, water everywhere, the floating zoo came to rest on a mountain. However, it would be a long seven months more before the earth would dry out enough for Noah and his family to disembark. In total, Noah and his family spent a little over a year in the ark.

Sunshine on My Shoulders
FROM GENESIS 8–9

Then God said to Noah, "Leave the boat, all of you—you and your wife, and your sons and their wives."

So Noah, his wife, and his sons and their wives left the boat. And all of the large and small animals and birds came out of the boat, pair by pair.

Then Noah built an altar to the LORD, and there he sacrificed as burnt offerings the animals and birds that had been approved for that purpose. And the LORD was pleased with the aroma of the sacrifice and said to himself, "I will never again curse

the ground because of the human race, even though everything they think or imagine is bent toward evil from childhood. I will never again destroy all living things. As long as the earth remains, there will be planting and harvest, cold and heat, summer and winter, day and night."

Then God blessed Noah and his sons and told them, "Be fruitful and multiply. Fill the earth. All the animals of the earth, all the birds of the sky, all the small animals that scurry along the ground, and all the fish in the sea will look on you with fear and terror. I have placed them in your power. I have given them to you for food, just as I have given you grain and vegetables. But you must never eat any meat that still has the lifeblood in it.

"And I will require the blood of anyone who takes another person's life. If a wild animal kills a person, it must die. And anyone who murders a fellow human must die. If anyone takes a human life, that person's life will also be taken by human hands. For God made human beings in his own image. Now be fruitful and multiply, and repopulate the earth."

Then God told Noah and his sons, "I hereby confirm my covenant with you and your descendants, and with all the animals that were on the boat with you—the birds, the livestock, and all the wild animals—every living creature on earth. Yes, I am confirming my covenant with you. Never again will floodwaters kill all living creatures; never again will a flood destroy the earth."

Then God said, "I am giving you a sign of my covenant with you and with all living creatures, for all generations to come. I have placed my rainbow in the clouds. It is the sign of my covenant with you and with all the earth. When I send clouds over the earth, the rainbow will appear in the clouds, and I will remember my covenant with you and with all living creatures. Never again will the floodwaters destroy all life. When I see the rainbow in the clouds, I will remember the eternal covenant between God and every living creature on earth." Then God said to Noah, "Yes, this rainbow is the sign of the covenant I am confirming with all the creatures on earth."

TRUTH FOR TODAY

The mother of all do-overs. The ark empties and life on earth begins anew, accompanied by a couple of important promises—one familiar, the other lesser-known but hidden in plain sight. They can be paraphrased as follows:

- So long as the earth endures, there will be seasons (planting and harvest), weather (hot and cold), and time (day and night; Genesis 8:22).
- God will not again destroy all life on earth by flood (Genesis 9:15).

God's word has power because the Lord keeps promises. While we don't know what the future holds, God does. This terrestrial ball that we call home was made by the Lord. As caretakers, we should care deeply for it. Simultaneously, in an age of apocalyptic climatic fear, we would do well to remember the planetary promises of God.

With God, a promise made is a promise kept.

WHERE IN THE WORLD

Where did Noah's ark land? "The ark came to rest on the mountains of Ararat" (Genesis 8:4, ESV). This is believed to be a range located in the eastern Anatolia region in modern-day Turkey that borders Georgia, Iran, and Iraq.

FYI

Nowhere is it indicated that the rainbow referenced in Genesis 9:13 is something new; rather, it now takes on significance as a sign of God's promise.

In obedience to God's command to "be fruitful and multiply," Noah's three sons—Shem, Ham, and Japheth (Ham the youngest, Japheth the eldest)—had sixteen sons between them and an unrecorded number of daughters.

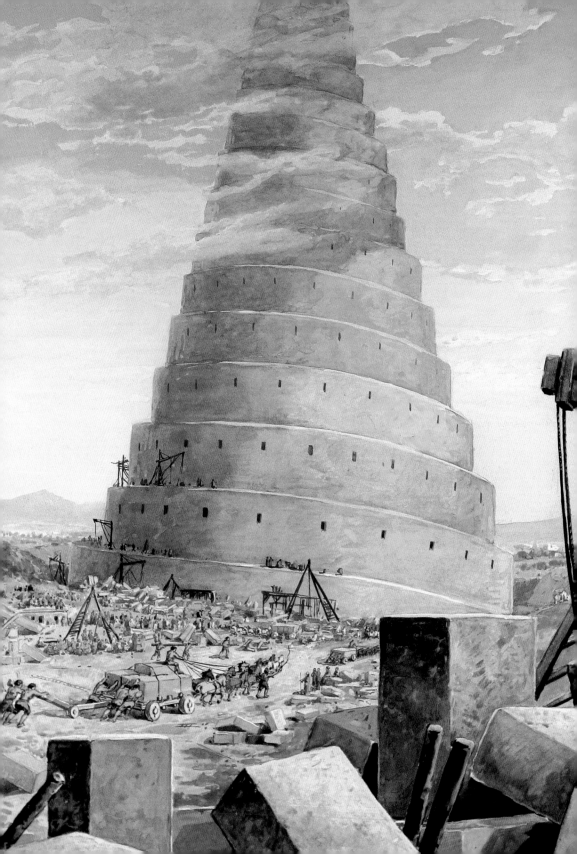

TOWER OF BABEL

SETTING THE SCENE

Several generations after the great flood, Noah's descendants—united by their shared ancestry and common language—amassed on the plain of Shinar. Here they commenced to create a city and take on an ambitious building project.

Parlez-Vous Français?

FROM GENESIS 11

At one time all the people of the world spoke the same language and used the same words. As the people migrated to the east, they found a plain in the land of Babylonia and settled there.

They began saying to each other, "Let's make bricks and harden them with fire." (In this region bricks were used instead of stone, and tar was used for mortar.) Then they said, "Come, let's build a great city for ourselves with a tower that reaches into the sky. This will make us famous and keep us from being scattered all over the world."

But the LORD came down to look at the city and the tower the people were building. "Look!" he said. "The people are united, and they all speak the same language. After this, nothing they set out to do will be impossible for them! Come, let's go down and confuse the people with different languages. Then they won't be able to understand each other."

In that way, the LORD scattered them all over the world, and they stopped building the city. That is why the city was called Babel, because that is where the LORD confused the people with different languages. In this way he scattered them all over the world.

TRUTH FOR TODAY

Contrary to conventional wisdom, sharing a universal language isn't all it's cracked up to be. In the aftermath of the flood, God's mandate was for humanity to "fill the earth" (Genesis 9:1). Empowered through a common tongue, people in their own "wisdom" thought it best to create a city and build a monument unto themselves instead. For all the lip service given to the value of diversity, people tend to opt for homogeny.

Just because something can be done
doesn't necessarily mean it should be.

WHERE IN THE WORLD

While there isn't agreement as to the exact location of where the ill-fated tower was located, it is generally thought to have been in ancient Mesopotamia, which falls in modern-day Iraq.

FYI

According to Ethnologue.com, more than seven thousand languages are spoken around the globe. However, as few as twenty-three languages cover half of the world's population. English is the language with the most speakers, and Mandarin Chinese is the language with the largest number of native speakers. If you combine the speakers of these two alone, they encompass more than two billion people!

The Burj Khalifa in Dubai (UAE), completed in 2009, is the world's tallest building (as of 2020), standing at 2,717 feet—over half a mile high! Although that's quite impressive, for comparison and scale, it's less than 10 percent of the height of Mount Everest (29,029 feet).

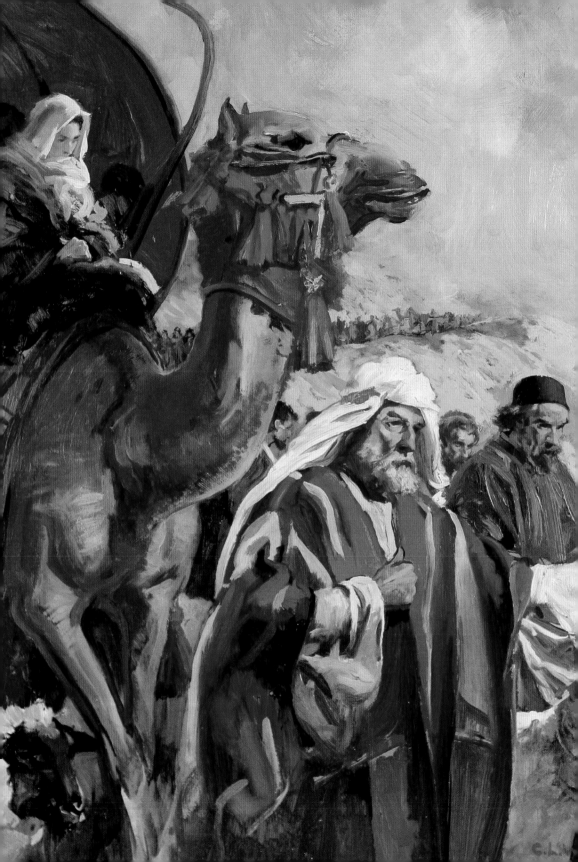

ABRAHAM AND SARAH

SETTING THE SCENE

Some years after civilization had dispersed from Babel, a man named Terah lived in Ur of the Chaldeans and had three sons: Abram, Nahor, and Haran. In time, Haran passed away, and Abram and Nahor took wives. Abram married Sarai, but they had no children because "Sarai was unable to become pregnant" (Genesis 11:30).

One day, Terah took his son Abram, daughter-in-law Sarai, and grandson Lot (son of Haran) and moved from Ur. Intending to travel to Canaan for unknown reasons, Terah instead settled his family in Haran, where he lived out the remainder of his days.

Following the death of his father, a spry seventy-five-year-old Abram prepared for another move.

Get a Move On

FROM GENESIS 12

The LORD had said to Abram, "Leave your native country, your relatives, and your father's family, and go to the land that I will show you. I will make you

into a great nation. I will bless you and make you famous, and you will be a blessing to others. I will bless those who bless you and curse those who treat you with contempt. All the families on earth will be blessed through you."

So Abram departed as the LORD had instructed, and Lot went with him. Abram was seventy-five years old when he left Haran. He took his wife, Sarai, his nephew Lot, and all his wealth—his livestock and all the people he had taken into his household at Haran—and headed for the land of Canaan. When they arrived in Canaan, Abram traveled through the land as far as Shechem. There he set up camp beside the oak of Moreh. At that time, the area was inhabited by Canaanites.

Then the LORD appeared to Abram and said, "I will give this land to your descendants." And Abram built an altar there and dedicated it to the LORD, who had appeared to him. After that, Abram traveled south and set up camp in the hill country, with Bethel to the west and Ai to the east. There he built another altar and dedicated it to the LORD, and he worshiped the LORD. Then Abram continued traveling south by stages toward the Negev.

TRUTH FOR TODAY

Before becoming one of the best-known couples in the Bible, Abraham and Sarah were simply Abram and Sarai—an older, childless couple from Ur who lived in Haran.

Abram and Sarai hardly seemed to be prime candidates for progenitors of a nation, yet God had big plans for the pair. But first, they had to *move* as God's invitation came with a "willing to relocate" checkbox. From Ur, to Haran, to Canaan, God's design for Abram and Sarai unfolded in different places and stages.

Sometimes people put arbitrary conditions on what they're willing to do—or not do ("I won't *until* ..." or "I will, *after ... if ... but only ...*"). While boundaries

like these can be healthy, if unmovable, they may also keep us from the journey of a lifetime.

When God comes calling, be willing to trust the Lord and leave the familiar.

WHERE IN THE WORLD

The city of Ur in Babylonia is thought to have been approximately two hundred miles southeast of modern Baghdad. The distance from Ur to Haran, near Urfa in the southern region of modern-day Turkey and north of the Syrian border, would have spanned between six hundred and seven hundred miles. From Haran, the land of Canaan lay roughly four hundred miles to the southwest.

FYI

In Genesis 17, the Lord changes Abram's name to Abraham and Sarai's to Sarah. It is here also that the rite of circumcision was instituted as a sign of God's covenant with Abraham as a father of nations.

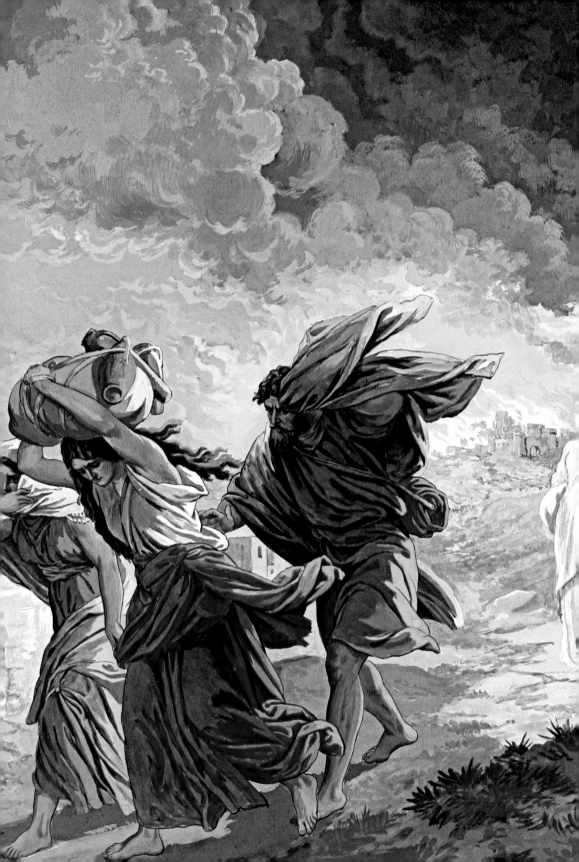

THE DESTRUCTION
OF SODOM

08

SETTING THE SCENE

Abraham's nephew, Lot, along with his wife and two daughters, lived in Sodom, a city that had a reputation for wickedness (Genesis 13:13). The Lord revealed to Abraham that because of the grievous evil of Sodom and Gomorrah, the neighboring town, judgment was near.

The Lord dispatched two angels to Sodom, and Abraham proceeded to intercede with God on behalf of Sodom. He pleaded for the Lord to spare the city if fifty righteous people could be found. Anxious that there would not be that many in the city, Abraham went back to the Lord five more times, successfully having the threshold for destruction lowered from fifty righteous to ten (Genesis 18:20–33).

Never Look Back

FROM GENESIS 19

That evening the two angels arrived in Sodom, while Lot was sitting near the city gate. When Lot saw them, he got up, bowed down low, and said, "Gentlemen, I am

your servant. Please come to my home. You can wash your feet, spend the night, and be on your way in the morning."

They told him, "No, we'll spend the night in the city square." But Lot kept insisting, until they finally agreed and went home with him. He baked some bread, cooked a meal, and they ate.

Before Lot and his guests could go to bed, every man in Sodom, young and old, came and stood outside his house and started shouting, "Where are your visitors? Send them out, so we can have sex with them!"

Lot went outside and shut the door behind him. Then he said, "Friends, please don't do such a terrible thing! I have two daughters who have never been married. I'll bring them out, and you can do what you want with them. But don't harm these men. They are guests in my home."

"Don't get in our way," the crowd answered. "You're an outsider. What right do you have to order us around? We'll do worse things to you than we're going to do to them."

The crowd kept arguing with Lot. Finally, they rushed toward the door to break it down. But the two angels in the house reached out and pulled Lot safely inside. Then they struck everyone in the crowd blind, and none of them could even find the door.

The two angels said to Lot, "The LORD has heard many terrible things about the people of Sodom, and he has sent us here to destroy the city. Take your family and leave. Take every relative you have in the city, as well as the men your daughters are going to marry."

Lot went to the men who were engaged to his daughters and said, "Hurry and get out of here! The LORD is going to destroy this city." But they thought he was joking, and they laughed at him.

Early the next morning the two angels tried to make Lot hurry and leave. They said, "Take your wife and your two daughters and get out of here as fast as you can! If you don't, every one of you will be killed when the LORD destroys the city." At first, Lot just stood there. But the LORD wanted to save him. So the angels took Lot, his wife, and his two daughters by the hand and led them out of the city. When they were outside, one of the angels said, "Run for your lives! Don't even look back...."

The sun was coming up as Lot reached the town of Zoar, and the LORD sent burning sulfur down like rain on Sodom and Gomorrah. He destroyed those cities and everyone who lived in them, as well as their land and the trees and grass that grew there.

On the way, Lot's wife looked back and was turned into a block of salt (CEV).

TRUTH FOR TODAY

Sodom wasn't a good place. There weren't even ten righteous people to be found there. It was a depraved and lawless city, and it also happened to be the place Lot and his family called home.

There's a danger that comes with being immersed in a toxic environment over an extended period of time. That which at first raised concern or was unthinkable begins to dull over time. The prevailing ethos starts to feel "normal."

To maintain moral clarity and avoid corruption, be mindful of the company you keep and where you choose to spend your time.

FYI

Pillar of salt formations still exist today in the region of the Dead Sea.

CROSS REFERENCE

In a dissertation concerning the coming Kingdom of God recorded in Luke's Gospel (Luke 17:20–37), Jesus makes a reference to the Sodom story, issuing a word of caution to those who might otherwise be tempted to "look back": "Remember Lot's wife!" (Luke 17:32, GNT).

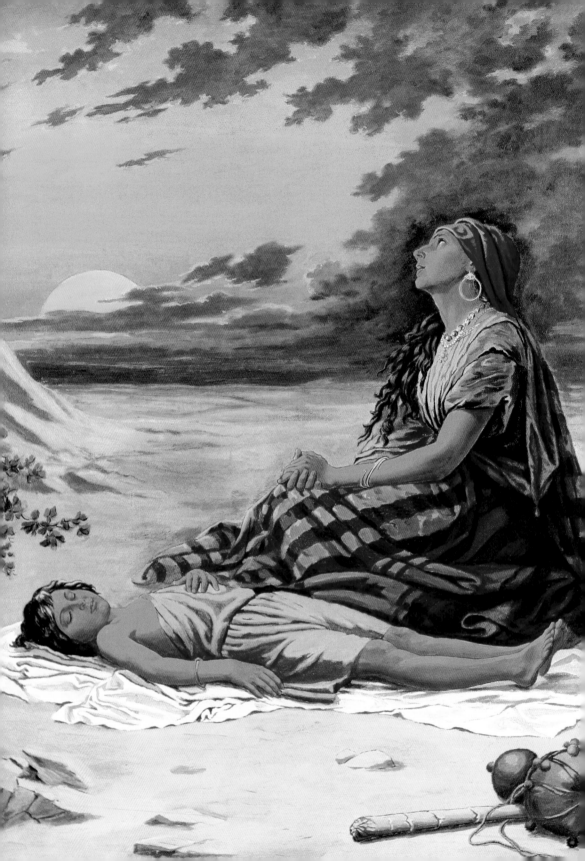

HAGAR AND ISHMAEL

SETTING THE SCENE

Twenty-five years earlier, God had called Abraham and Sarah to leave Haran for Canaan and made them a promise: "I will make you into a great nation" (Genesis 12:2).

Ten years afterward, Sarah remained barren. Under the strain of aging and waiting, Sarah offered Abraham a surrogate—her Egyptian maidservant, Hagar. Thus, fourteen years before the happy occasion of the birth of the promised heir born to Abraham by Sarah, a son named Ishmael was born to Abraham by Hagar.

Father Abraham

FROM GENESIS 21

The LORD kept his word and did for Sarah exactly what he had promised. She became pregnant, and she gave birth to a son for Abraham in his old age. This happened at just the time God had said it would. And Abraham named their son Isaac. Eight days after Isaac was born, Abraham circumcised him as God had commanded. Abraham was 100 years old when Isaac was born.

And Sarah declared, "God has brought me laughter. All who hear about this will laugh with me. Who would have said to Abraham that Sarah would nurse a baby? Yet I have given Abraham a son in his old age!"

When Isaac grew up and was about to be weaned, Abraham prepared a huge feast to celebrate the occasion. But Sarah saw Ishmael—the son of Abraham and her Egyptian servant Hagar—making fun of her son, Isaac. So she turned to Abraham and demanded, "Get rid of that slave woman and her son. He is not going to share the inheritance with my son, Isaac. I won't have it!"

This upset Abraham very much because Ishmael was his son. But God told Abraham, "Do not be upset over the boy and your servant. Do whatever Sarah tells you, for Isaac is the son through whom your descendants will be counted. But I will also make a nation of the descendants of Hagar's son because he is your son, too."

So Abraham got up early the next morning, prepared food and a container of water, and strapped them on Hagar's shoulders. Then he sent her away with their son, and she wandered aimlessly in the wilderness of Beersheba.

When the water was gone, she put the boy in the shade of a bush. Then she went and sat down by herself about a hundred yards away. "I don't want to watch the boy die," she said, as she burst into tears.

But God heard the boy crying, and the angel of God called to Hagar from heaven, "Hagar, what's wrong? Do not be afraid! God has heard the boy crying as he lies there. Go to him and comfort him, for I will make a great nation from his descendants."

Then God opened Hagar's eyes, and she saw a well full of water. She quickly filled her water container and gave the boy a drink.

And God was with the boy as he grew up in the wilderness. He became a skillful archer, and he settled in the wilderness of Paran. His mother arranged for him to marry a woman from the land of Egypt.

TRUTH FOR TODAY

There are stories replete with multiple forms of injustice throughout the Bible. From murder, to slavery, to sexual assault, the sins of the present were also the vices of the past. Rather than attempting to mask the human condition, the Bible gives us a glimpse of God's grace.

> Call me Ishmael.
>
> —HERMAN MELVILLE,
> *Moby-Dick*

Such is the case of Hagar and Ishmael. Though Ishmael was born out of impatience and an attempt to bring about God's plan via human means, God protected and provided for this son of Abraham and his mother.

There perhaps exists no greater example of the consequences of taking matters into one's own hands than the enmity that persists to this day between the descendants of Isaac and the descendants of Ishmael.

A rash decision made in the moment can have consequences that last for generations.

FYI

Abraham was eighty-six years old when Ishmael was born and one hundred at Isaac's birth, making Sarah a first-time mom in her nineties! Presuming Isaac was weaned at the age of two or three, Ishmael would have been around sixteen years old when he and his mother were released into the wilderness.

Abraham is a central figure in three major world religions: Islam, Christianity, and Judaism.

Genesis 25 lists the names of twelve of Ishmael's sons, who became tribal leaders. Abraham's grandson through Isaac also was the father of twelve sons, from whom the twelve tribes of Israel descended. Thus, Father Abraham is recognized as the patriarch of a multitude of nations.

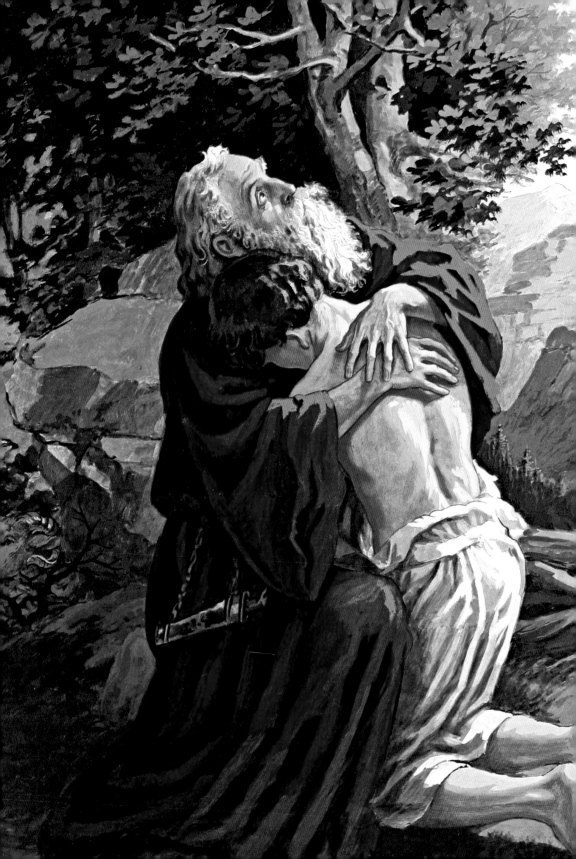

ABRAHAM AND ISAAC

10

SETTING THE SCENE

In Genesis 21, as covered in the previous chapter, the long-awaited son of promise was born to Abraham and Sarah. Some years later, Abraham, Sarah, and Isaac were dwelling in Beersheba, a city in the Negev region of southern Canaan, approximately fifty miles southwest of modern Jerusalem.

Where's the Lamb?

FROM GENESIS 22

Some years later God decided to test Abraham, so he spoke to him.

Abraham answered, "Here I am, LORD."

The LORD said, "Go get Isaac, your only son, the one you dearly love! Take him to the land of Moriah, and I will show you a mountain where you must sacrifice him to me on the fires of an altar." So Abraham got up early the next morning and chopped wood for the fire. He put a saddle on his donkey and left with Isaac and two servants for the place where God had told him to go.

Three days later Abraham looked off in the distance and saw the place. He told his servants, "Stay here with the donkey, while my son and I go over there to worship. We will come back."

Abraham put the wood on Isaac's shoulder, but he carried the hot coals and the knife. As the two of them walked along, Isaac said, "Father, we have the coals and the wood, but where is the lamb for the sacrifice?"

"My son," Abraham answered, "God will provide the lamb."

The two of them walked on, and when they reached the place that God had told him about, Abraham built an altar and placed the wood on it. Next, he tied up his son and put him on the wood. He then took the knife and got ready to kill his son. But the LORD's angel shouted from heaven, "Abraham! Abraham!"

"Here I am!" he answered.

"Don't hurt the boy or harm him in any way!" the angel said. "Now I know that you truly obey God, because you were willing to offer him your only son."

Abraham looked up and saw a ram caught by its horns in the bushes. So he took the ram and sacrificed it in place of his son.

Abraham named that place "The LORD Will Provide." And even now people say, "On the mountain of the LORD it will be provided."

The LORD's angel called out from heaven a second time:

> You were willing to offer the LORD your only son, and so he makes you this solemn promise, "I will bless you and give you such a large family that someday your descendants will be more numerous than the stars in the sky or the grains of sand along the beach. They will defeat their enemies and take over the cities where their enemies live. You have obeyed me, and so you and your descendants will be a blessing to all nations on earth" (CEV).

Abraham had been promised that Isaac, his only son, would continue his family. But when Abraham was tested, he had faith and was willing to sacrifice Isaac, because he was sure that God could raise people to life.
HEBREWS 11:17–19 (CEV)

TRUTH FOR TODAY

I confess that this story always stops me dead in my tracks, wondering to myself, *Who would ask such a thing?!* And so it is that God's testing of Abraham's faith serves as a test of our faith in God, as well. The Lord who had promised a son and delivered on that promise now commands Abraham regarding that son.

> **G**ive up your Isaac, and Isaac shall not need to be given up.
> —CHARLES SPURGEON, Sermon 868. Mature Faith— Illustrated by Abraham's Offering Up Isaac (1869)

If I were to remain hung up on the weight of such an audacious request, I would miss Abraham's equally bold response: immediate obedience, no protestations or bargaining, but a resolute conviction that God would provide.

When in the midst of a trial, ask yourself: *Is there something I'm holding onto that I need to lay down before God and trust Him with the outcome— whatever that may be?* In this world, we will be tested. The issue is where we place our trust.

When tested, put your faith in the Lord who provides.

FYI

From a Christian perspective, this story foreshadows the sacrifice of God's Son, Jesus. A beloved son, carrying wood up a hill. Though in the case of Christ, He is the sacrificial Lamb. Which brings us back to the question: Who would ask such a thing? A God who "so loved the world, that he gave his only begotten Son, that whosoever believeth in him should not perish, but have everlasting life" (John 3:16, KJV).

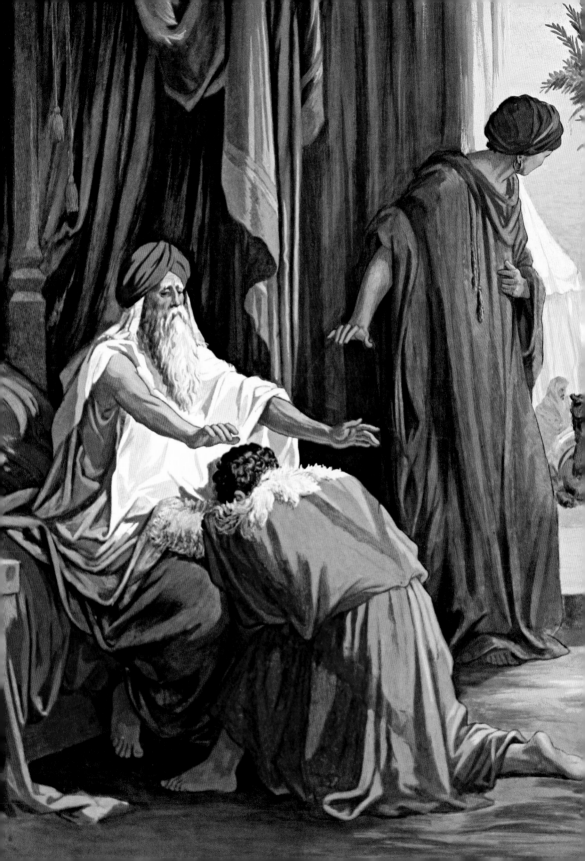

JACOB AND ESAU

SETTING THE SCENE

Abraham and Sarah's son, Isaac, married Rebekah, and they had twin boys—Esau and Jacob. From the beginning, these two were rivals jostling in Rebekah's womb, with Jacob, the younger of the twins, grasping his brother's heel at birth.

Though twins, they could not have been more different in both appearance and temperament. Esau was hairy and an outdoorsman who liked to hunt. Jacob was smooth-skinned and quiet, preferring to spend time at home.

Further fueling their rivalry, Isaac, a fan of wild game, preferred Esau, while Jacob was Rebekah's favorite.

Sibling Rivalry

FROM GENESIS 27

After Isaac had become old and almost blind, he called in his first-born son Esau, who asked him, "Father, what can I do for you?"

Isaac replied, "I am old and might die at any time. So take your bow and arrows, then go out in the fields, and kill a wild animal. Cook some of that tasty food that I love so much and bring it to me. I want to eat it once more and give you my blessing before I die."

Rebekah had been listening, and as soon as Esau left to go hunting, she said to Jacob, "I heard your father tell Esau to kill a wild animal and cook some tasty food for your father before he dies. Your father said this because he wants to bless your brother with the Lord as his witness. Now, my son, listen carefully to what I want you to do. Go and kill two of your best young goats and bring them to me. I'll cook the tasty food that your father loves so much. Then you can take it to him, so he can eat it and give you his blessing before he dies."

"My brother Esau is a hairy man," Jacob reminded her. "And I am not. If my father touches me and realizes I am trying to trick him, he will put a curse on me instead of giving me a blessing."

Rebekah insisted, "Let his curse fall on me! Just do what I say and bring me the meat." Then she took Esau's best clothes and put them on Jacob. She also covered the smooth part of his hands and neck with goatskins and gave him some bread and the tasty food she had cooked.

Jacob went to his father and said, "Father, here I am."

"Which one of my sons are you?" his father asked.

Jacob replied, "I am Esau, your first-born, and I have done what you told me. Please sit up and eat the meat I have brought. Then you can give me your blessing."

Isaac asked, "My son, how did you find an animal so quickly?"

"The Lord your God was kind to me," Jacob answered.

"My son," Isaac said, "come closer, where I can touch you and find out if you really are Esau." Jacob went closer. His father touched him and said, "You sound like Jacob, but your hands feel hairy like Esau's." And so Isaac blessed Jacob, thinking he was Esau.

Isaac asked, "Are you really my son Esau?"

"Yes, I am," Jacob answered.

So Isaac told him, "Serve me the wild meat, and I can give you my blessing."

Then Isaac said, "Son, come over here and kiss me." While Jacob was kissing him, Isaac caught the smell of his clothes and said:

> "The smell of my son is like a field the Lord has blessed. God will bless you, my son, with dew from heaven and with fertile fields, rich with grain and grapes. Nations will be your servants and bow down to you. You will rule over your brothers, and they will kneel at your feet. Anyone who curses you will be cursed; anyone who blesses you will be blessed."

Right after Isaac had given Jacob his blessing and Jacob had gone, Esau came back from hunting (CEV).

TRUTH FOR TODAY

This wasn't Jacob and Esau's first clash involving their respective positions as heirs. Prior to this episode, Esau had returned home famished one day and foolishly traded away his birthright to Jacob for a bowl of stew. His attitude toward his status of eldest son was so indifferent that it is said of this incident that "Esau despised his birthright" (Genesis 25:34, ESV).

> Oh, what a tangled web we weave When first we practise to deceive!
> —SIR WALTER SCOTT, Marmion, (1808)

Ironically, the Lord had already revealed to Rebekah during her pregnancy that she would have twins and that "the older shall serve the younger" (Genesis 25:23 ESV). Rather than leaving things be, Rebekah schemed to deceive blind Isaac in order for Jacob to receive his blessing. And in Jacob Rebekah had a willing accomplice.

While successful in having Jacob receive Isaac's blessing, the deceit further fractured this already fragile family, resulting in Jacob fleeing in fear to Haran (the far-away home of Rebekah's family), never to see his mother alive again.

Oh, the unintended pain and repercussions when we plot and scheme to manipulate circumstances to our advantage.

You can make many plans, but the LORD's purpose will prevail. Proverbs 19:21

FYI

So what's the big deal about the *blessing* in Bible times? It was a bequeathing similar to a last will and testament, whereas *birthright* had more to do with one's standing or authority to lead a family or tribe.

There are two sets of known twins in the Bible: Jacob and Esau and Perez and Zerah. As noted in Genesis 38, Perez and Zerah were Jacob's grandsons, born to his son Judah.

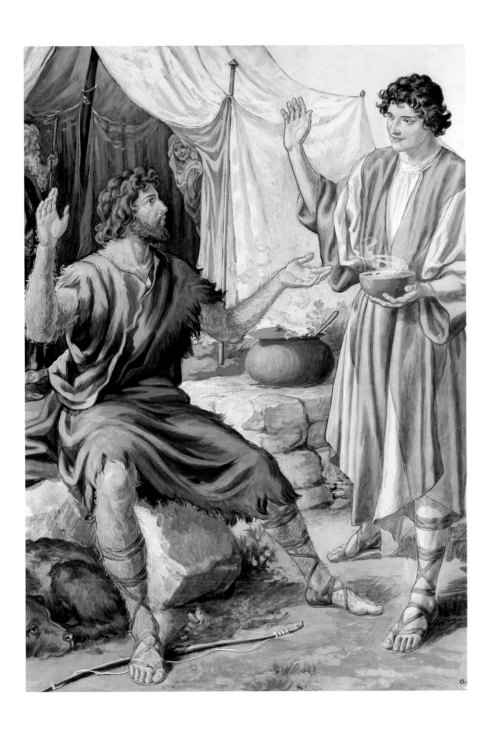

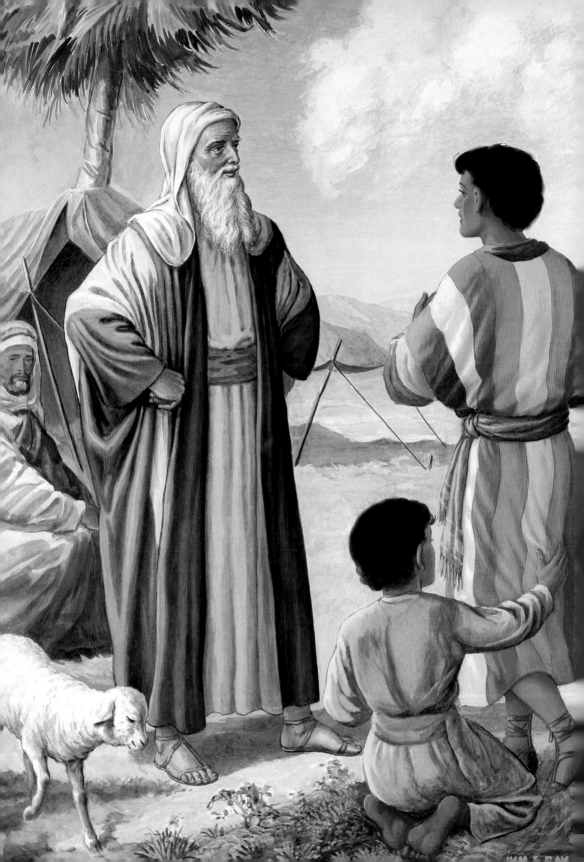

JOSEPH'S COAT
AND DREAMS

SETTING THE SCENE

Jacob's own experience of being caught up as a child in parental favoritism (Chapter 11) wasn't enough to prevent him from repeating the same mistake. The father of twelve sons, he took his turn in exhibiting partiality. This is made clear through a conspicuous gift given to his second-youngest son, seventeen-year-old Joseph.

Favored Son

FROM GENESIS 37

So Jacob settled again in the land of Canaan, where his father had lived as a foreigner.

This is the account of Jacob and his family. When Joseph was seventeen years old, he often tended his father's flocks. He worked for his half brothers, the sons of his father's wives Bilhah and Zilpah. But Joseph reported to his father some of the bad things his brothers were doing.

Jacob loved Joseph more than any of his other children because Joseph had been born to him in his old age. So one day Jacob had a special gift made for Joseph—a beautiful robe. But his brothers hated Joseph because their father loved him more than the rest of them. They couldn't say a kind word to him.

One night Joseph had a dream, and when he told his brothers about it, they hated him more than ever. "Listen to this dream," he said. "We were out in the field, tying up bundles of grain. Suddenly my bundle stood up, and your bundles all gathered around and bowed low before mine!"

His brothers responded, "So you think you will be our king, do you? Do you actually think you will reign over us?" And they hated him all the more because of his dreams and the way he talked about them.

Soon Joseph had another dream, and again he told his brothers about it. "Listen, I have had another dream," he said. "The sun, moon, and eleven stars bowed low before me!"

This time he told the dream to his father as well as to his brothers, but his father scolded him. "What kind of dream is that?" he asked. "Will your mother and I and your brothers actually come and bow to the ground before you?" But while his brothers were jealous of Joseph, his father wondered what the dreams meant.

TRUTH FOR TODAY

Parenting 101: Don't play favorites!

Jacob's apparent obtuseness or overt disinterest regarding the impact his favoritism toward Joseph was having on his family only served to make matters worse.

Familial favoritism breeds resentment and can have long-term negative effects on the family. If you're a parent, do your family a favor and avoid the appearance of partiality. And if partiality is an issue you wrestle against, maintain awareness, seek forgiveness, and practice fairness as the antidote.

Fairness foils family feuds and fosters affection.

FYI

Various Bible translations render Jacob's gift to Joseph in different ways. From "coat of many colours" (NKJV) to variants such as: "robe of many colors" (ESV); "ornate robe" (NIV); "varicolored tunic" (NASB); and "fancy coat" (CEV).

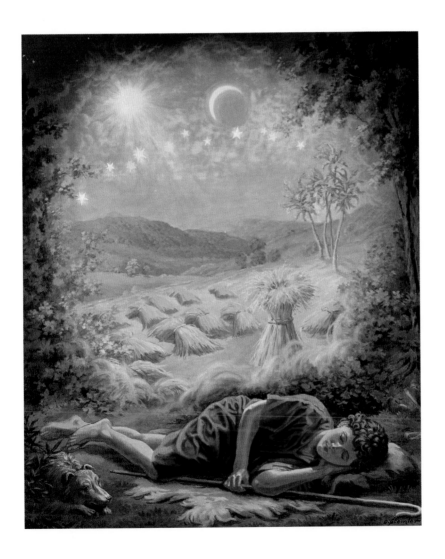

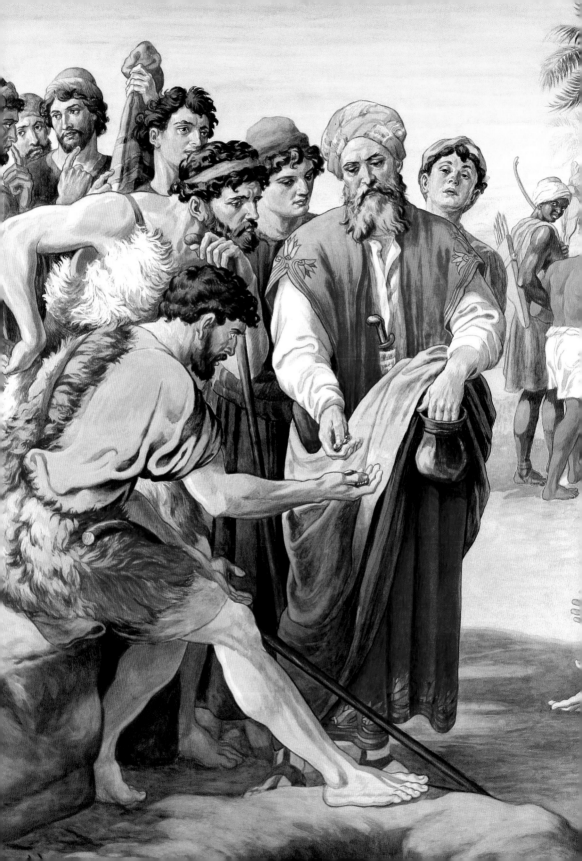

FAMILY BETRAYAL

SETTING THE SCENE

The saga of Joseph and his brothers continues.

After Joseph had shared his dreams with his brothers (Chapter 12), they took the family flock of sheep to graze in an area farther away from home. Jacob summoned Joseph and sent him to go check on them and report on how they were doing and the condition of the flock.

Wearing his fancy coat, Joseph headed out in search of his older brothers.

The Crime and the Cover Up
FROM GENESIS 37

Joseph left and found his brothers in Dothan. But before he got there, they saw him coming and made plans to kill him. They said to one another, "Look, here comes the hero of those dreams! Let's kill him and throw him into a pit and say that some wild animal ate him. Then we'll see what happens to those dreams."

Reuben heard this and tried to protect Joseph from them. "Let's not kill him," he said. "Don't murder him or even harm him. Just throw him into a dry well out here in the desert." Reuben planned to rescue Joseph later and take him back to his father.

When Joseph came to his brothers, they pulled off his fancy coat and threw him into a dry well.

As Joseph's brothers sat down to eat, they looked up and saw a caravan of Ishmaelites coming from Gilead. Their camels were loaded with all kinds of spices that they were taking to Egypt. So Judah said, "What will we gain if we kill our brother and hide his body? Let's sell him to the Ishmaelites and not harm him. After all, he is our brother." And the others agreed.

When the Midianite merchants came by, Joseph's brothers took him out of the well, and for twenty pieces of silver they sold him to the Ishmaelites who took him to Egypt.

When Reuben returned to the well and did not find Joseph there, he tore his clothes in sorrow. Then he went back to his brothers and said, "The boy is gone! What am I going to do?"

Joseph's brothers killed a goat and dipped Joseph's fancy coat in its blood. After this, they took the coat to their father and said, "We found this! Look at it carefully and see if it belongs to your son."

Jacob knew it was Joseph's coat and said, "It's my son's coat! Joseph has been torn to pieces and eaten by some wild animal."

Jacob mourned for Joseph a long time, and to show his sorrow he tore his clothes and wore sackcloth.

Meanwhile, the Midianites had sold Joseph in Egypt to a man named Potiphar, who was the king's official in charge of the palace guard (CEV).

TRUTH FOR TODAY

Without minimizing or excusing the evil wrought against Joseph by the brothers and their cruel deception against their father, it seems that Jacob did little to try

and temper, or de-escalate, the toxic family dynamic. Nor did Joseph seem aware or particularly concerned with curbing the contention.

Among the characteristics which can reasonably be ascribed to young Joe are these: tattletale; over-sharer; lacking self-awareness, at best; and at worst, full of himself. And the cherry on top of the sibling sundae? He was Papa Jacob's favorite.

While God would use Joseph greatly, as we shall see in Chapter 14, his youthful lack of humility did not serve him well in his relationships with his older brothers.

Pride leads to disgrace, but with humility comes wisdom.
Proverbs 11:2

FYI

The Ishmaelites were a nomadic tribal group who also happened to be descendants of Abraham's first son, Ishmael. In effect, Abraham's great-grandson, Joseph, is sold to the tribe of his grandfather Isaac's half-brother, Ishmael.

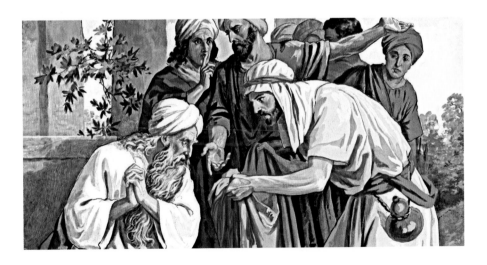

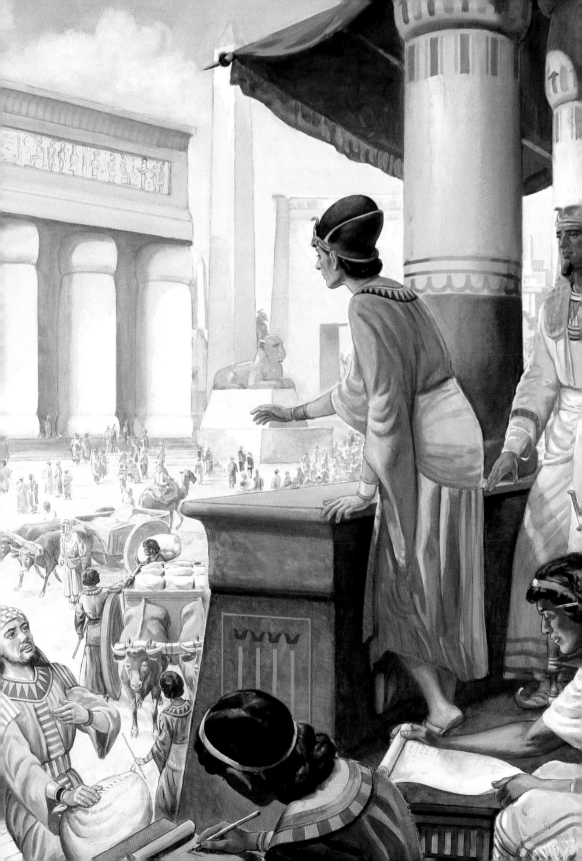

JOSEPH:
PRINCE OF EGYPT

SETTING THE SCENE

The caravan that Joseph's brothers had sold him to had arrived in Egypt, and Joseph was bought by Potiphar, Pharaoh's captain of the guard. It wasn't long before Potiphar put the talented young Joseph in charge of overseeing the affairs of his household. Joseph did this until he was accused of attempted rape by Potiphar's wife. Though he was innocent and had repeatedly rebuffed her advances, he was thrown in prison.

Joseph found favor once again—this time with the warden—and was placed in a position of trust and responsibility in the prison. While there, Joseph accurately interpreted the dreams of two of Pharaoh's officials, the chief baker and chief cupbearer, who had displeased their boss and found themselves in jail.

The cupbearer was restored to his position and promptly forgot about Joseph. Two years later, Pharaoh had a pair of dreams that none of his advisors could explain. Suddenly, the cupbearer remembered Joseph.

Dream Whisperer

FROM GENESIS 41

The king sent for Joseph, and he was immediately brought from the prison. After he had shaved and changed his clothes, he came into the king's presence. The king said to him, "I have had a dream, and no one can explain it. I have been told that you can interpret dreams."

Joseph answered, "I cannot, Your Majesty, but God will give a favorable interpretation."

The king said, "I dreamed that I was standing on the bank of the Nile, when seven cows, fat and sleek, came up out of the river and began feeding on the grass. Then seven other cows came up which were thin and bony. They were the poorest cows I have ever seen anywhere in Egypt. The thin cows ate up the fat ones, but no one would have known it, because they looked just as bad as before. Then I woke up. I also dreamed that I saw seven heads of grain which were full and ripe, growing on one stalk. Then seven heads of grain sprouted, thin and scorched by the desert wind, and the thin heads of grain swallowed the full ones. I told the dreams to the magicians, but none of them could explain them to me."

Joseph said to the king, "The two dreams mean the same thing; God has told you what he is going to do. There will be seven years of great plenty in all the land of Egypt. After that, there will be seven years of famine, and all the good years will be forgotten, because the famine will ruin the country.

"Now you should choose some man with wisdom and insight and put him in charge of the country. You must also appoint other officials and take a fifth of the crops during the seven years of plenty. Order them to collect all the food during the good years that are coming, and give them authority to store up grain in the cities and guard it. The food will be a reserve supply for the country during the seven years of famine which are going to come on Egypt. In this way the people will not starve."

The king and his officials approved this plan, and he said to them, "We will never find a better man than Joseph, a man who has God's spirit in him." The king said to Joseph, "God has shown you all this, so it is obvious that you have greater wisdom and insight than anyone else. I will put you in charge of my country, and all my people will obey your orders. Your authority will be second only to mine. I now appoint you governor over all Egypt." The king removed from his finger the ring engraved with the royal seal and put it on Joseph's finger. He put a fine linen robe on him, and placed a gold chain around his neck. He gave him the second royal chariot to ride in, and his guard of honor went ahead of him and cried out, "Make way! Make way!" And so Joseph was appointed governor over all Egypt (GNT).

TRUTH FOR TODAY

Work experience: chief household slave, jail trustee, and governor in Egypt. Talk about an unconventional career path.

The secret to Governor Joe's resiliency and success? We are told three times in Genesis 39 that "the Lord was with Joseph." Even as a harassed servant and forgotten prisoner, God was with him at every point along the way.

Not only was God with Joseph, but the Lord had a plan for his life *and* was able to give purpose to his unwelcome circumstances. If God brought meaning to Joseph's trials and tribulations, don't doubt He'll do the same for you.

Whether you profess to know God or not, God knows you, knows your circumstances, and has a purpose for your life.

FYI

Joseph was thirty years old when he entered into Pharaoh's service; thirteen years had passed since he was sold by his brothers at age seventeen.

Ironically and providentially, by ridding themselves of their kid brother by selling him to slave traders, the brothers set into motion Joseph's sojourn in Egypt. This act provided salvation (from murder) for Joseph and the future salvation from starvation for not only Egypt, but also for his brothers and their families.

Trust in the LORD with all your heart; do not depend on your own understanding. Seek his will in all you do, and he will show you which path to take."

PROVERBS 3:5–6

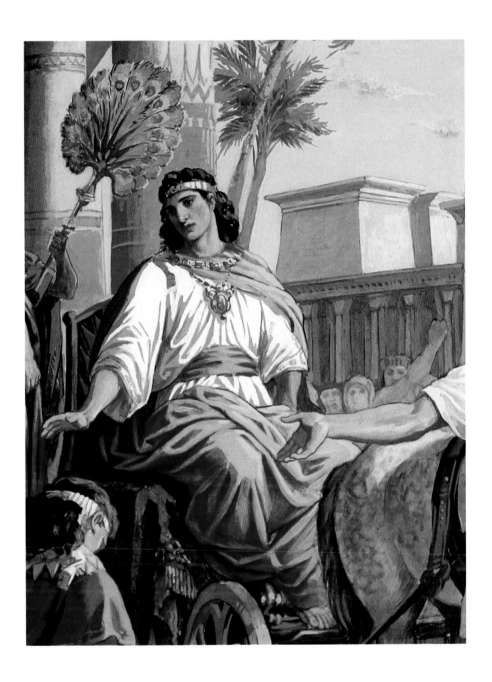

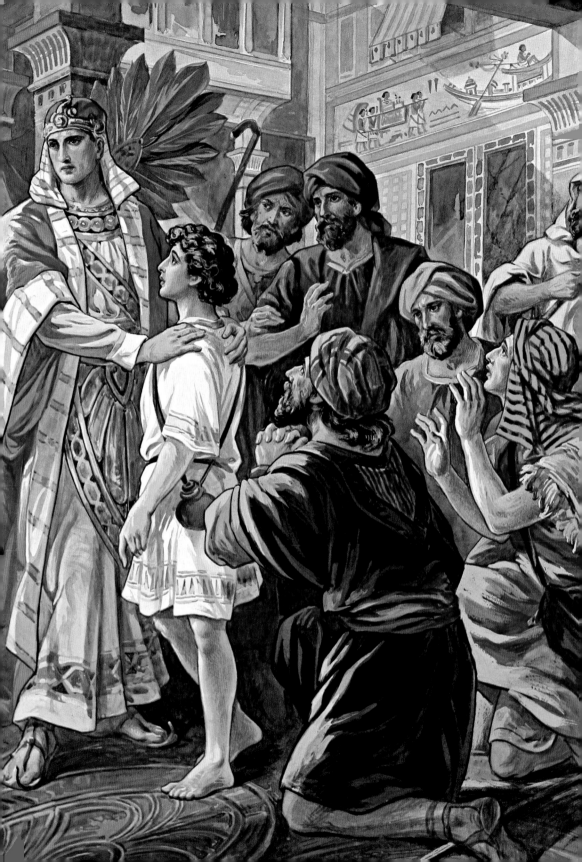

JOSEPH'S BROTHERS
IN EGYPT

SETTING THE SCENE

Pharaoh's strange dreams that Joseph had interpreted had come to pass. Egypt experienced seven years of plenty before a devastating famine engulfed the region. Hearing that there was food available in Egypt, Jacob sent his sons—except for the youngest, Benjamin—to buy grain.

This errand brought them face-to-face with the government official who administered Egypt's provisions—their long-lost brother. Though many years had passed, Joseph recognized his brothers on sight; however, they did not recognize him.

Joseph kept his true identity hidden from them during their first interaction. To ensure a second audience, he manipulated their transaction in such a way that required the brothers' making a return trip to Egypt with Benjamin accompanying them. Upon their reappearance, Joseph gathered them together for the big reveal.

We Are Family

FROM GENESIS 45

Then Joseph could not control himself before all those who stood by him. He cried, "Make everyone go out from me." So no one stayed with him when Joseph made himself known to his brothers. And he wept aloud, so that the Egyptians heard it, and the household of Pharaoh heard it. And Joseph said to his brothers, "I am Joseph! Is my father still alive?" But his brothers could not answer him, for they were dismayed at his presence.

So Joseph said to his brothers, "Come near to me, please." And they came near. And he said, "I am your brother, Joseph, whom you sold into Egypt. And now do not be distressed or angry with yourselves because you sold me here, for God sent me before you to preserve life. For the famine has been in the land these two years, and there are yet five years in which there will be neither plowing nor harvest. And God sent me before you to preserve for you a remnant on earth, and to keep alive for you many survivors. So it was not you who sent me here, but God. He has made me a father to Pharaoh, and lord of all his house and ruler over all the land of Egypt. Hurry and go up to my father and say to him, 'Thus says your son Joseph, God has made me lord of all Egypt. Come down to me; do not tarry.' Then he fell upon his brother Benjamin's neck and wept, and Benjamin wept upon his neck. And he kissed all his brothers and wept upon them. After that his brothers talked with him.

> It's wise to be patient and show what you are like by forgiving others.
> PROVERBS 19:11 (CEV)

When the report was heard in Pharaoh's house, "Joseph's brothers have come," it pleased Pharaoh and his servants. And Pharaoh said to Joseph, "Say to your brothers, 'Do this: load your beasts and go back to the land of Canaan, and take your father and your households, and come to me, and I will give you the best of the land of Egypt, and you shall eat the fat of the land.'"

Then he sent his brothers away, and as they departed, he said to them, "Do not quarrel on the way."

So they went up out of Egypt and came to the land of Canaan to their father Jacob. And they told him, "Joseph is still alive, and he is ruler over all the land of Egypt." And his heart became numb, for he did not believe them. But when they told him all the words of Joseph, which he had said to them, and when he saw the wagons that Joseph had sent to carry him, the spirit of their father Jacob revived. And Israel said, "It is enough; Joseph my son is still alive. I will go and see him before I die" (ESV).

TRUTH FOR TODAY

Despite the gravest of trials and deepest regrets, as long as the estranged parties are still living, reconciliation is possible.

While Joseph could have raged at his brothers and exacted revenge, he wept and extended his embrace. Later, Joseph would tell his brothers, "As for you, you meant evil against me, but God meant it for good, to bring it about that many people should be kept alive, as they are today" (Genesis 50:20, ESV).

Despite having gone through hard times that he would not have willingly chosen, Joseph was able to see God's purpose at work.

When you are tempted to write off life's trials and tribulations to random chance or "bad luck," remember Joseph.

God is able to use for good that which others intend for harm.

FYI

The brothers' first appearance before Joseph (Genesis 42:6) marked the fulfillment of the dream he had shared with them some twenty years prior (Genesis 37:7, 9).

JOSEPH IN EGYPT TIMELINE

- Young Joe was seventeen when his brothers sold him and he was taken to Egypt.

- His next thirteen years in Egypt were split between working in Potiphar's house and prison.

- Joseph was thirty when Pharaoh appointed him governor. This was followed by seven years of plenty, and then a seven-year famine.

- Joseph's brothers first came to Egypt in the second year of the famine. Joseph would have been pushing forty by this time.

- Joseph passed away in Egypt surrounded by his family at the age of 110.

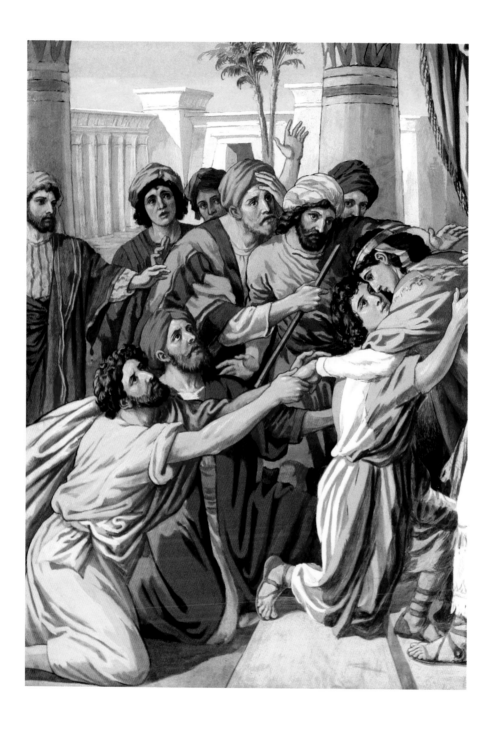

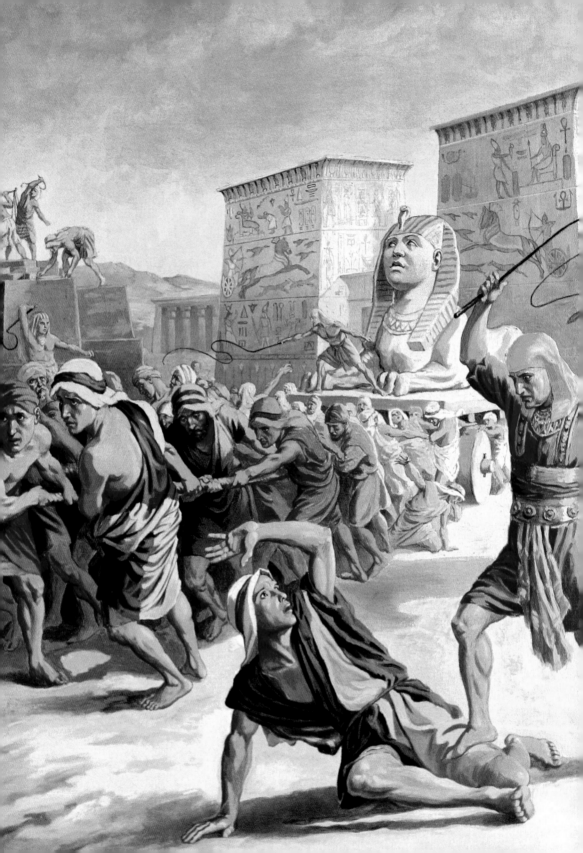

ISRAEL ENSLAVED

SETTING THE SCENE

During Joseph's sojourn in Egypt, he had risen to a powerful position. In appreciation for Joseph's leadership, which had saved people during a time of extended famine, Pharaoh welcomed Joseph's father, Jacob (known also as Israel), and his entire family—a rag-tag band of seventy people—to live as honored guests in his kingdom.

Fast-forward several generations; the number of Israelites living in the land has grown exponentially.

Times They Are A-Changin'
FROM EXODUS 1

These are the names of the sons of Israel (that is, Jacob) who moved to Egypt with their father, each with his family: Reuben, Simeon, Levi, Judah, Issachar, Zebulun, Benjamin, Dan, Naphtali, Gad, and Asher. In all, Jacob had seventy descendants in Egypt, including Joseph, who was already there.

In time, Joseph and all of his brothers died, ending that entire generation. But their descendants, the Israelites, had many children and grandchildren. In fact, they multiplied so greatly that they became extremely powerful and filled the land.

Eventually, a new king came to power in Egypt who knew nothing about Joseph or what he had done. He said to his people, "Look, the people of Israel now outnumber us and are stronger than we are. We must make a plan to keep them from growing even more. If we don't, and if war breaks out, they will join our enemies and fight against us. Then they will escape from the country."

So the Egyptians made the Israelites their slaves. They appointed brutal slave drivers over them, hoping to wear them down with crushing labor. They forced them to build the cities of Pithom and Rameses as supply centers for the king. But the more the Egyptians oppressed them, the more the Israelites multiplied and spread, and the more alarmed the Egyptians became. So the Egyptians worked the people of Israel without mercy. They made their lives bitter, forcing them to mix mortar and make bricks and do all the work in the fields. They were ruthless in all their demands.

Treat others as you want them to treat you.
MATTHEW 7:12 (CEV)

TRUTH FOR TODAY

Whether in a place of freedom or oppression, two things are certain: God is at work, and things change over time. Sometimes change is painfully slow— sometimes for better, sometimes for worse. What or who is "in" today may fall out of favor tomorrow. The real challenge over the course of one's lifetime is knowing who to place your faith in, especially during dark days and long nights.

Treat everyone well
(if for no other reason than the people you meet
on the way up may be the same people you encounter
on the way down).

FYI

Israel was the name God gave to Jacob (Genesis 32:28), the son of Isaac and Rebekah, the grandson of Abraham and Sarah, and the father of twelve sons—recognized as the fathers of the twelve tribes of Israel.

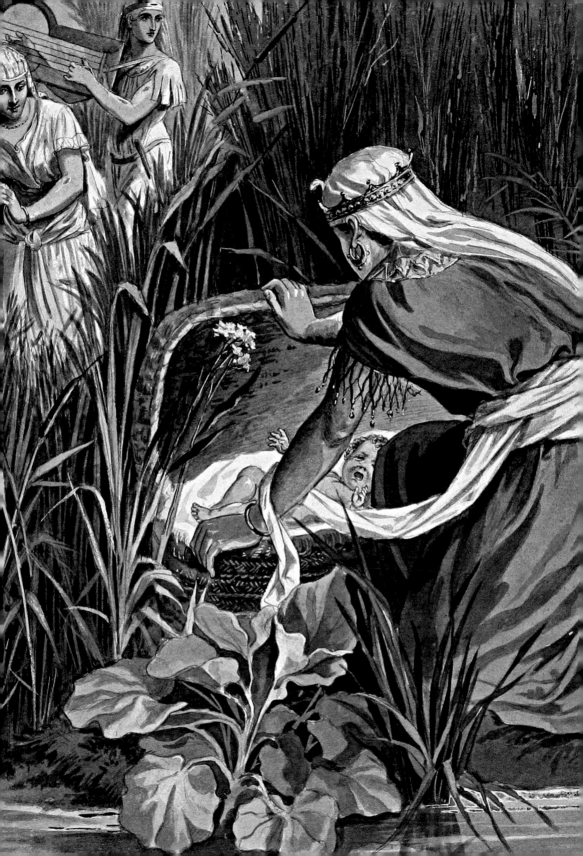

BABY MOSES IN A BASKET

SETTING THE SCENE

In an effort to stem the robust and fast-growing population of Israelites, the ruling pharaoh in Egypt had instructed two Hebrew midwives to kill newborn boys upon birth. That effort failed because the midwives feared God more than Pharaoh. Undeterred, he moved to "Plan B."

Rescue 9-1-1

FROM EXODUS 1–2

Then Pharaoh gave this order to all his people: "Throw every newborn Hebrew boy into the Nile River. But you may let the girls live."

About this time, a man and woman from the tribe of Levi got married. The woman became pregnant and gave birth to a son. She saw that he was a special baby and kept him hidden for three months. But when she could no longer hide him, she

got a basket made of papyrus reeds and waterproofed it with tar and pitch. She put the baby in the basket and laid it among the reeds along the bank of the Nile River. The baby's sister then stood at a distance, watching to see what would happen to him.

Soon Pharaoh's daughter came down to bathe in the river, and her attendants walked along the riverbank. When the princess saw the basket among the reeds, she sent her maid to get it for her. When the princess opened it, she saw the baby. The little boy was crying, and she felt sorry for him. "This must be one of the Hebrew children," she said.

Then the baby's sister approached the princess. "Should I go and find one of the Hebrew women to nurse the baby for you?" she asked.

"Yes, do!" the princess replied. So the girl went and called the baby's mother.

"Take this baby and nurse him for me," the princess told the baby's mother. "I will pay you for your help." So the woman took her baby home and nursed him.

Later, when the boy was older, his mother brought him back to Pharaoh's daughter, who adopted him as her own son. The princess named him Moses, for she explained, "I lifted him out of the water."

TRUTH FOR TODAY

The heartless extermination of the innocent is as tragic today as it was then. If not for a number of heroic women coming to his aid, Moses would not have lived. In addition to the brave Hebrew midwives (Shiphrah and Puah), other noble figures include Moses's mother (Jochebed), his sister (Miriam), and Pharaoh's own daughter!

The sacrificial love of a mother is a beautiful thing and a force for good in the world.

FYI

The Hebrew word used for *basket* in this story appears twice in the Old Testament: once here (rendered as "basket") and once in Genesis 6, where it is rendered as "ark." Though very different in terms of size, both vessels were used as a means of deliverance.

In Hebrew, the Egyptian name "Moses" sounds like a word that means "to draw out."

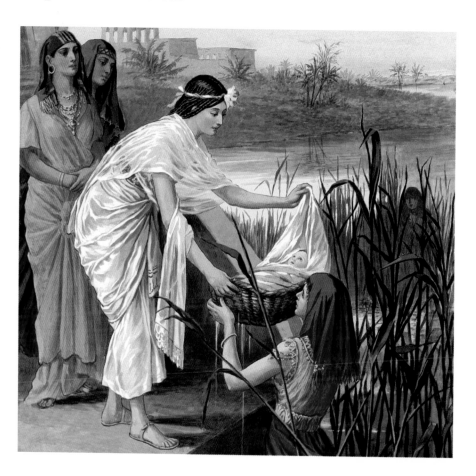

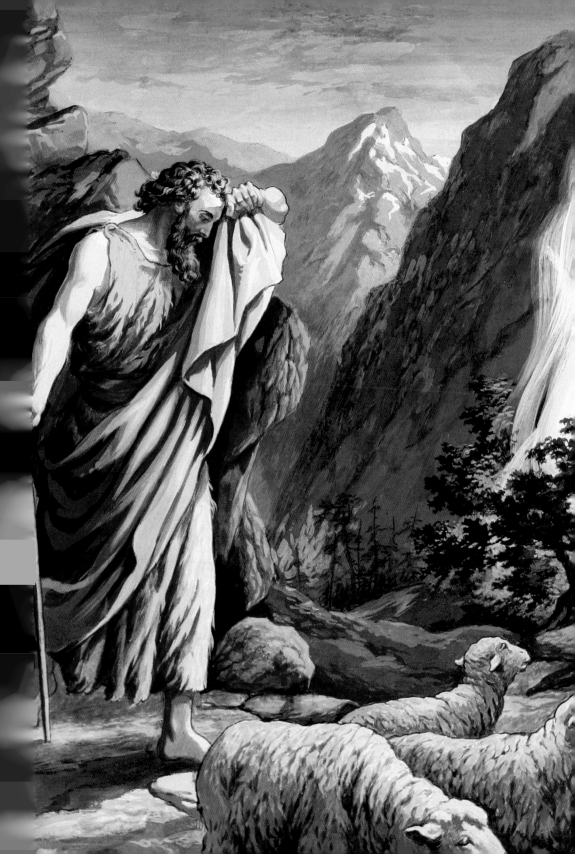

MOSES AND THE BURNING BUSH

SETTING THE SCENE

Having been rescued out of the Nile and adopted by Pharaoh's daughter, Moses grew up as part of Pharaoh's household and was trained and educated in the ways of Egypt. However, he still empathized with the people of his birth.

One day, Moses, then a grown man, went out to where the Hebrews were and observed an Egyptian beating a Hebrew slave. Taking matters into his own hands, Moses killed the Egyptian and buried him in the sand. Finding out the next day that his crime was known, he fled Egypt in fear for his life.

Forty years later, with his time in Egypt seemingly lost to the past, Moses was tending his father-in-law's flock on a mountainside in the Midian wilderness when something unusual captured his attention.

MISSION POSSIBLE

FROM EXODUS 3

One day Moses was tending the flock of his father-in-law, Jethro, the priest of Midian. He led the flock far into the wilderness and came to Sinai, the mountain of God. There the angel of the LORD appeared to him in a blazing fire from the middle of a bush. Moses stared in amazement. Though the bush was engulfed in flames, it didn't burn up. "This is amazing," Moses said to himself. "Why isn't that bush burning up? I must go see it."

When the LORD saw Moses coming to take a closer look, God called to him from the middle of the bush, "Moses! Moses!"

"Here I am!" Moses replied.

"Do not come any closer," the LORD warned. "Take off your sandals, for you are standing on holy ground. I am the God of your father—the God of Abraham, the God of Isaac, and the God of Jacob." When Moses heard this, he covered his face because he was afraid to look at God.

Then the LORD told him, "I have certainly seen the oppression of my people in Egypt. I have heard their cries of distress because of their harsh slave drivers. Yes, I am aware of their suffering. So I have come down to rescue them from the power of the Egyptians and lead them out of Egypt into their own fertile and spacious land. It is a land flowing with milk and honey—the land where the Canaanites, Hittites, Amorites, Perizzites, Hivites, and Jebusites now live. Look! The cry of the people of Israel has reached me, and I have seen how harshly the Egyptians abuse them. Now go, for I am sending you to Pharaoh. You must lead my people Israel out of Egypt."

But Moses protested to God, "Who am I to appear before Pharaoh? Who am I to lead the people of Israel out of Egypt?"

God answered, "I will be with you. And this is your sign that I am the one who has sent you: When you have brought the people out of Egypt, you will worship God at this very mountain."

But Moses protested, "If I go to the people of Israel and tell them, 'The God of your ancestors has sent me to you,' they will ask me, 'What is his name?' Then what should I tell them?"

God replied to Moses, "I AM WHO I AM. Say this to the people of Israel: I AM has sent me to you." God also said to Moses, "Say this to the people of Israel: 'Yahweh, the God of your ancestors—the God of Abraham, the God of Isaac, and the God of Jacob—has sent me to you.'

"This is my eternal name, my name to remember for all generations."

TRUTH FOR TODAY

The Lord was recruiting Moses for a particular assignment. In religious parlance, Moses was being called by God. While intrigued by God's pyrotechnics in getting his attention, Moses was less than enthusiastic about the opportunity.

Perhaps replaying in the back of his mind was the time forty years earlier when, impetuously and in his own power, he had tried to intervene on behalf of his tribe, only to fail miserably. Gone was the verve of yesteryear, and in its place was self-doubt.

Be it a past failure, loss, or unrealized dream, you may feel resigned to your current state. Or maybe just the opposite: you're cruising along and enjoying life as it is. Whatever the case, keep your eyes open for the extraordinary ordinary—looking and listening for God's calling on your life.

> The most fundamental question you can ask yourself is: 'Why am I here?' God makes everything with a purpose. Every plant has a purpose, every animal has a purpose, and if you are alive that means that God has a purpose for your life.
>
> —RICK WARREN, from the article "What on Earth Am I Here For?" (Pastors.com, January 16, 2015)

The call God has for you is something you have been uniquely created and equipped to do.

FYI

MOSES, A LIFE IN THREE ACTS:

- He spent his first forty years in Egypt.

- He lived and worked in the land of Midian as a shepherd for the next forty years.

- He returned to Egypt and led Israel for the final forty years of his life.

When Moses asked God what His name was, the response was "I AM WHO I AM", which corresponds to a Hebrew verb "Yahweh" (YHWH), which means "to be." Most English-language Bibles replace the Hebrew name for God, Yahweh, with "the LORD," rendering "Lord" in small capital letters.*

Not so far in the future from his initial encounter with God at the burning bush, Moses returned to the same mountain and received the Ten Commandments.

Exodus 3:14, 15 verse notes in the ESV Study Bible, Crossway, 2008.

GOD REPLIED TO MOSES, "I AM WHO I AM. SAY THIS TO THE PEOPLE OF ISRAEL: I AM HAS SENT ME TO YOU." EXODUS 3:14

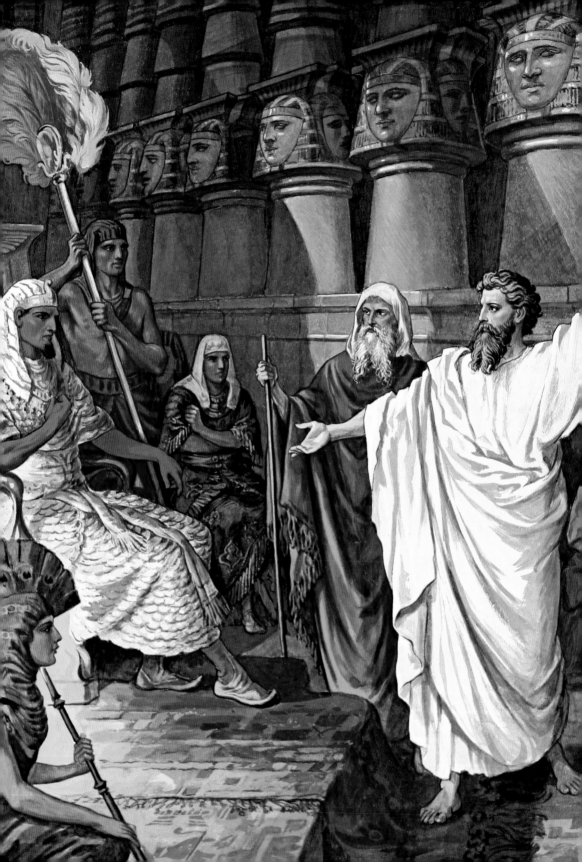

MOSES AND AARON BEFORE PHARAOH

SETTING THE SCENE

Having been called by God to return to Egypt, Moses sought leave from his father-in-law, Jethro, and headed back to the land of his birth.

In response to Moses's excuse that he wasn't eloquent of speech, God teamed him up with his loquacious older brother, Aaron. After addressing the Hebrew elders, Moses and Aaron prepared to confront Pharaoh for the first time.

Let My People Go!

FROM EXODUS 5–7

Then Moses and Aaron went to the king of Egypt and said, "The LORD, the God of Israel, says, 'Let my people go, so that they can hold a festival in the desert to honor me.'"

"Who is the LORD?" the king demanded. "Why should I listen to him and let Israel go? I do not know the LORD; and I will not let Israel go."

Moses and Aaron replied, "The God of the Hebrews has revealed himself to us. Allow us to travel three days into the desert to offer sacrifices to the LORD our God. If we don't do so, he will kill us with disease or by war."

The king said to Moses and Aaron, "What do you mean by making the people neglect their work? Get those slaves back to work! You people have become more numerous than the Egyptians. And now you want to stop working!"

That same day the king commanded the Egyptian slave drivers and the Israelite foremen: "Stop giving the people straw for making bricks. Make them go and find it for themselves. But still require them to make the same number of bricks as before, not one brick less."

Then the foremen went to the king and complained, "Why do you do this to us, Your Majesty? We are given no straw, but we are still ordered to make bricks! And now we are being beaten. It is your people that are at fault."

The king answered, "You are lazy and don't want to work, and that is why you ask me to let you go and offer sacrifices to the LORD. Now get back to work!"

As they were leaving, they met Moses and Aaron, who were waiting for them. They said to Moses and Aaron, "The LORD has seen what you have done and will punish you for making the king and his officers hate us. You have given them an excuse to kill us."

Then Moses turned to the LORD again and said, "Lord, why do you mistreat your people? Why did you send me here? Ever since I went to the king to speak for you, he has treated them cruelly. And you have done nothing to help them!"

Then the LORD said to Moses, "Now you are going to see what I will do to the king. I will force him to let my people go. In fact, I will force him to drive them out of his land."

The LORD said, "I am going to make you like God to the king, and your brother Aaron will speak to him as your prophet. Tell Aaron everything I command you, and he will tell the king to let the Israelites leave his country. But I will make the king stubborn, and he will not listen to you, no matter how many terrifying things I do in Egypt. Then I will bring severe punishment on Egypt and lead the tribes of my

people out of the land. The Egyptians will then know that I am the LORD, when I raise my hand against them and bring the Israelites out of their country" (GNT).

TRUTH FOR TODAY

Coming out of their first and seemingly counterproductive conference with Pharaoh, Moses asked the Lord, "Why did you send me here?"

In this case, the Egyptian ruler's intransigence was part of God's plan: "I will make the king stubborn, and he will not listen to you." Moses would find himself in front of Pharaoh at least another ten times with similar results. However, Moses remained faithful and stayed the course.

As Moses discovered, just because God calls you to do something doesn't mean it's going to be a cakewalk.

> Never give in—never, never, never, never, in nothing great or small, large or petty, never give in except to convictions of honour and good sense.
>
> —SIR WINSTON CHURCHILL, Harrow School speech (October 29, 1941)

Trust in God's call and stay the course—even when things don't go as hoped for or expected.

FYI

Accompanying many of the appearances Moses made before Pharaoh were numerous miraculous signs. The first three—a staff turning into a snake, water turning into blood, and the bringing forth of frogs—were things Pharaoh's court magicians, Jannes and Jambres, were able to partially duplicate. But for the many signs after those, the magicians themselves proclaimed to Pharaoh, "This is the finger of God!" (Exodus 8:19).

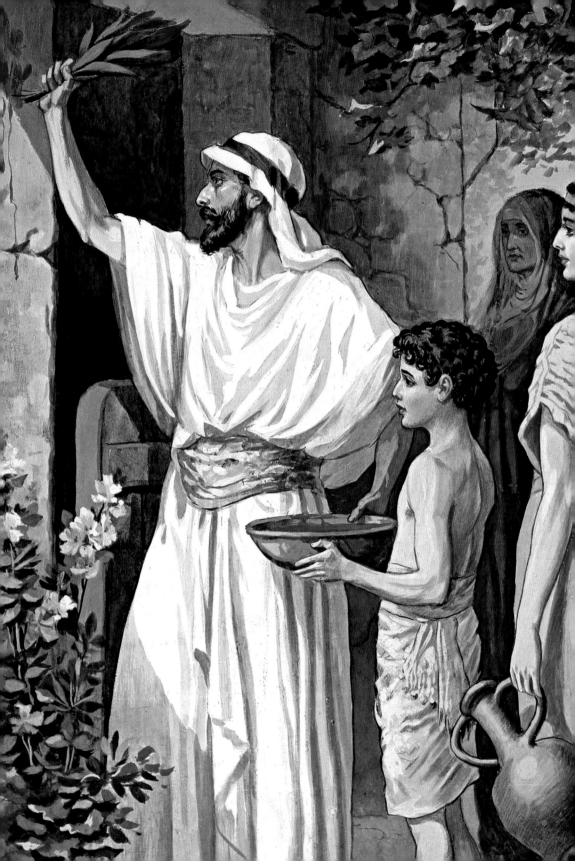

THE PASSOVER

SETTING THE SCENE

Pharaoh defiantly refused to let the Hebrew people go, even in the face of a succession of nine calamitous plagues that the Lord had brought as punishment against Egypt. Despite the devastation that had been wrought on the Egyptians, their land, and their livestock, Egypt's ruler resisted humbling himself before God. The time had come for Moses to deliver God's final pronouncement to Pharaoh.

The Tenth Plague

FROM EXODUS 11–12

Then the LORD said to Moses, "I will send only one more punishment on the king of Egypt and his people. After that he will let you leave. In fact, he will drive all of you out of here. Now speak to the people of Israel and tell all of them to ask their neighbors for gold and silver jewelry." The LORD made the Egyptians respect the Israelites. Indeed, the officials and all the people considered Moses to be a very great man.

Moses then said to the king, "The LORD says, 'At about midnight I will go through Egypt, and every first-born son in Egypt will die, from the king's son, who is heir to the throne, to the son of the slave woman who grinds grain. The first-born of all the cattle will die also. There will be loud crying all over Egypt, such as there has never been before or ever will be again. But not even a dog will bark at the Israelites or their animals. Then you will know that I, the LORD, make a distinction between the Egyptians and the Israelites.'" Moses concluded by saying, "All your officials will come to me and bow down before me, and they will beg me to take all my people and go away. After that, I will leave." Then in great anger Moses left the king.

Moses called for all the leaders of Israel and said to them, "Each of you is to choose a lamb or a young goat and kill it, so that your families can celebrate Passover. Take a sprig of hyssop, dip it in the bowl containing the animal's blood, and wipe the blood on the doorposts and the beam above the door of your house. Not one of you is to leave the house until morning. When the LORD goes through Egypt to kill the Egyptians, he will see the blood on the beams and the doorposts and will not let the Angel of Death enter your houses and kill you. You and your children must obey these rules forever. When you enter the land that the LORD has promised to give you, you must perform this ritual. When your children ask you, 'What does this ritual mean?' you will answer, 'It is the sacrifice of Passover to honor the LORD, because he passed over the houses of the Israelites in Egypt. He killed the Egyptians, but spared us.'"

The Israelites knelt down and worshiped. Then they went and did what the LORD had commanded Moses and Aaron.

At midnight the LORD killed all the first-born sons in Egypt, from the king's son, who was heir to the throne, to the son of the prisoner in the dungeon; all the first-born of the animals were also killed. That night, the king, his officials, and all the other Egyptians were awakened. There was loud crying throughout Egypt, because there was not one home in which there was not a dead son (GNT).

TRUTH FOR TODAY

Some eighty years prior to this long night of wailing in Egypt, the Pharaoh at that time had ordered all newborn Hebrew males to be killed. In a devastating turn of events, every household in Egypt, save for the homes marked by the blood of the Passover lamb, suffered loss.

While Israel's sojourn in Egypt had been long, freedom by the hand of God arrived in the Lord's timing.

Blessed are you who trust in God,
*who make God your stronghold.**

**Excerpted from the Birkat Hamazon, a series of Hebrew blessings said after a meal.*

FYI

THE TEN PLAGUES OF EGYPT (EXODUS CHAPTERS 7–12)

1. Water to blood

2. Frogs

3. Gnats*

4. Flies

5. Death of livestock

6. Boils

7. Hail

8. Locusts

9. Darkness

10. Death of firstborn

**Translated as lice in the King James Version, and as insects in the New American Standard Bible, but rendered as "gnats" in most modern English translations.*

The Passover, instituted by God just prior to Israel's exodus from Egypt approximately 3,500 years ago, is still observed and celebrated annually by Jews today in commemoration of the deliverance of the Hebrews.

God went before Israel in a pillar of cloud during the day and a pillar of fire at night (Exodus 13:22).

CROSS REFERENCE

In the Christian tradition, Jesus is sometimes referred to as "the Lamb of God," a name which John the Baptist called Jesus (John 1:29, 36). Likewise, the apostle Paul refers to Jesus as "our Passover Lamb" in his first epistle to the Corinthians:

> "Christ, our Passover Lamb, has been sacrificed for us. So let us celebrate the festival, not with the old bread of wickedness and evil, but with the new bread of sincerity and truth" (1 Corinthians 5:7c–8).

In the Christian view, Jesus was slain on behalf of humanity, making salvation possible through His death on the cross.

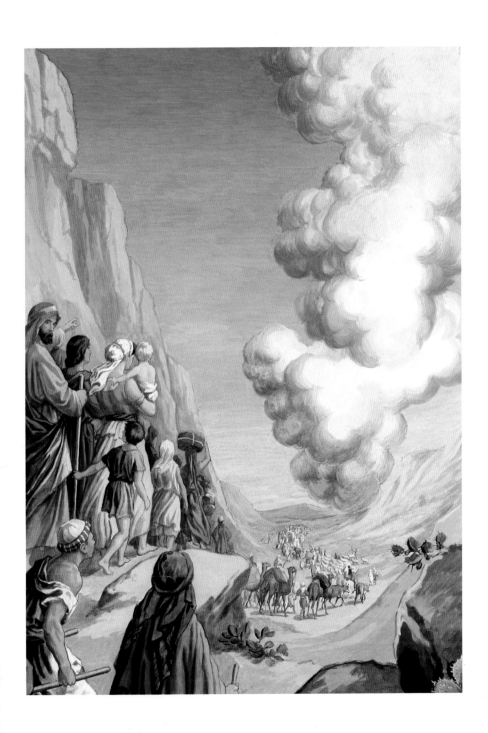

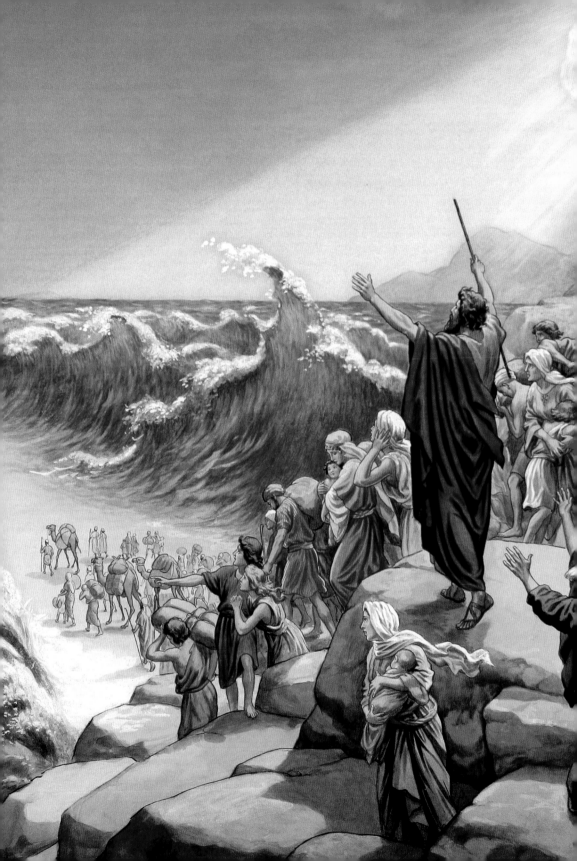

CROSSING THE RED SEA

SETTING THE SCENE

During the night of the tenth plague, Pharaoh summoned Moses and told him to take the Israelites and get out of Egypt. Moses and Aaron wasted no time in assembling the Hebrew nation to commence their exodus from the land of their oppression. As they traveled, the Lord went before Israel in a pillar of cloud during the day and a pillar of fire at night.

A Mighty Wind

FROM EXODUS 14

When the king of Egypt heard that the Israelites had finally left, he and his officials changed their minds and said, "Look what we have done! We let them get away, and they will no longer be our slaves."

The king got his war chariot and army ready. He commanded his officers in charge of his six hundred best chariots and all his other chariots to start after the Israelites. The LORD made the king so stubborn that he went after them, even though

the Israelites proudly went on their way. But the king's horses and chariots and soldiers caught up with them while they were camping by the Red Sea near Pi-Hahiroth and Baal-Zephon.

When the Israelites saw the king coming with his army, they were frightened and begged the LORD for help. They also complained to Moses, "Wasn't there enough room in Egypt to bury us? Is that why you brought us out here to die in the desert? Why did you bring us out of Egypt anyway? While we were there, didn't we tell you to leave us alone? We had rather be slaves in Egypt than die in this desert!"

But Moses answered, "Don't be afraid! Be brave, and you will see the LORD save you today. These Egyptians will never bother you again. The LORD will fight for you, and you won't have to do a thing."

All this time God's angel had gone ahead of Israel's army, but now he moved behind them. A large cloud had also gone ahead of them, but now it moved between the Egyptians and the Israelites. The cloud gave light to the Israelites, but made it dark for the Egyptians, and during the night they could not come any closer.

Moses stretched his arm over the sea, and the LORD sent a strong east wind that blew all night until there was dry land where the water had been. The sea opened up, and the Israelites walked through on dry land with a wall of water on each side.

The Egyptian chariots and cavalry went after them. But before daylight the LORD looked down at the Egyptian army from the fiery cloud and made them panic. Their chariot wheels got stuck, and it was hard for them to move. So the Egyptians said to one another, "Let's leave these people alone! The LORD is on their side and is fighting against us."

The LORD told Moses, "Stretch your arm toward the sea—the water will cover the Egyptians and their cavalry and chariots." Moses stretched out his arm, and at daybreak the water rushed toward the Egyptians. They tried to run away, but the LORD drowned them in the sea.

Because of the mighty power he had used against the Egyptians, the Israelites worshiped him and trusted him and his servant Moses (CEV).

TRUTH FOR TODAY

"Hey, Moe, why did you bring us out here to the desert to die!?"

Fresh out of Egypt, and seemingly pinned against the sea, it didn't take long for the Israelites' thrill of victory to turn to feelings of fear and distress. True to form, Pharaoh reversed course and decided to give chase.

Times of testing often seem to follow a great success or long-sought victory as exhilaration gives way to fear. When focused on our circumstances instead of the source of our deliverance, faith succumbs to fear.

With God there are no dead ends, only detours.

FYI

What had begun as a ragtag band of seventy people when Jacob and his family came to join Joseph in Egypt (Exodus 1:5) exploded into a small nation numbering approximately six hundred thousand men, not including women and children, by the end of the Hebrews' sojourn in Egypt (Exodus 12:37).

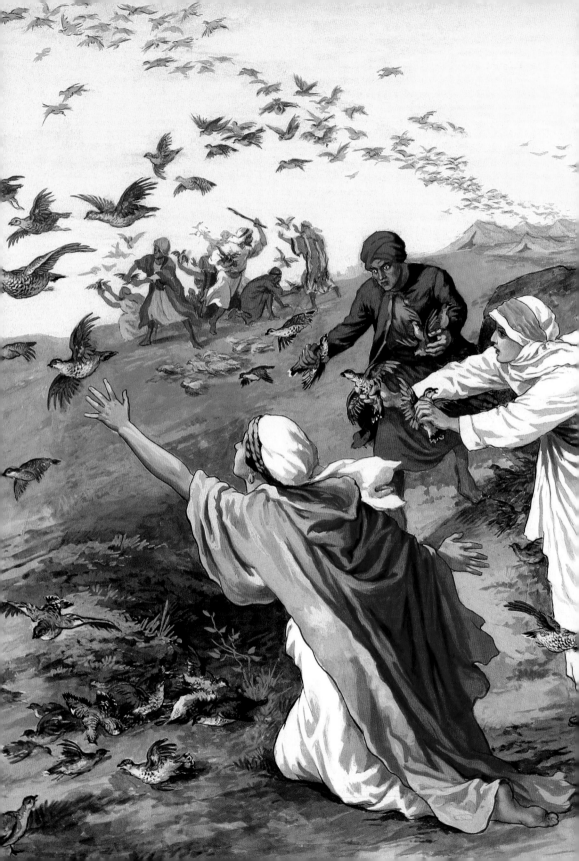

GOD PROVIDES MANNA AND QUAIL

SETTING THE SCENE

After the miraculous Red Sea crossing, the Israelites broke into song. However, it didn't take long before songs of deliverance gave way to grumbling and complaining. Though God had provided Israel with water in the desert—first making bitter water drinkable and then leading them to an oasis—their attention quickly turned to their stomachs.

Hunger Game

FROM EXODUS 16

On the fifteenth day of the second month after the Israelites had escaped from Egypt, they left Elim and started through the western edge of the Sinai Desert in the direction of Mount Sinai. There in the desert they started complaining to Moses and Aaron, "We wish the LORD had killed us in Egypt. When we lived

117

there, we could at least sit down and eat all the bread and meat we wanted. But you have brought us out here into this desert, where we are going to starve."

The LORD said to Moses, "I will send bread down from heaven like rain. Each day the people can go out and gather only enough for that day. That's how I will see if they obey me. But on the sixth day of each week they must gather and cook twice as much."

Moses and Aaron told the people, "This evening you will know that the LORD was the one who rescued you from Egypt. And in the morning you will see his glorious power, because he has heard your complaints against him. Why should you grumble to us? Who are we?"

Then Moses continued, "You will know it is the LORD when he gives you meat each evening and more than enough bread each morning. He is really the one you are complaining about, not us—we are nobodies—but the LORD has heard your complaints."

That evening a lot of quails came and landed everywhere in the camp, and the next morning dew covered the ground. After the dew had gone, the desert was covered with thin flakes that looked like frost. The people had never seen anything like this, and they started asking each other, "What is it?"

Moses answered, "This is the bread that the LORD has given you to eat. And he orders you to gather about two quarts for each person in your family—that should be more than enough."

They did as they were told. Some gathered more and some gathered less, according to their needs, and none was left over.

Moses told them not to keep any overnight. Some of them disobeyed, but the next morning what they kept was stinking and full of worms, and Moses was angry.

Each morning everyone gathered as much as they needed, and in the heat of the day the rest melted. However, on the sixth day of the week, everyone gathered enough to have four quarts, instead of two. When the leaders reported this to Moses, he told them that the LORD had said, "Tomorrow is

the Sabbath, a sacred day of rest in honor of me. So gather all you want to bake or boil, and make sure you save enough for tomorrow."

The people obeyed, and the next morning the food smelled fine and had no worms.

The Israelites called the bread manna. It was white like coriander seed and delicious as wafers made with honey (CEV).

TRUTH FOR TODAY

Today's forecast: Manna, with a chance of quail.

God didn't lead Israel out of Egypt to let them perish in the wilderness. The Lord's plan for their provision involved something no one had ever seen before: bread from heaven.

And what did the provision of manna require? That the people harvest only what they needed for the day, except for a double portion for the Sabbath. In so doing, the people exhibited *daily* obedience and trust in the Lord. And when tempted to try to accumulate more than their daily bread, that which was hoarded became maggot-infested and foul-smelling, while that which was permitted to be stored for the Sabbath remained edible.

If God was able to sustain a massive swarm of people in the wilderness, the Lord is more than able to meet you at your point of need day by day.

Our needs are not unknown to God, and the Lord is more than able to supply us with "our daily bread."

FYI

God provided manna to the Israelites during the entirety of their forty years in the wilderness. Not until they had crossed the Jordan River, signifying their entering the Promised Land, did the daily provision of manna cease (Joshua 5:12).

CROSS REFERENCE

In the sixth chapter of the Gospel of John, Jesus refers to Himself as both "the bread of life" and also as "living bread." To read what Jesus says related to this claim, see John 6:35–58.

I am the LORD, the God of
all the peoples of the world.
Is anything too hard for me?
JEREMIAH 32:27

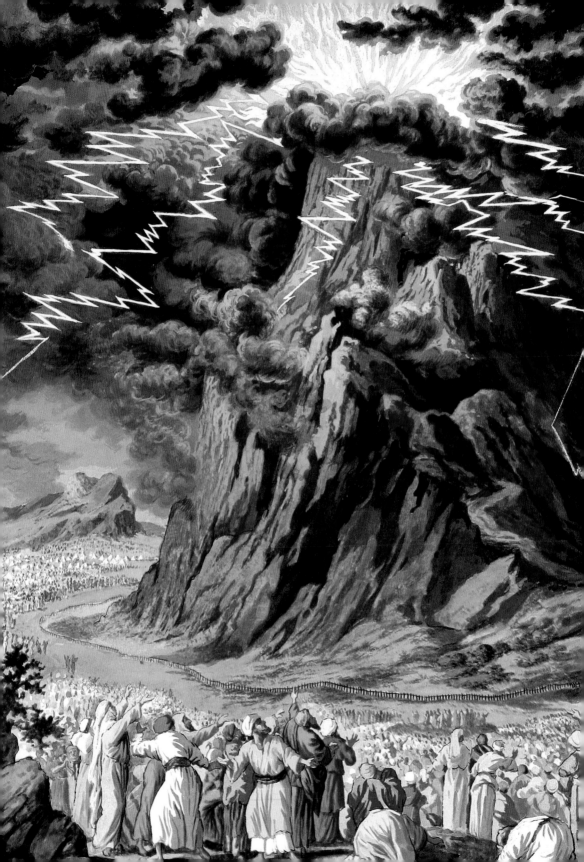

THE TEN COMMANDMENTS

23

SETTING THE SCENE

Not long after the exodus from Egypt, Moses led the Israelites to the foot of Mount Sinai to meet with God. The Lord descended onto the mountain and called Moses to ascend to the top. It was here the Lord spoke to Moses and gave him what we know as the Ten Commandments.

The Ultimate "Top Ten"

FROM EXODUS 20

And God spoke all these words, saying,

"I am the LORD your God, who brought you out of the land of Egypt, out of the house of slavery.

"You shall have no other gods before me.

"You shall not make for yourself a carved image, or any likeness of anything that is in heaven above, or that is in the earth beneath, or that is in the water under the earth. You shall not bow down to them or serve them, for I the LORD your God am a jealous God, visiting the iniquity of the fathers on the children to the third and the fourth generation of those who hate me, but showing steadfast love to thousands of those who love me and keep my commandments.

"You shall not take the name of the LORD your God in vain, for the LORD will not hold him guiltless who takes his name in vain.

"Remember the Sabbath day, to keep it holy. Six days you shall labor, and do all your work, but the seventh day is a Sabbath to the LORD your God. On it you shall not do any work, you, or your son, or your daughter, your male servant, or your female servant, or your livestock, or the sojourner who is within your gates. For in six days the LORD made heaven and earth, the sea, and all that is in them, and rested on the seventh day. Therefore the LORD blessed the Sabbath day and made it holy.

"Honor your father and your mother, that your days may be long in the land that the LORD your God is giving you.

"You shall not murder.

"You shall not commit adultery.

"You shall not steal.

"You shall not bear false witness against your neighbor.

"You shall not covet your neighbor's house; you shall not covet your neighbor's wife, or his male servant, or his female servant, or his ox, or his donkey, or anything that is your neighbor's" (ESV).

TRUTH FOR TODAY

The Lord delivered the Ten Commandments to Moses to share with the people. Commonly considered as a standard to live up to, the flip side is that these

commands reveal to us our need for God, since we invariably fall short in attempting to keep the whole of the law in our own power.

As recorded in the New Testament (Matthew 22:34–40), when asked by an expert in the Jewish Law what the greatest commandment was, Jesus smartly and succinctly boiled the Mosaic Law down to its essence: "Love the LORD" (from Deuteronomy 6:5) and "Love your neighbor" (from Leviticus 19:18).

In order to truly love others, enemies included, we must first know God's love. It is through experiencing God's love that we are able to rightly relate to others.

Love God wholly and love others as you wish to be loved.

FYI

THE TEN COMMANDMENTS IN THIRTY WORDS

1. Have no other gods before me

2. Don't worship false gods

3. Don't profane God's name

4. Keep the Sabbath

5. Honor parents

6. Don't murder

7. Don't commit adultery

8. Don't steal

9. Don't lie

10. Don't covet

The Ten Commandments are recorded in two places in the Bible: Exodus 20:2–17 and Deuteronomy 5:6–21.

MOSES ON THE BIG SCREEN

Two of the most notable movies made depicting the life of Moses:

- Cecil B. DeMille's 1956 epic *The Ten Commandments* (runtime three hours, forty minutes) is, according to Box Office Mojo (2019), the #6 all-time domestic (U.S.) grossing film (adjusted for ticket price inflation).

- The popular 1998 animated DreamWorks film *The Prince of Egypt.*

CROSS REFERENCE

In Matthew 5:17, Jesus tells us, "Do not think that I have come to abolish the Law or the Prophets; I have not come to abolish them but to fulfill them" (ESV). This is why in the Christian tradition Jesus represents what is called the New Covenant, reconciling humankind to God through His death on the cross.

Moses stayed there with the LORD forty days and nights, eating and drinking nothing. He wrote on the tablets the words of the covenant—the Ten Commandments.

EXODUS 34:28 (GNT)

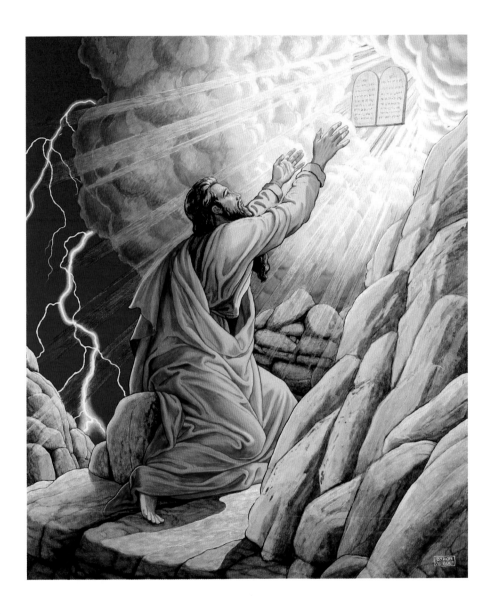

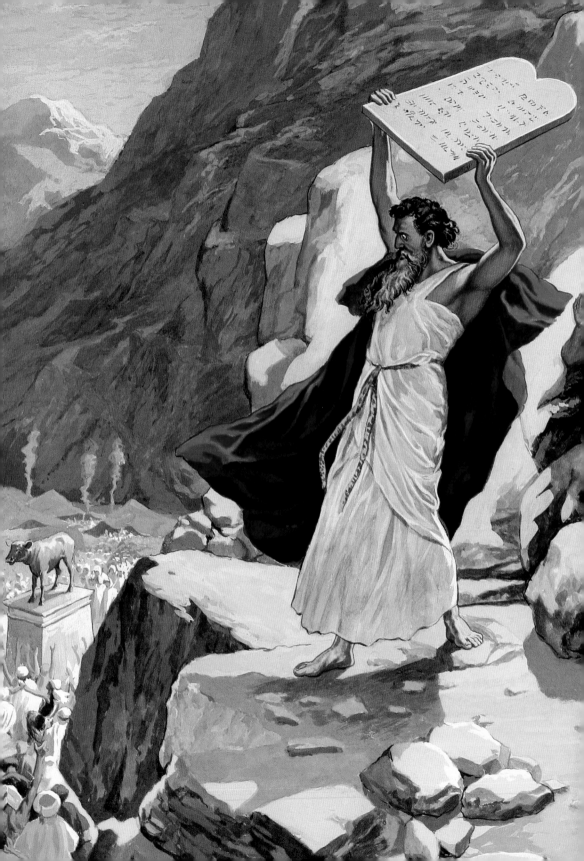

THE GOLDEN CALF

SETTING THE SCENE

At God's request, Moses ascended to the top of Mount Sinai to receive the Lord's commands on tablets of stone, as "written by the finger of God" (Exodus 31:18). Moses remained engulfed in the cloud on top of the mountain for forty days.

Meanwhile, back at camp, Moses's brother Aaron had been left in charge. As the days turned into weeks with no sign of Moses, the people grew increasingly restless.

Idol Hands Are the Devil's Workshop

FROM EXODUS 32

When the people saw that Moses had not come down from the mountain but was staying there a long time, they gathered around Aaron and said to him, "We do not know what has happened to this man Moses, who led us out of Egypt; so make us a god to lead us."

Aaron said to them, "Take off the gold earrings which your wives, your sons, and your daughters are wearing, and bring them to me." He took the earrings, melted

them, poured the gold into a mold, and made a gold bull calf.

The people said, "Israel, this is our god, who led us out of Egypt!"

Then Aaron built an altar in front of the gold bull calf and announced, "Tomorrow there will be a festival to honor the LORD." Early the next morning they brought some animals to burn as sacrifices and others to eat as fellowship offerings. The people sat down to a feast, which turned into an orgy of drinking and sex.

The LORD said to Moses, "Hurry and go back down, because your people, whom you led out of Egypt, have sinned and rejected me. They have already left the way that I commanded them to follow; they have made a bull calf out of melted gold and have worshiped it and offered sacrifices to it. They are saying that this is their god, who led them out of Egypt. I know how stubborn these people are. Now, don't try to stop me. I am angry with them, and I am going to destroy them. Then I will make you and your descendants into a great nation."

But Moses pleaded with the LORD his God and said, "LORD, why should you be so angry with your people, whom you rescued from Egypt with great might and power? Why should the Egyptians be able to say that you led your people out of Egypt, planning to kill them in the mountains and destroy them completely? Stop being angry; change your mind and do not bring this disaster on your people. Remember your servants Abraham, Isaac, and Jacob. Remember the solemn promise you made to them to give them as many descendants as there are stars in the sky and to give their descendants all that land you promised would be their possession forever." So the LORD changed his mind and did not bring on his people the disaster he had threatened.

Moses went back down the mountain, carrying the two stone tablets with the commandments written on both sides.

Joshua heard the people shouting and said to Moses, "I hear the sound of battle in the camp."

Moses said, "That doesn't sound like a shout of victory or a cry of defeat; it's the sound of singing."

When Moses came close enough to the camp to see the bull calf and to see the people dancing, he became furious. There at the foot of the mountain, he threw

down the tablets he was carrying and broke them. He took the bull calf which they had made, melted it, ground it into fine powder, and mixed it with water. Then he made the people of Israel drink it (GNT).

TRUTH FOR TODAY

Evidently requesting a search party was out of the question, or somehow seemed less reasonable than asking for a counterfeit god. In hindsight, it's easy to moralize about Israel's sinful behavior (idolatry, drunken revelry, and acts of debauchery—oh my!). However, the reality is that we, humanity, have a sin problem.

As so honestly revealed through these Bible stories, although people are capable of incredible acts of goodness and justice, humankind has a propensity toward sin. And lest we're tempted to relegate this to "Bible times," this condition is further evidenced by our own sinful thoughts and actions.

Ironically, this nature serves to point us to our need for God. Not a god made by human hands, but the God of Creation and deliverance.

Seeking gods of our own making leads to sin while seeking God leads to salvation.

FYI

The old saying "idle hands are the devil's tools," with "tools" sometimes rendered as "workshop" or "playground," is thought to have first appeared in literature in Chaucer's *Tale of Melibee* (circa 1386).

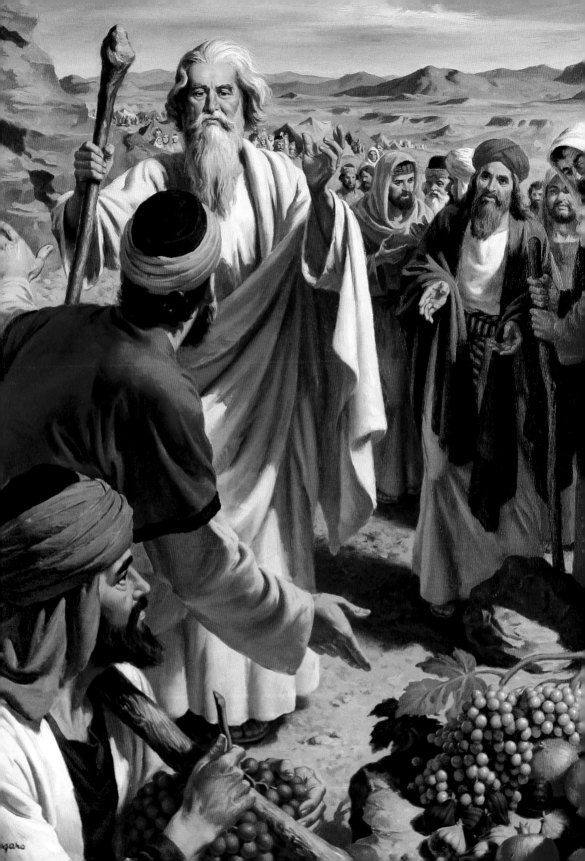

THE TWELVE SPIES

SETTING THE SCENE

After leaving Egypt and spending some time near Mount Sinai, Israel was once again on the move. The nation in exile headed closer to what God had designated as the destination point of their travels: the Promised Land. In the Desert of Paran, near the southern edge of the land of Canaan, Moses pulled together a reconnaissance team and prepared them for their mission.

A Land of Milk and Honey
FROM NUMBERS 13

The LORD said to Moses, "Choose a leader from each tribe and send them into Canaan to explore the land I am giving you."

The twelve men left to explore Canaan from the Zin Desert in the south all the way to the town of Rehob near Lebo-Hamath in the north. As they went through the Southern Desert, they came to the town of Hebron, which was seven years older than the Egyptian town of Zoan. In Hebron, they saw the three Anakim clans of

Ahiman, Sheshai, and Talmai. When they got to Bunch Valley, they cut off a branch with such a huge bunch of grapes, that it took two men to carry it on a pole. That's why the place was called Bunch Valley. Along with the grapes, they also took back pomegranates and figs.

After exploring the land of Canaan for forty days, the twelve men returned to Kadesh in the Paran Desert and told Moses, Aaron, and the people what they had seen. They showed them the fruit and said:

> "Look at this fruit! The land we explored is rich with milk and honey. But the people who live there are strong, and their cities are large and walled. We even saw the three Anakim clans. Besides that, the Amalekites live in the Southern Desert; the Hittites, Jebusites, and Amorites are in the hill country; and the Canaanites live along the Mediterranean Sea and the Jordan River."

Caleb calmed down the crowd and said, "Let's go and take the land. I know we can do it!"

But the other men replied, "Those people are much too strong for us." Then they started spreading rumors and saying, "We won't be able to grow anything in that soil. And the people are like giants. In fact, we saw the Nephilim, who are the ancestors of the Anakim. They were so big that we felt as small as grasshoppers" (CEV).

But when I am afraid, I will put my trust in you.
PSALM 56:3

TRUTH FOR TODAY

The forty-day excursion into Canaan confirmed that the land was good: "rich with milk and honey." *But, however, nevertheless....* Talk about a momentum killer. In the history of buts, this is a big one. You could call it "the forty-year but."

The facts were in agreement, so it came down to a matter of perspective. The majority report, representing ten of the twelve spies, was characterized by fear and was followed up with contradictions and exaggeration. The minority opinion, boldly delivered by Caleb on behalf of himself and Joshua, was rooted in faith.

Expressing faith in the face of a challenge often requires a willingness to stand apart. In this dispute between the "we cans" and the "we can'ts," the fearful majority prevailed, but not without consequence. Because of a lack of trust in God, a generation forfeited its ticket to the Promised Land.

If you find yourself always standing with the majority, move.

> **FYI**
>
> From Numbers 14:6–9, we know that Joshua stood with Caleb, since it is recorded that together they exhorted their fellow Israelites to not be afraid and to trust God to give them the land—but to no avail.

Due to the people's lack of faith in the Lord, God pronounced that they would spend forty years in the desert (one year for each day spent exploring the Promised Land) and that no one who had been counted in the census who was twenty years or older, except for Joshua and Caleb, would be permitted to enter the Promised Land (Numbers 14:29–35).

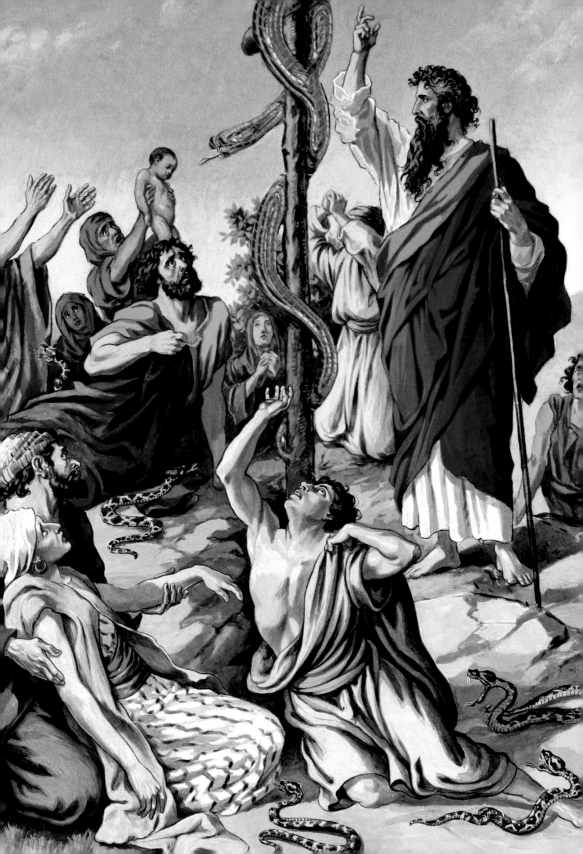

THE BRONZE SERPENT

SETTING THE SCENE

Heretofore the Israelites had been wandering in the wilderness for approximately forty years. In the midst of moving locations, the people grew increasingly impatient and spoke against God by complaining of no bread, when in fact God regularly supplied them with bread (called manna) from Heaven. While complaining about food may seem to us like a minor and perhaps frequently heard gripe, in this instance it was the equivalent of rejecting God by rejecting God's provision.

Snake on a Pole

FROM NUMBERS 21

Then the people of Israel set out from Mount Hor, taking the road to the Red Sea to go around the land of Edom. But the people grew impatient with the long journey, and they began to speak against God and Moses. "Why have you brought us out of Egypt to die here in the wilderness?" they complained. "There is nothing to eat here and nothing to drink. And we hate this horrible manna!"

So the LORD sent poisonous snakes among the people, and many were bitten and died. Then the people came to Moses and cried out, "We have sinned by speaking against the LORD and against you. Pray that the LORD will take away the snakes." So Moses prayed for the people.

Then the LORD told him, "Make a replica of a poisonous snake and attach it to a pole. All who are bitten will live if they simply look at it!" So Moses made a snake out of bronze and attached it to a pole. Then anyone who was bitten by a snake could look at the bronze snake and be healed!

TRUTH FOR TODAY

"Don't make me stop this car!" Do you recall a time growing up when your father was pushed to the edge? Imagine for a moment a holy and gracious heavenly Father—One who has continually provided for a people who, more often than not, are ungrateful. There will be consequences.

Recognize God's provision (your daily bread) and be mindful to be thankful for it. (The next time you're tempted to complain about your food, don't.)

FYI

While there are several explanations for the origin of the recognizable medical symbol that embodies snakes on a staff, known as a caduceus, my bet is the next time you see the image this story will come to mind!

The bronze snake was also known by the name Nehushtan. It was ultimately destroyed by King Hezekiah of Judah because the Israelites were treating it as an idol (2 Kings 18:4).

CROSS REFERENCE

In the Gospel of John, Jesus cites this incident as a harbinger of his death on a cross (John 3:14).

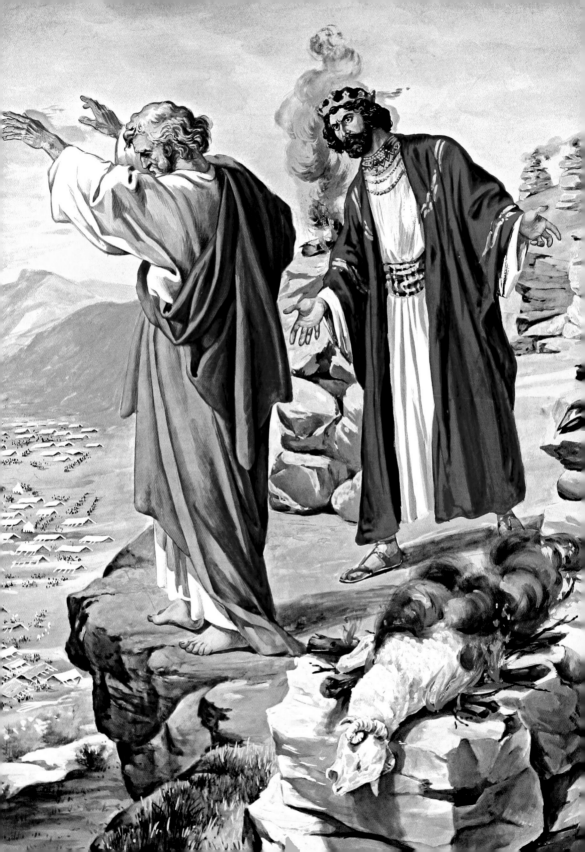

BALAK AND BALAAM

27

SETTING THE SCENE

The Hebrew nation was encamped in the desert east of the Jordan River and the Dead Sea near the Arnon River, which served as a border between the Moabites and the Amorites. Israel dispatched an envoy to Sihon, king of the Amorites, requesting passage through his territory to the Promised Land. Sihon refused, instead decided to go on the offense, and launched an attack on the Hebrews—only to suffer defeat.

A second regional leader, King Og of Bashan, subsequently decided to march against Israel, suffering the same fate as the Amorites. This left the remaining power in the Transjordan area, Moab, in fear of the Israelites. Its leader, Balak, decided to take a different approach; instead of confronting the Israelites in battle, Balak sought out a prophet to curse the Israelites.

Prophet for Hire

FROM NUMBERS 22–23

When King Balak of Moab and his people heard how many Israelites there were and what they had done to the Amorites, he and the Moabites were terrified and

panicked. They said to the Midianite leaders, "That bunch of Israelites will wipe out everything in sight, like a bull eating grass in a field."

So King Balak sent a message to Balaam son of Beor, who lived among his relatives in the town of Pethor near the Euphrates River. It said:

I need your help. A huge group of people has come here from Egypt and settled near my territory. They are too powerful for us to defeat, so would you come and place a curse on them? Maybe then we can run them off. I know that anyone you bless will be successful, but anyone you curse will fail.

The next morning, Balaam said to Balak's officials, "Go on back home. The LORD says I cannot go with you."

The officials left and told Balak that Balaam refused to come.

Then Balak sent a larger group of officials, who were even more important than the first ones. They went to Balaam and told him that Balak had said, "Balaam, if you come to Moab, I'll pay you very well and do whatever you ask. Just come and place a curse on these people."

That night, God said, "Balaam, I'll let you go to Moab with Balak's messengers, but do only what I say."

Balaam said to Balak, "Build seven altars here, then bring seven bulls and seven rams."

After Balak had done this, they sacrificed a bull and a ram on each altar. Then Balaam said, "Wait here beside your offerings, and I'll go somewhere to be alone. Maybe the LORD will appear to me. If He does, I will tell you everything He says." And he left.

When God appeared to him, Balaam said, "I have built seven altars and have sacrificed a bull and a ram on each one."

The LORD gave Balaam a message, then sent him back to tell Balak. When Balaam returned, he found Balak and his officials standing beside the offerings. Balaam said:

"King Balak of Moab brought me from the hills of Syria to curse Israel and announce its doom. But I can't go against God!" He did not curse or condemn Israel.

"From the mountain peaks, I look down and see Israel, the obedient people of God. They are living alone in peace. And though they are many, they don't bother the other nations.

"I hope to obey God for as long as I live and to die in such peace."

Balak said, "What are you doing? I asked you to come and place a curse on my enemies. But you have blessed them instead!"

Balaam answered, "I can say only what the LORD tells me" (CEV).

TRUTH FOR TODAY

Balak thought he could buy a curse on God's people. In the prophet Balaam he had a willing and interested party, but at the end of the day, God would only allow the truth to proceed from Balaam's mouth. In Balaam's words, "How can I curse whom God has not cursed?" (Numbers 23:8, ESV). What Balak had intended to be a curse on Israel ended up as a word of blessing.

While there are situations for which we desire a certain result, and may even employ resources to accomplish it, at the end of the day, the outcome ultimately rests with the Lord.

Weigh your words wisely and be a truth-teller.

FYI

For another interesting Balaam episode, see Numbers 22:21–35 to read about Balaam, an angel, and a talking donkey.

While Balak's plan to have Balaam curse Israel didn't work, part of Balak's objective to weaken the Israelites came to fruition when, upon Balaam's advice, the daughters of Moab seduced some of the Hebrews through the rites of Baal worship (Numbers 25 and 31:16).

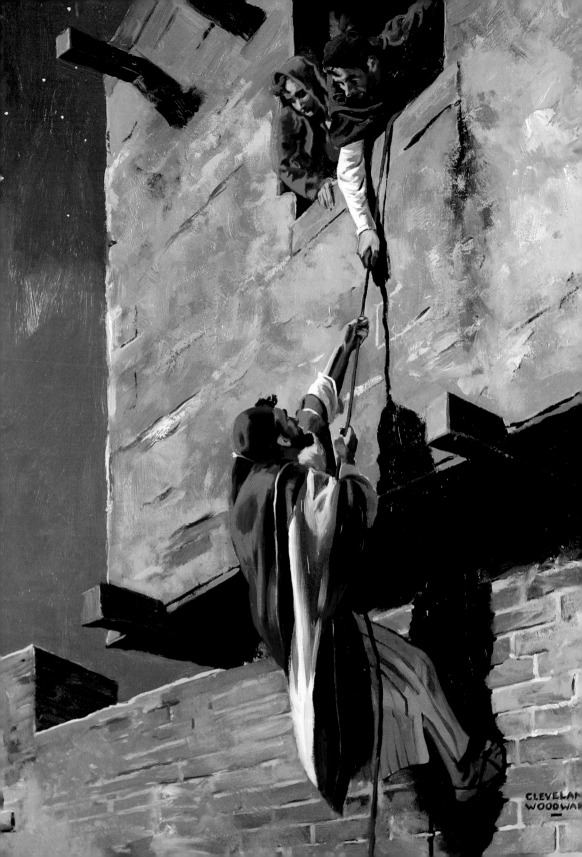

RAHAB AND THE SPIES

SETTING THE SCENE

After a generation spent in the wilderness, Israel's faithful leader, Moses, passed away. A new leader, Joshua, is commissioned by the Lord and charged with leading the people into the land God had sworn to their ancestors.

Once again Israel finds itself on the threshold of the Promised Land. As Moses had done nearly forty years earlier, Joshua sends spies into the land. However, this time only two are sent.

A Great Escape

FROM JOSHUA 2

Then Joshua secretly sent out two spies from the Israelite camp at Acacia Grove. He instructed them, "Scout out the land on the other side of the Jordan River, especially around Jericho." So the two men set out and came to the house of a prostitute named Rahab and stayed there that night.

But someone told the king of Jericho, "Some Israelites have come here tonight to spy out the land." So the king of Jericho sent orders to Rahab: "Bring out the

men who have come into your house, for they have come here to spy out the whole land."

Rahab had hidden the two men, but she replied, "Yes, the men were here earlier, but I didn't know where they were from. They left the town at dusk, as the gates were about to close. I don't know where they went. If you hurry, you can probably catch up with them." (Actually, she had taken them up to the roof and hidden them beneath bundles of flax she had laid out.) So the king's men went looking for the spies along the road leading to the shallow crossings of the Jordan River. And as soon as the king's men had left, the gate of Jericho was shut.

Before the spies went to sleep that night, Rahab went up on the roof to talk with them. "I know the LORD has given you this land," she told them. "We are all afraid of you. Everyone in the land is living in terror. For we have heard how the LORD made a dry path for you through the Red Sea when you left Egypt. And we know what you did to Sihon and Og, the two Amorite kings east of the Jordan River, whose people you completely destroyed. No wonder our hearts have melted in fear! No one has the courage to fight after hearing such things. For the LORD your God is the supreme God of the heavens above and the earth below.

"Now swear to me by the LORD that you will be kind to me and my family since I have helped you. Give me some guarantee that when Jericho is conquered, you will let me live, along with my father and mother, my brothers and sisters, and all their families."

"We offer our own lives as a guarantee for your safety," the men agreed. "If you don't betray us, we will keep our promise and be kind to you when the LORD gives us the land."

Then, since Rahab's house was built into the town wall, she let them down by a rope through the window.

TRUTH FOR TODAY

One of the most endearing characteristics of the Bible is its unflinching portrayal of heroes, *warts and all*. The heroine of this story, Rahab, is no exception. Identified as a prostitute, and a deceiver of her own king, she willingly put herself and her family at risk by harboring and helping the spies. In so doing, she chose to align herself and her future with God.

Thank God for examples like Rahab. She wasn't perfect, and didn't need to be, in order for her life to be used by God. Like Rahab, despite our flaws and past failures, faith in God gives us a future.

You don't have to have it all together for God to be able to give purpose and meaning to your life.

FYI

Before his death, Moses climbed a mountain opposite from Jericho where he could view the Promised Land. The Bible tells us Moses died and was buried by the Lord, and the spot he was buried in is a mystery. Moses was 120 years old at the time of his death (Deuteronomy 34:6-7).

When the Lord chose Joshua to lead Israel following the death of Moses, God's promise to Joshua was: "As I was with Moses, so I will be with you. I will not leave you or forsake you" (Joshua 1:5, ESV).

CROSS REFERENCE

According to the genealogy of Jesus as recorded in Chapter 1 of the Gospel of Matthew, Rahab is noted as the mother of Boaz (husband of Ruth), which also makes her King David's great-grandmother.

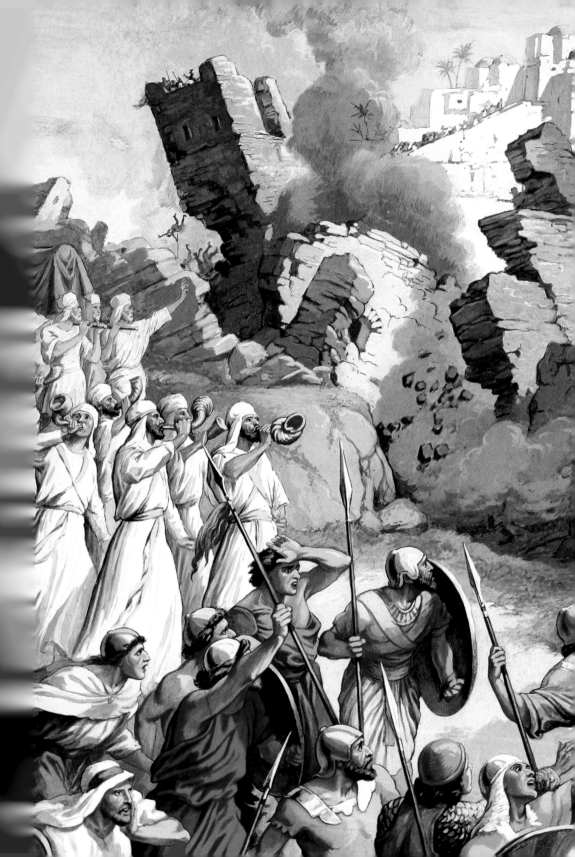

THE FALL OF JERICHO

29

SETTING THE SCENE

In the forty years since they left Egypt, the Lord miraculously sustained the Hebrew people in the wilderness. Now, having crossed the Jordan River, they had finally entered the Promised Land. Approximately seven miles north of the Dead Sea and five miles to the west of the Jordan lay their first test—the ancient and well-fortified city of Jericho.

The Walls Came Tumblin' Down
FROM JOSHUA 6

Now the gates of Jericho were tightly shut because the people were afraid of the Israelites. No one was allowed to go out or in. But the LORD said to Joshua, "I have given you Jericho, its king, and all its strong warriors. You and your fighting men should march around the town once a day for six days. Seven priests will walk ahead of the Ark, each carrying a ram's horn. On the seventh day you are to march around the town seven times, with the priests blowing the horns. When you hear

the priests give one long blast on the rams' horns, have all the people shout as loudly as they can. Then the walls of the city will collapse, and the people can charge straight into the town."

So Joshua called together the priests and said, "Take up the Ark of the Lord's Covenant, and assign seven priests to walk in front of it, each carrying a ram's horn." Then he gave orders to the people: "March around the town, and the armed men will lead the way in front of the Ark of the Lord."

After Joshua spoke to the people, the seven priests with the rams' horns started marching in the presence of the Lord, blowing the horns as they marched. And the Ark of the Lord's Covenant followed behind them. Some of the armed men marched in front of the priests with the horns and some behind the Ark, with the priests continually blowing the horns. "Do not shout; do not even talk," Joshua commanded. "Not a single word from any of you until I tell you to shout. Then shout!" So the Ark of the Lord was carried around the town once that day, and then everyone returned to spend the night in the camp.

Joshua got up early the next morning, and the priests again carried the Ark of the Lord. The seven priests with the rams' horns marched in front of the Ark of the Lord, blowing their horns. Again the armed men marched both in front of the priests with the horns and behind the Ark of the Lord. All this time the priests were blowing their horns. On the third day they again marched around the town once and returned to the camp. They followed this pattern for six days.

On the seventh day the Israelites got up at dawn and marched around the town as they had done before. But this time they went around the town seven times. The seventh time around, as the priests sounded the long blast on their horns, Joshua commanded the people, "Shout! For the Lord has given you the town! Jericho and everything in it must be completely destroyed as an offering to the Lord. Only Rahab the prostitute and the others in her house will be spared, for she protected our spies."

When the people heard the sound of the rams' horns, they shouted as loudly as they could. Suddenly, the walls of Jericho collapsed, and the Israelites charged straight into the town and captured it.

TRUTH FOR TODAY

Trumpet blasts and loud shouts: God's unconventional and psychological warfare campaign had begun.

Lest Israel be tempted to become proud in their own strength, the very essence of their conquest over Jericho gave testament to the divine nature of the victory. However, there's also another important take-away from this battle: The people obeyed and did what God asked of them, as strange as it surely must have seemed.

When God says shout, shout! (And then stand back and watch!)

FYI

Upon Jericho's fall, and as promised, Rahab and her family were spared (Joshua 6:25). The window of her home along the wall was marked by the scarlet cord given to her by the Hebrew spies she had helped escape.

God provided for Israel in extraordinary ways during their forty years in the wilderness. In addition to providing daily bread (manna) that continued until they came to the Promised Land (Exodus 16:35), their clothes and sandals did not wear out in the wilderness (Deuteronomy 29:5).

WHERE IN THE WORLD

The biblical city of Jericho, said to be one of the earliest settlements in the world, lay close to the existing city in Israel of the same name. Modern Jericho is about fifteen miles northeast of Jerusalem and is the lowest city in the world, at over eight hundred feet below sea level.

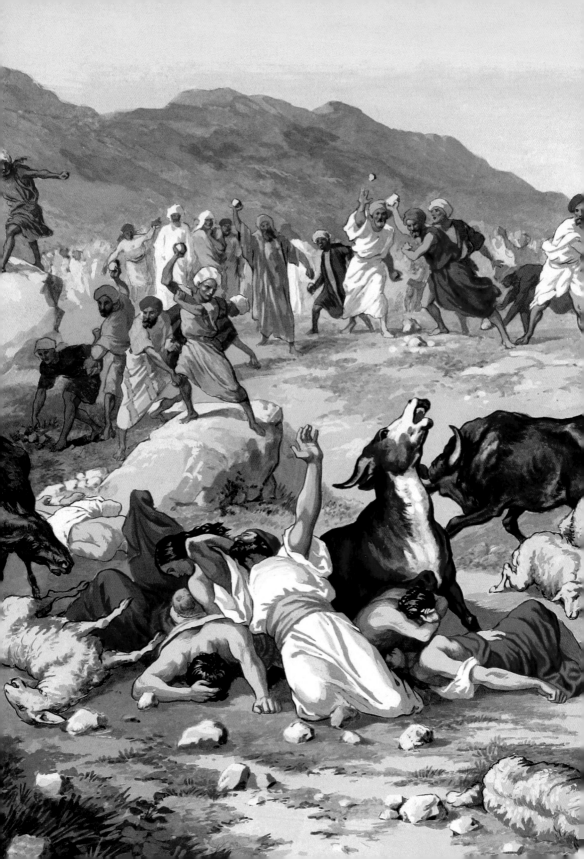

THE SIN OF ACHAN

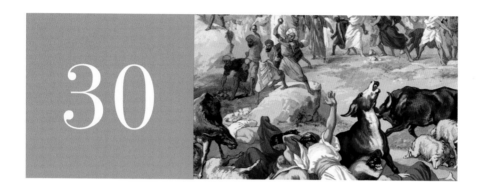

SETTING THE SCENE

Fresh off their first victory in the Promised Land at Jericho, Israel's leader, Joshua, sets his sights on the next town: Ai. Smaller and not as well fortified as Jericho, a modest contingent of soldiers is sent to take care of what should be an easy victory.

Stoned

FROM JOSHUA 7

The LORD's command to Israel not to take from Jericho anything that was to be destroyed was not obeyed. A man named Achan disobeyed that order, and so the LORD was furious with the Israelites.

Joshua sent some men from Jericho to Ai, a city east of Bethel, near Bethaven, with orders to go and explore the land. When they had done so, they reported back to Joshua:

"There is no need for everyone to attack Ai. Send only about two or three thousand men. Don't send the whole army up there to fight; it is not a large city." So

about three thousand Israelites attacked the city, but they were forced to retreat. The men of Ai chased them from the city gate as far as some quarries and killed about thirty-six of them on the way down the hill. Then the Israelites lost their courage and were afraid.

Joshua and the leaders of Israel tore their clothes in grief, threw themselves to the ground before the LORD's Covenant Box, and lay there till evening with dust on their heads to show their sorrow.

The LORD said to Joshua, "Get up! Why are you lying on the ground like this? Israel has sinned! They have broken the agreement with me that I ordered them to keep. They have taken some of the things condemned to destruction. They stole them, lied about it, and put them with their own things. This is why the Israelites cannot stand against their enemies. They retreat from them because they themselves have now been condemned to destruction! I will not stay with you any longer unless you destroy the things you were ordered not to take!"

Early the next morning Joshua brought Israel forward, tribe by tribe, and the tribe of Judah was picked out. He brought the tribe of Judah forward, clan by clan, and the clan of Zerah was picked out. Then he brought the clan of Zerah forward, family by family, and the family of Zabdi was picked out. He then brought Zabdi's family forward, one by one, and Achan, the son of Carmi and grandson of Zabdi, was picked out. Joshua said to him, "My son, tell the truth here before the LORD, the God of Israel, and confess. Tell me now what you have done. Don't try to hide it from me."

"It's true," Achan answered. "I have sinned against the LORD, Israel's God, and this is what I did. Among the things we seized I saw a beautiful Babylonian cloak, about five pounds of silver, and a bar of gold weighing over one pound. I wanted them so much that I took them. You will find them buried inside my tent, with the silver at the bottom."

Joshua, along with all the people of Israel, seized Achan, the silver, the cloak, and the bar of gold, together with Achan's sons and daughters, his cattle, donkeys, and sheep, his tent, and everything else he owned; and they took them

to Trouble Valley. And Joshua said, "Why have you brought such trouble on us? The LORD will now bring trouble on you!" All the people then stoned Achan to death; they also stoned and burned his family and possessions.

Then the LORD was no longer furious (GNT).

TRUTH FOR TODAY

The story of Achan's sin and subsequent punishment is jarring. Upon an initial reading, it appears harsh and capricious. While it's clear he committed theft, the punishment seems excessive, and even more extreme that charges would extend to his family. However, as is the case with many lessons in the Bible, there is more to the story.

Israel as a nation was a covenant community, abiding by the principle of corporate solidarity. When Achan sinned he not only broke faith with God personally, but also corporately. In cultures with an emphasis on individual liberties and personal accountability, this is largely a foreign concept. However, for Israel his crime was no small or individual matter.

Achan's action ended up contributing to the death of an estimated three dozen troops. This elevated the seriousness of the previously undiscovered theft, extending guilt to those living under Achan's tent who, presumably, knew of the stashed, ill-gotten loot but had remained silent. With God, that which has been hidden will eventually be exposed.

Individual actions have corporate consequences.

FYI

Why stoning as a means of execution? While brutal, in a covenant nation like Israel, stoning involved the community in meting out the punishment and spared any single person from being the executioner. As a practical matter, stones were readily available in the region.

One of the laws given to Moses was: "Parents must not be put to death for the sins of their children, nor children for the sins of their parents. Those deserving to die must be put to death for their own crimes" (Deuteronomy 24:16). Based on this, it seems probable that Achan's family knew of his trespass and thus shared in his guilt.

The name Achan is similar to the Hebrew word *akhar*, which can mean disaster or trouble. Elsewhere in the Old Testament, Achan is referred to as "the troubler of Israel, who broke faith in the matter of the devoted thing" (1 Chronicles 2:7, ESV).

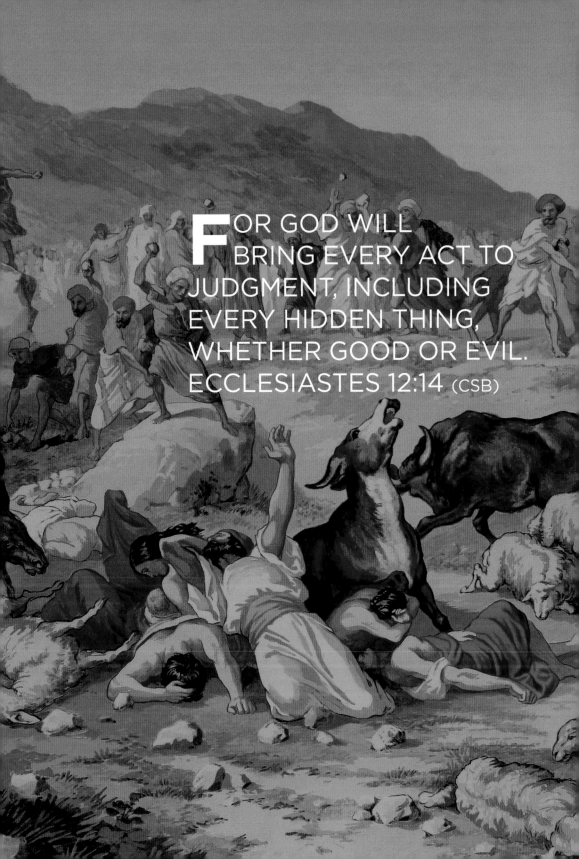

FOR GOD WILL BRING EVERY ACT TO JUDGMENT, INCLUDING EVERY HIDDEN THING, WHETHER GOOD OR EVIL. ECCLESIASTES 12:14 (CSB)

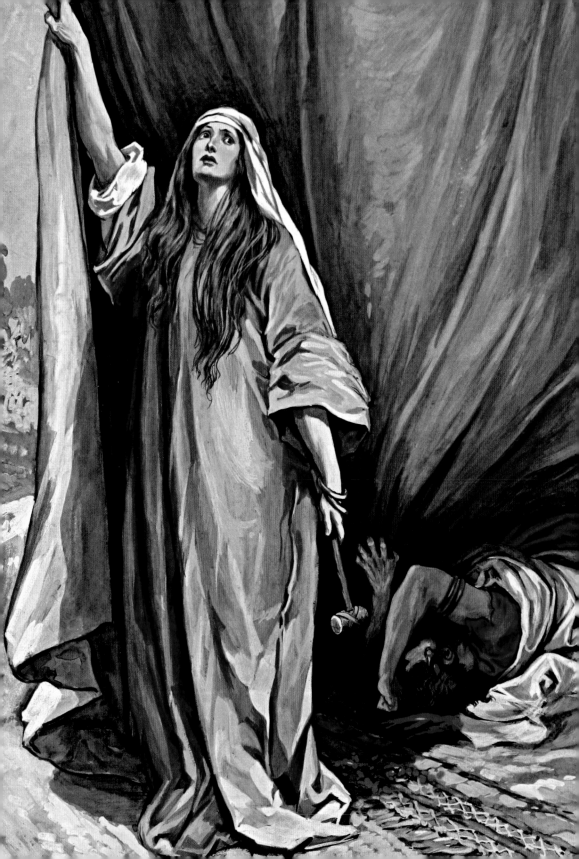

JAEL AND SISERA

SETTING THE SCENE

At this time in history, Israel had entered the Promised Land several years earlier under the leadership of Joshua, after having wandered in the wilderness for forty long years following Moses's leading them out of Egypt. Once Israel crossed the Jordan River into the land of promise, they began a military campaign to secure the land.

Fast forward several years after Joshua's death, and we find the Israelites still facing enemies who don't want them in the land (in this instance, the Canaanites), and Israel under the leadership of a series of what the Bible calls Judges. Deborah, a prophetess and the only woman in the Bible identified as a Judge, was directing Barak, the reluctant leader of a timid and fearful band of Israelite warriors, to go against the superior forces of the Canaanites, under the command of Sisera.

Stakeout

FROM JUDGES 4

When Sisera was told that Barak, son of Abinoam, had gone up to Mount Tabor, he called for all 900 of his iron chariots and all of his warriors, and they marched from Harosheth-haggoyim to the Kishon River.

Then Deborah said to Barak, "Get ready! This is the day the LORD will give you victory over Sisera, for the LORD is marching ahead of you." So Barak led his 10,000 warriors down the slopes of Mount Tabor into battle. When Barak attacked, the LORD threw Sisera and all his chariots and warriors into a panic. Sisera leaped down from his chariot and escaped on foot. Then Barak chased the chariots and the enemy army all the way to Harosheth-haggoyim, killing all of Sisera's warriors. Not a single one was left alive.

Meanwhile, Sisera ran to the tent of Jael, the wife of Heber the Kenite, because Heber's family was on friendly terms with King Jabin of Hazor. Jael went out to meet Sisera and said to him, "Come into my tent, sir. Come in. Don't be afraid." So he went into her tent, and she covered him with a blanket.

"Please give me some water," he said. "I'm thirsty." So she gave him some milk from a leather bag and covered him again.

"Stand at the door of the tent," he told her. "If anybody comes and asks you if there is anyone here, say no."

But when Sisera fell asleep from exhaustion, Jael quietly crept up to him with a hammer and tent peg in her hand. Then she drove the tent peg through his temple and into the ground, and so he died.

When Barak came looking for Sisera, Jael went out to meet him. She said, "Come, and I will show you the man you are looking for." So he followed her into the tent and found Sisera lying there dead, with the tent peg through his temple.

So on that day Israel saw God defeat Jabin, the Canaanite king. And from that time on Israel became stronger and stronger against King Jabin until they finally destroyed him.

TRUTH FOR TODAY

While this story paints an admittedly gruesome picture, keep in mind this was a war zone. The death of Sisera led the way for Israel to be delivered out of the hand of Jabin, king of Canaan. In the battle against the Canaanites, it was two women, Deborah and Jael, who against the odds stepped up to face the enemy of Israel. Perhaps the more unexpected hero of the two was Jael, not a leader that we know of, and not of Israel.

When God presents you with an opportunity that calls for bold action, be willing to take a risk and rise to the occasion, regardless of your station in life.

FYI

The land of Canaan surrounded the Promised Land. The Canaanites were descendants of Canaan, son of Ham, who was the son of Noah, making Canaan Noah's grandson.

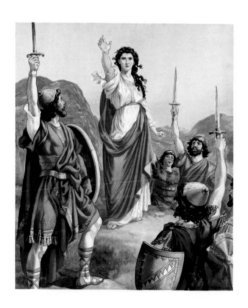

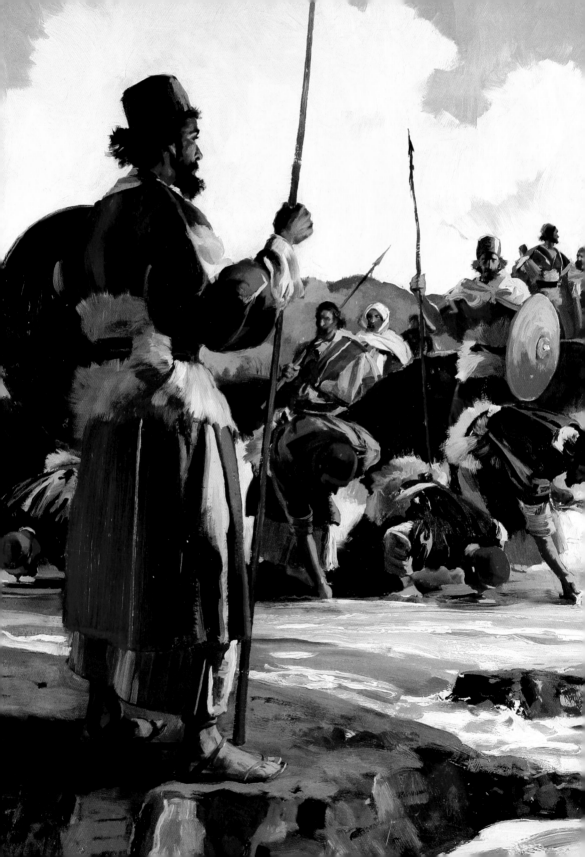

GIDEON'S ARMY

SETTING THE SCENE

It would be fair to categorize Gideon as a reluctant leader. When the Bible first introduces us to Gideon, he is hiding in a hole in the ground. An angel of the Lord appears and announces that God has called him to lead Israel against the enemy he is hiding from. Not fully believing what he is hearing, Gideon asks the Lord for a sign, and God obliges. Gideon then prepares to lead an army of thirty-two thousand into battle.

Three Hundred

FROM JUDGES 7

The LORD said to Gideon, "The men you have are too many for me to give them victory over the Midianites. They might think that they had won by themselves, and so give me no credit. Announce to the people, 'Anyone who is afraid should go back home, and we will stay here at Mount Gilead.'" So twenty-two thousand went back, but ten thousand stayed.

Then the LORD said to Gideon, "You still have too many men. Take them down to the water, and I will separate them for you there. If I tell you a man should go with you, he will go. If I tell you a man should not go with you, he will not go." Gideon took the men down to the water, and the LORD told him, "Separate everyone who laps up the water with his tongue like a dog, from everyone who gets down on his knees to drink." There were three hundred men who scooped up water in their hands and lapped it; all the others got down on their knees to drink. The LORD said to Gideon, "I will rescue you and give you victory over the Midianites with the three hundred men who lapped the water. Tell everyone else to go home." So Gideon sent all the Israelites home, except the three hundred, who kept all the supplies and trumpets.

> For my thoughts are not your thoughts, neither are your ways my ways, declares the LORD.
> ISAIAH 55:8 (ESV)

That night the LORD commanded Gideon, "Get up and attack the camp; I am giving you victory over it. But if you are afraid to attack, go down to the camp with your servant Purah. You will hear what they are saying, and then you will have the courage to attack."

When Gideon arrived, he heard a man telling a friend about a dream. He was saying, "I dreamed that a loaf of barley bread rolled into our camp and hit a tent. The tent collapsed and lay flat on the ground."

His friend replied, "It's the sword of the Israelite, Gideon son of Joash! It can't mean anything else! God has given him victory over Midian and our whole army!"

When Gideon heard about the man's dream and what it meant, he fell to his knees and worshiped the LORD. Then he went back to the Israelite camp and said, "Get up! The LORD is giving you victory over the Midianite army!" He divided his three hundred men into three groups and gave each man a trumpet and a jar with a torch inside it. He told them, "When I get to the edge of the camp, watch me, and do what I do. When my group and I blow our trumpets, then you blow yours all around the camp and shout, 'For the LORD and for Gideon!'"

Gideon and his one hundred men came to the edge of the camp a while before midnight, just after the guard had been changed. Then they blew the trumpets and

broke the jars they were holding, and the other two groups did the same. While Gideon's men were blowing their trumpets, the LORD made the enemy troops attack each other with their swords (GNT).

TRUTH FOR TODAY

After asking Gideon to cull his army to what ends up being less than ten percent of the original force, God reassures Gideon: "I will rescue you and give you victory over the Midianites with the three hundred…."

God's unconventional approach to this battle left no doubt that the victory came about by the hand of the Lord. Simply put, God doesn't abide by the same playbook humankind has used throughout the ages.

With God, victory is not dependent on traditional means or superior numbers.

FYI

One of the things Gideon is known for is asking God for a sign—something he actually did three different times. Two of these instances involved laying out a fleece of wool as part of seeking to confirm (in this case double- and triple-check) what God had called him to do. It is from this act that the phrase "put out a fleece" originated. To read more about this, see Judges 6:36–40.

The name Gideon means "mighty warrior." Perhaps God has more of a sense of humor than people tend to think.

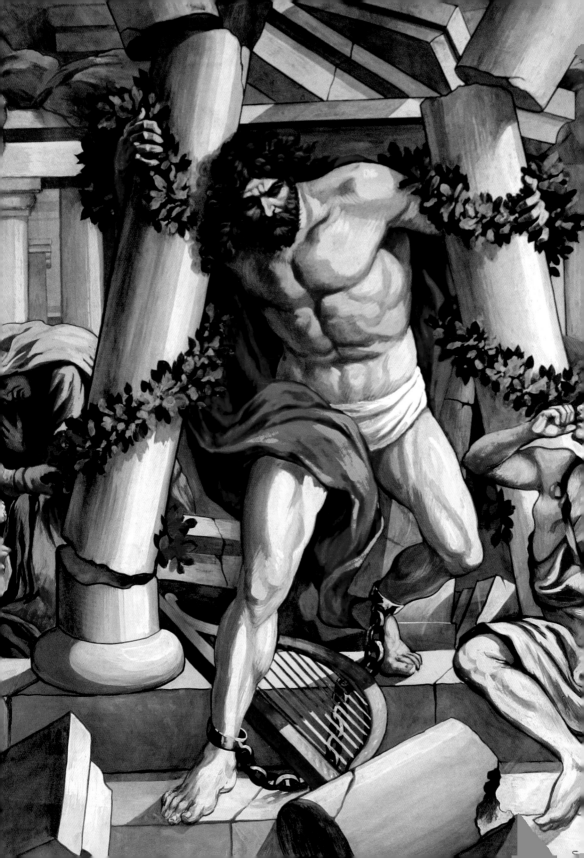

SAMSON IN THE
TEMPLE OF DAGON

SETTING THE SCENE

Born to God-fearing parents, Samson was dedicated from birth as a Nazirite to lead Israel against its arch-enemy—the Philistines. Endowed by God with exceptional physical strength, he was a true "Superman." His kryptonite? Women.

Disregarding the advice of his parents, Samson chased the daughters of the enemy of Israel—most notably, Delilah. In league with the Philistine rulers, Delilah attempts on three occasions to get Samson to reveal to her the secret of his strength, only to be fooled by Samson. Undeterred, she goads him into telling her the truth.

The Original Strongman
FROM JUDGES 16

Some time later Samson fell in love with a woman named Delilah.... The rulers of the Philistines went to her and said, "Entice Samson to tell you what makes him so

strong and how he can be overpowered and tied up securely. Then each of us will give you 1,100 pieces of silver."

Then Delilah pouted, "How can you tell me, 'I love you,' when you don't share your secrets with me? You've made fun of me three times now, and you still haven't told me what makes you so strong!" She tormented him with her nagging day after day until he was sick to death of it.

Finally, Samson shared his secret with her. "My hair has never been cut," he confessed, "for I was dedicated to God as a Nazirite from birth. If my head were shaved, my strength would leave me, and I would become as weak as anyone else."

Delilah realized he had finally told her the truth, so she sent for the Philistine rulers. "Come back one more time," she said, "for he has finally told me his secret." So the Philistine rulers returned with the money in their hands. Delilah lulled Samson to sleep with his head in her lap, and then she called in a man to shave off the seven locks of his hair. In this way she began to bring him down, and his strength left him.

Then she cried out, "Samson! The Philistines have come to capture you!"

When he woke up, he thought, "I will do as before and shake myself free." But he didn't realize the LORD had left him.

So the Philistines captured him and gouged out his eyes. They took him to Gaza, where he was bound with bronze chains and forced to grind grain in the prison.

But before long, his hair began to grow back.

The Philistine rulers held a great festival, offering sacrifices and praising their god, Dagon. They said, "Our god has given us victory over our enemy Samson!"

When the people saw him, they praised their god, saying, "Our god has delivered our enemy to us! The one who killed so many of us is now in our power!"

Half drunk by now, the people demanded, "Bring out Samson so he can amuse us!" So he was brought from the prison to amuse them, and they had him stand between the pillars supporting the roof.

Samson said to the young servant who was leading him by the hand, "Place my hands against the pillars that hold up the temple. I want to rest against them." Now the temple was completely filled with people. All the Philistine

rulers were there, and there were about 3,000 men and women on the roof who were watching as Samson amused them.

Then Samson prayed to the LORD, "Sovereign LORD, remember me again. O God, please strengthen me just one more time. With one blow let me pay back the Philistines for the loss of my two eyes." Then Samson put his hands on the two center pillars that held up the temple. Pushing against them with both hands, he prayed, "Let me die with the Philistines." And the temple crashed down on the Philistine rulers and all the people. So he killed more people when he died than he had during his entire lifetime.

TRUTH FOR TODAY

Samson is a tragic figure. Morally weak, in the face of Delilah's constant nagging, he allowed himself to be compromised. We're told that "he didn't realize the LORD had left him." Truly one of the saddest lines in the whole of Scripture.

Though the consequences Samson faced due to his bad judgment were grave, in his blind and captive state, he humbly called out to the Lord. This provides a good reminder to us all that as long as one has breath yet in their lungs, it's not too late to turn one's heart back to God.

> *Don't give in to persistent bullying and badgering from people pursuing their own self-serving agenda.*

FYI

To be set apart in the service of God as a Nazirite entailed:

- Abstaining from the fruit of the vine, including wine as well as other fermented drinks
- Forgoing haircuts
- Avoiding contact with the dead (Numbers 6:1–8).

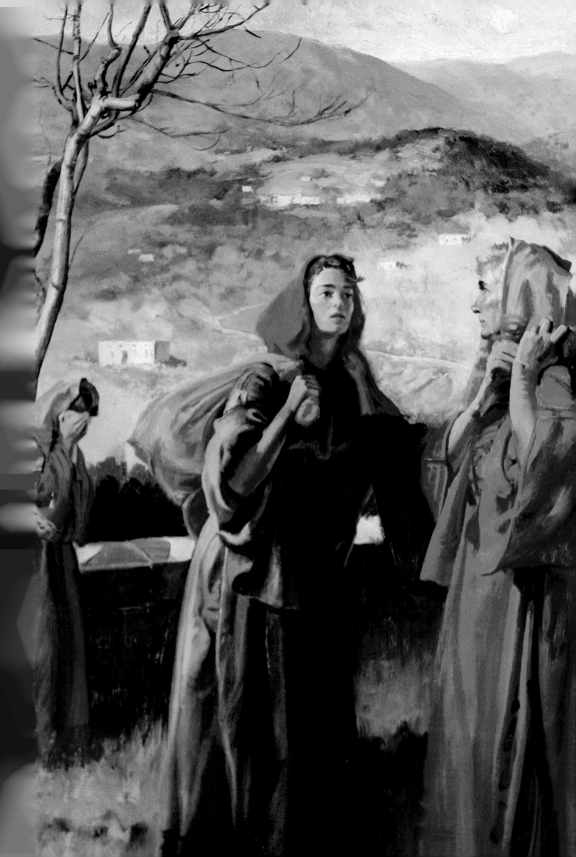

RUTH AND NAOMI

SETTING THE SCENE

During a time of famine in Israel, a Hebrew woman by the name of Naomi, her husband, and two sons moved to the land of Moab. While in Moab, Naomi's sons married Moabite women, and her husband died. Further adding to her grief, she also lost both of her sons. Eventually she determined that the time had come for her to return home.

World's Best Daughter-in-Law

FROM RUTH 1

Some time later, Naomi heard that the LORD had blessed his people by giving them good crops; so she got ready to leave Moab with her daughters-in-law. They started out together to go back to Judah, but on the way she said to them, "Go back home and stay with your mothers. May the LORD be as good to you as you have been to me and to those who have died. And may the LORD make it possible for each of you to marry again and have a home."

So Naomi kissed them good-bye. But they started crying and said to her, "No! We will go with you to your people."

"You must go back, my daughters," Naomi answered. "Why do you want to come with me? Do you think I could have sons again for you to marry? Go back home, for I am too old to get married again. Even if I thought there was still hope, and so got married tonight and had sons, would you wait until they had grown up? Would this keep you from marrying someone else? No, my daughters, you know that's impossible. The LORD has turned against me, and I feel very sorry for you."

> **M**any will say they are loyal friends, but who can find one who is truly reliable?
> PROVERBS 20:6

Again they started crying. Then Orpah kissed her mother-in-law good-bye and went back home, but Ruth held on to her. So Naomi said to her, "Ruth, your sister-in-law has gone back to her people and to her god. Go back home with her."

But Ruth answered, "Don't ask me to leave you! Let me go with you. Wherever you go, I will go; wherever you live, I will live. Your people will be my people, and your God will be my God. Wherever you die, I will die, and that is where I will be buried. May the LORD's worst punishment come upon me if I let anything but death separate me from you!"

When Naomi saw that Ruth was determined to go with her, she said nothing more.

They went on until they came to Bethlehem. When they arrived, the whole town became excited, and the women there exclaimed, "Is this really Naomi?"

"Don't call me Naomi," she answered; "call me Marah, because Almighty God has made my life bitter. When I left here, I had plenty, but the LORD has brought me back without a thing. Why call me Naomi when the LORD Almighty has condemned me and sent me trouble?"

This, then, was how Naomi came back from Moab with Ruth, her Moabite daughter-in-law. When they arrived in Bethlehem, the barley harvest was just beginning (GNT).

TRUTH FOR TODAY

"Wherever you go, I will go; wherever you live, I will live. Your people will be my people, and your God will be my God." This ancient expression of Ruth's love and loyalty resonates with people across the ages and around the globe.

As beautiful as the words of Ruth are, more impressive still is what she did to stand behind them.

Putting on the virtue of loyalty and faithfully standing with those in need pleases God and puts one on a path of righteousness and honor.

True loyalty puts feet to words.

In biblical times, the land of Moab was next to Canaan (the Promised Land), east of the Jordan River (modern day Jordan).

FYI

Ruth is part of the lineage of the House of David; she was King David's great-grandmother (on his father's side).

You can read more about Ruth in the book of the Bible of the same name. It's a short and fast-moving account of God's provision in the lives of Ruth and Naomi.

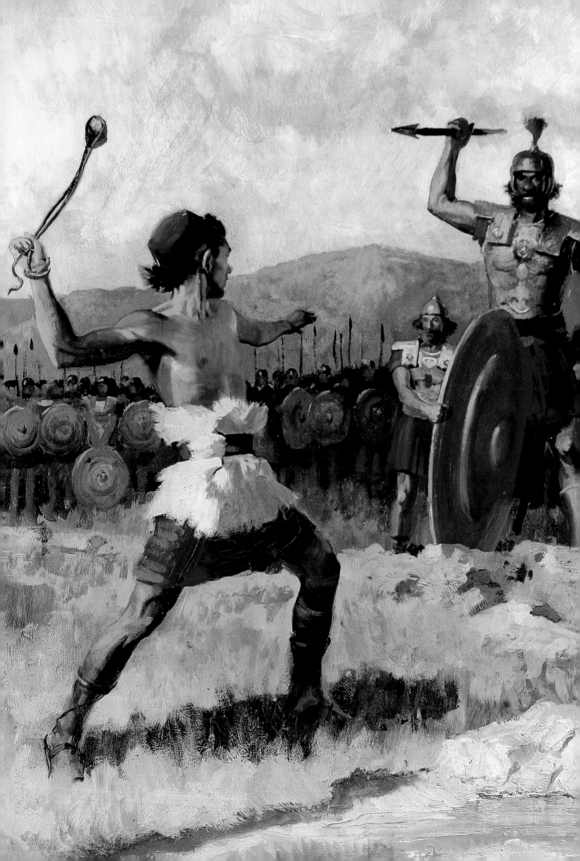

DAVID AND GOLIATH

SETTING THE SCENE

King Saul, the first king of Israel, had assembled his troops and was in a stand-off against Israel's old foe, the Philistines. Among Saul's soldiers were the three oldest sons of a man named Jesse.

A youth named David, the youngest of Jesse's eight sons, was tending his father's sheep. Taking a break from his shepherding duties, David was sent out by his father to check on his brothers, deliver some food, and bring back news from the front. He arrived just in time to see the Philistines' champion, Goliath, issue a challenge to Saul's army.

Giant Slayer

FROM 1 SAMUEL 17

A man named Goliath, from the city of Gath, came out from the Philistine camp to challenge the Israelites. He was over nine feet tall and wore bronze armor that weighed about 125 pounds and a bronze helmet.

Goliath challenged the Israelites every morning and evening for forty days.

David said to Saul, "Your Majesty, no one should be afraid of this Philistine! I will go and fight him."

"No," answered Saul. "How could you fight him? You're just a boy, and he has been a soldier all his life!"

"Your Majesty," David said, "I take care of my father's sheep. Any time a lion or a bear carries off a lamb, I go after it, attack it, and rescue the lamb. And if the lion or bear turns on me, I grab it by the throat and beat it to death. I have killed lions and bears, and I will do the same to this heathen Philistine, who has defied the army of the living God. The LORD has saved me from lions and bears; he will save me from this Philistine."

"All right," Saul answered. "Go, and the LORD be with you." He gave his own armor to David for him to wear: a bronze helmet, which he put on David's head, and a coat of armor. David strapped Saul's sword over the armor and tried to walk, but he couldn't, because he wasn't used to wearing them. "I can't fight with all this," he said to Saul. "I'm not used to it." So he took it all off. He took his shepherd's stick and then picked up five smooth stones from the stream and put them in his bag.

The Philistine started walking toward David, with his shield bearer walking in front of him. He kept coming closer, and when he got a good look at David, he was filled with scorn for him because he was just a nice, good-looking boy. He said to David, "What's that stick for? Do you think I'm a dog?" And he called down curses from his god on David.

David answered, "You are coming against me with sword, spear, and javelin, but I come against you in the name of the LORD Almighty, the God of the Israelite armies, which you have defied. This very day the LORD will put you in my power; I will defeat you and cut off your head. And I will give the bodies of the Philistine soldiers to the birds and animals to eat. Then the whole world will know that Israel has a God, and everyone here will see that the LORD does not need swords or spears to save his people. He is victorious in battle, and he will put all of you in our power."

Goliath started walking toward David again, and David ran quickly toward the Philistine battle line to fight him. He reached into his bag and took out a stone, which he slung at Goliath. It hit him on the forehead and broke his skull, and Goliath fell facedown on the ground. David ran to him, stood over him, took Goliath's sword out of its sheath, and cut off his head and killed him.

> It's not the size of the dog in the fight, it's the size of the fight in the dog.
> —MARK TWAIN

When the Philistines saw that their hero was dead, they ran away (GNT).

TRUTH FOR TODAY

One of the best-known and well-loved stories in the Bible, this is the ultimate underdog story. David was such a longshot that the only person who believed he could win was himself.

Though but a youth, David didn't lack confidence. The secret was the source of his confidence and the purity of his motives. His faith in God's ability to grant him victory was absolute, and his purpose was to bring glory to the Lord.

When facing life's giants, turn to God in total trust and seek an end that honors the Lord.

FYI

In addition to being a shepherd and a warrior, David was also a musician and poet, writing many of the most well-known and beloved psalms in the Bible, including Psalm 23.

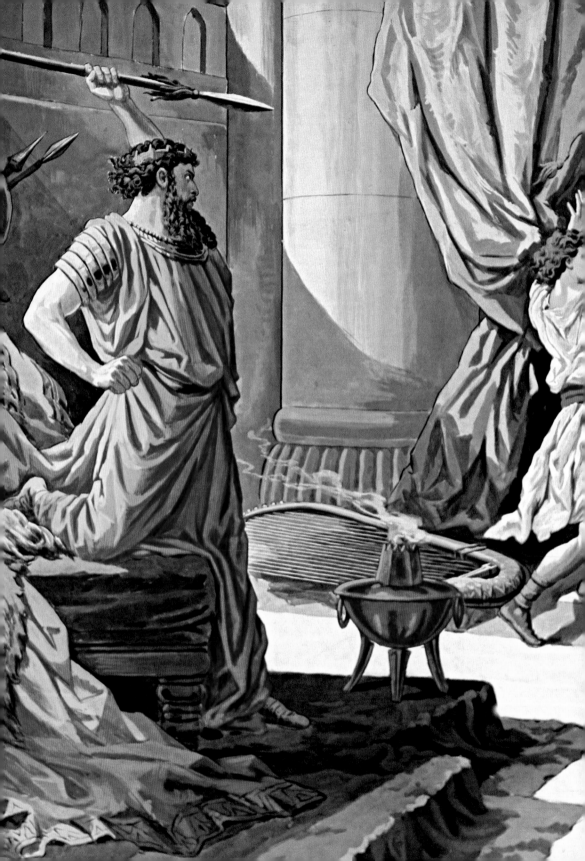

SAUL TRIES TO KILL DAVID

SETTING THE SCENE

Returning from victory over Goliath and the Philistines, the women of Israel toasted David in song. Though David was a humble and loyal subject, his sudden popularity grated on the king.

Having conscripted David into service as part of his court, Saul kept a watchful eye on the young hero. One of David's regular duties was to play the harp. However, as will be seen, the soothing music did not lift the king's dark mood.

Too Close for Comfort

FROM 1 SAMUEL 18

When the victorious Israelite army was returning home after David had killed the Philistine, women from all the towns of Israel came out to meet King Saul. They sang and danced for joy with tambourines and cymbals. This was their song:

"Saul has killed his thousands, and David his ten thousands!"

This made Saul very angry. "What's this?" he said. "They credit David with ten thousands and me with only thousands. Next they'll be making him their king!" So from that time on Saul kept a jealous eye on David.

The very next day a tormenting spirit from God overwhelmed Saul, and he began to rave in his house like a madman. David was playing the harp, as he did each day. But Saul had a spear in his hand, and he suddenly hurled it at David, intending to pin him to the wall. But David escaped him twice.

Saul was then afraid of David, for the LORD was with David and had turned away from Saul. Finally, Saul sent him away and appointed him commander over 1,000 men, and David faithfully led his troops into battle.

David continued to succeed in everything he did, for the LORD was with him. When Saul recognized this, he became even more afraid of him. But all Israel and Judah loved David because he was so successful at leading his troops into battle.

TRUTH FOR TODAY

Though David was nothing but loyal, Saul felt threatened by him. This spirit of jealousy fed the king's anger and fueled his violent behavior toward David.

The undeniable secret to David's success—and the equally obvious reason for Saul's fear and insecurity—was this: "The LORD was with David and had turned away from Saul."

David chose to fear and honor God, and the spirit of the Lord was with him. But early on in his own reign, Saul had chosen to go his own way.

Jealousy feeds a spirit of fear and insecurity,
while faith and trust in God bring peace.

FYI

Following the victory over Goliath and the Philistines, David became fast friends with King Saul's eldest son and heir apparent, Jonathan.

The Hebrew word *kinnor,* which is often rendered as *harp* in English language Bibles, is thought by many to actually be *lyre*—an ancient instrument and precursor to the harp.

An angry person is dangerous, but a jealous person is even worse.

PROVERBS 27:4 (CEV)

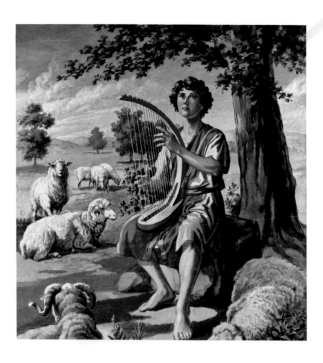

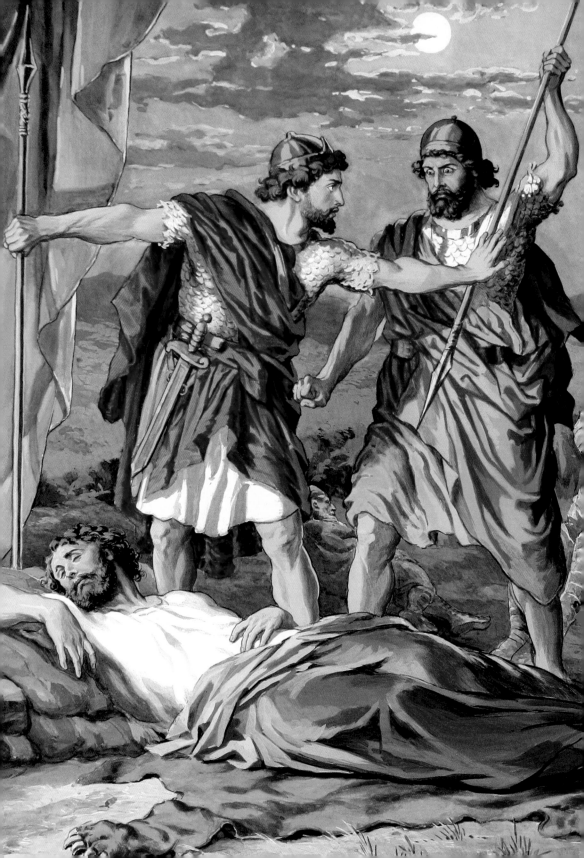

DAVID SPARES
SAUL'S LIFE

SETTING THE SCENE

David, along with a small band of loyalists, was laying low in the wilderness to avoid the murderous wrath of King Saul. Obsessed with David and not content simply to have him out of sight, Saul mobilized a search party to track him down so he could make another attempt on his life.

Vengeance Is Thine, *Not* Mine
FROM 1 SAMUEL 26

Now some men from Ziph came to Saul at Gibeah to tell him, "David is hiding on the hill of Hakilah, which overlooks Jeshimon."

So Saul took three thousand of Israel's elite troops and went to hunt him down in the wilderness of Ziph.

David slipped over to Saul's camp one night to look around. Saul and Abner son of Ner, the commander of his army, were sleeping inside a ring formed by the

slumbering warriors. "Who will volunteer to go in there with me?" David asked Ahimelech the Hittite and Abishai son of Zeruiah, Joab's brother.

"I'll go with you," Abishai replied. So David and Abishai went right into Saul's camp and found him asleep, with his spear stuck in the ground beside his head. Abner and the soldiers were lying asleep around him.

"God has surely handed your enemy over to you this time!" Abishai whispered to David. "Let me pin him to the ground with one thrust of the spear; I won't need to strike twice!"

> **D**on't take it on yourself to repay a wrong. Trust the LORD and he will make it right.
>
> PROVERBS 20:22 (GNT)

"No!" David said. "Don't kill him. For who can remain innocent after attacking the LORD's anointed one? Surely the LORD will strike Saul down someday, or he will die of old age or in battle. The LORD forbid that I should kill the one he has anointed! But take his spear and that jug of water beside his head, and then let's get out of here!"

David climbed the hill opposite the camp until he was at a safe distance. Then he shouted down to the soldiers and to Abner son of Ner, "Wake up, Abner!"

"Who is it?" Abner demanded.

"Well, Abner, you're a great man, aren't you?" David taunted. "Where in all Israel is there anyone as mighty? So why haven't you guarded your master the king when someone came to kill him? This isn't good at all! I swear by the LORD that you and your men deserve to die, because you failed to protect your master, the LORD's anointed! Look around! Where are the king's spear and the jug of water that were beside his head?"

Saul recognized David's voice and called out, "Is that you, my son David?"

And David replied, "Yes, my lord the king. Why are you chasing me? What have I done? What is my crime?

Then Saul confessed, "I have sinned. Come back home, my son, and I will no longer try to harm you, for you valued my life today. I have been a fool and very, very wrong."

"Here is your spear, O king," David replied. "Let one of your young men come over and get it. The LORD gives his own reward for doing good and for

being loyal, and I refused to kill you even when the LORD placed you in my power, for you are the LORD's anointed one. Now may the LORD value my life, even as I have valued yours today. May he rescue me from all my troubles."

And Saul said to David, "Blessings on you, my son David. You will do many heroic deeds, and you will surely succeed." Then David went away, and Saul returned home.

TRUTH FOR TODAY

David refused to lift his hand against his enemy or permit those close to him to do so on his behalf. His view was that God had established Saul as king and that it was up to the Lord to discharge him.

Contrary to the wishes of those around him, David's unwavering faith in God gave him the strength to leave Saul's fate in the hands of God and patience enough to wait for God's timing.

David was also practical and wise enough to keep Saul at a safe distance.

When presented with the opportunity to exact revenge, resist the temptation to pay back evil for evil.

FYI

This story is the second of two similar accounts showing Saul hunting David and David sparing Saul. The first account involves Saul in the act of relieving himself in a cave. You can read it for yourself in 1 Samuel 24.

David had a fiercely loyal inner circle of men who became known as "David's Mighty Men." To read about these men and some of their exploits, see 2 Samuel 23:8–39.

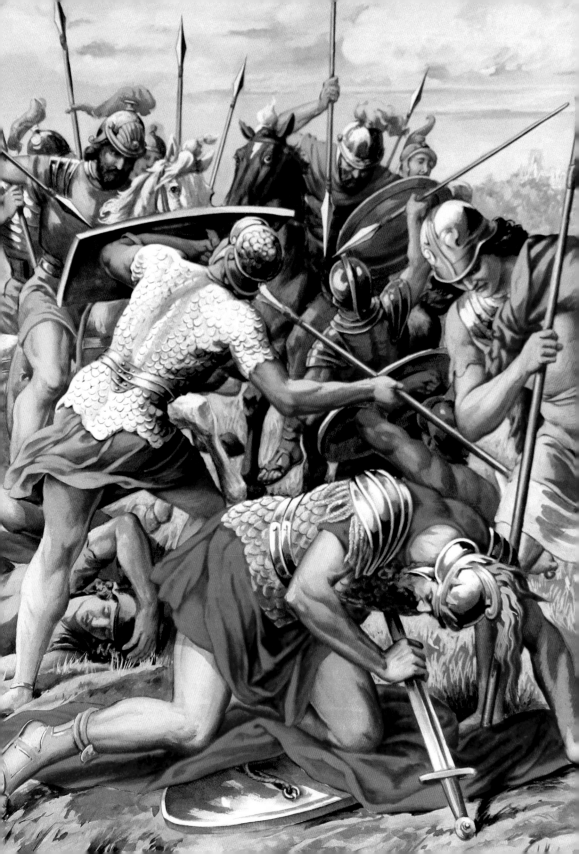

THE DEATH OF SAUL

SETTING THE SCENE

Saul's forty-year reign was marked by ongoing conflict with the Philistines. Ahead of what would be his last military campaign, he consulted a medium—the witch of Endor. God warned against this practice in the Levitical law: "If any of you go for advice to people who consult the spirits of the dead, I will turn against you and will no longer consider you one of my people" (Leviticus 20:6, GNT).

Seppuku

FROM 1 CHRONICLES 10

Now the Philistines attacked Israel, and the men of Israel fled before them. Many were slaughtered on the slopes of Mount Gilboa. The Philistines closed in on Saul and his sons, and they killed three of his sons—Jonathan, Abinadab, and Malkishua. The fighting grew very fierce around Saul, and the Philistine archers caught up with him and wounded him.

Saul groaned to his armor bearer, "Take your sword and kill me before these pagan Philistines come to taunt and torture me."

But his armor bearer was afraid and would not do it. So Saul took his own sword and fell on it. When his armor bearer realized that Saul was dead, he fell on his own sword and died. So Saul and his three sons died there together, bringing his dynasty to an end.

When all the Israelites in the Jezreel Valley saw that their army had fled and that Saul and his sons were dead, they abandoned their towns and fled. So the Philistines moved in and occupied their towns.

The next day, when the Philistines went out to strip the dead, they found the bodies of Saul and his sons on Mount Gilboa. So they stripped off Saul's armor and cut off his head. Then they proclaimed the good news of Saul's death before their idols and to the people throughout the land of Philistia. They placed his armor in the temple of their gods, and they fastened his head to the temple of Dagon.

But when everyone in Jabesh-gilead heard about everything the Philistines had done to Saul, all their mighty warriors brought the bodies of Saul and his sons back to Jabesh. Then they buried their bones beneath the great tree at Jabesh, and they fasted for seven days.

So Saul died because he was unfaithful to the LORD. He failed to obey the LORD's command, and he even consulted a medium instead of asking the LORD for guidance. So the LORD killed him and turned the kingdom over to David son of Jesse.

TRUTH FOR TODAY

While Saul had long ago chosen to go his own way, his death was still a sad occasion for Israel. The only king they had ever known, along with his sons, had been lost.

Even though Saul attempted to take his own life, ultimately it was the Lord who allowed this to be Saul's end.

A truism about life—or death, in this case—is we don't know when the end will come, only that it will. However, we can choose to turn our hearts to God today while there is still breath in our lungs.

Our time is in God's hands.

In this world nothing can be said to be certain, except death and taxes.
—BENJAMIN FRANKLIN

FYI

Seppuku is a word of Japanese origin that refers to a form of ritual suicide, which is also sometimes called *hara-kiri*.

When word reached David and the men with him about the death of Saul, they "tore their clothes in sorrow…. They mourned and wept and fasted all day for Saul and his son Jonathan, and for the LORD's army and the nation of Israel" (2 Samuel 1:11–12).

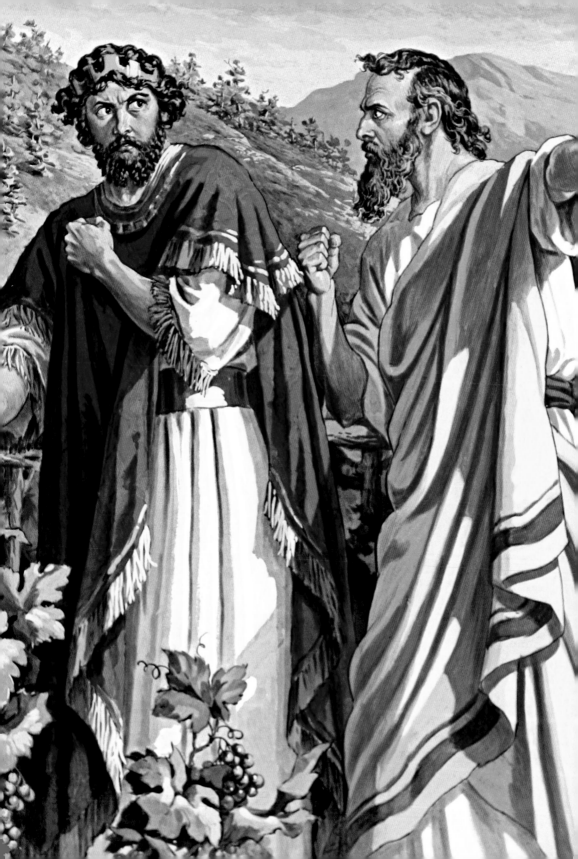

KING DAVID AND THE PROPHET NATHAN

SETTING THE SCENE

Following the death of King Saul, David was anointed as king at age thirty by his ancestral tribe, Judah. However, David would have to wait approximately another seven years before he was recognized as king over all the tribes of Israel. During the early years of his kingship, David was mighty in battle, leading the nation in victorious campaigns against its adversaries, for the Lord was with him.

Then one spring, King David, now middle-aged, decided to remain in Jerusalem instead of leading his men in battle. This seemingly innocuous decision set into motion a string of increasingly bad choices:

1. David committed adultery with Bathsheba, the wife of Uriah, one of David's best and most loyal warriors.

2. When the affair resulted in a pregnancy, David made a failed attempt to cover up his indiscretion by inviting Uriah home from the battle.

3. With increasing desperation and callous disregard, the king arranged for Uriah to be killed in battle.

Following Uriah's death, David brought Bathsheba to his palace, and she became his wife. However, the Lord was displeased with David's evil deeds and sent the prophet Nathan to confront the king.

Truth and Consequences

FROM 2 SAMUEL 12

So the LORD sent Nathan the prophet to tell David this story: "There were two men in a certain town. One was rich, and one was poor. The rich man owned a great many sheep and cattle. The poor man owned nothing but one little lamb he had bought. He raised that little lamb, and it grew up with his children. It ate from the man's own plate and drank from his cup. He cuddled it in his arms like a baby daughter. One day a guest arrived at the home of the rich man. But instead of killing an animal from his own flock or herd, he took the poor man's lamb and killed it and prepared it for his guest."

David was furious. "As surely as the LORD lives," he vowed, "any man who would do such a thing deserves to die! He must repay four lambs to the poor man for the one he stole and for having no pity."

Then Nathan said to David, "You are that man! The LORD, the God of Israel, says: 'I anointed you king of Israel and saved you from the power of Saul. I gave you your master's house and his wives and the kingdoms of Israel and Judah. And if that had not been enough, I would have given you much, much more. Why, then, have you despised the word of the LORD and done this horrible deed? For you have murdered Uriah the Hittite with the sword of the Ammonites and stolen his wife. From this time on, your family will live by the sword because you have despised me by taking Uriah's wife to be your own.'

"This is what the LORD says: 'Because of what you have done, I will cause your own household to rebel against you. I will give your wives to another man

before your very eyes, and he will go to bed with them in public view. You did it secretly, but I will make this happen to you openly in the sight of all Israel.'"

Then David confessed to Nathan, "I have sinned against the LORD."

Nathan replied, "Yes, but the LORD has forgiven you, and you won't die for this sin. Nevertheless, because you have shown utter contempt for the word of the LORD by doing this, your child will die."

> To err is human; to forgive, divine.
> —ALEXANDER POPE
> (1711)

Then on the seventh day the child died.

Then David comforted Bathsheba, his wife, and slept with her. She became pregnant and gave birth to a son, and David named him Solomon.

TRUTH FOR TODAY

Nothing is hidden from God. He knows all our faults, failures, and foibles. As David discovered, we are only fooling ourselves when we think that our sins won't be found out.

Rarely has someone so starkly exemplified both the best and worst in man. But lest we're tempted to comfort ourselves by comparison, there's a line between righteousness and sin that everyone has fallen short of.

The good news is that there is grace to be found with God. We don't have to be defined by our failures if we are willing to humble ourselves before God and recognize (turn from denial), acknowledge (accept responsibility), and repent of our sins before the Lord in true contrition, turning away from evil and toward God.

When you find yourself in a hole, stop digging.

FYI

Uriah was so honorable, loyal, and trustworthy that when David sent a letter to Joab, the commander of Israel's army, ordering him to place Uriah on the front line to ensure his death, Uriah himself carried it (2 Samuel 11:14–15).

To read the biblical account of David's misdeeds for yourself, look up 2 Samuel 11. If you don't have a Bible of your own, there are a number of easy to read modern translations of the Bible available online and/or as apps (such as BibleGateway or Bible Hub).

Some of the most moving and heartfelt psalms written by David, notably Psalm 32 and 51, come out of this dark time in his life.

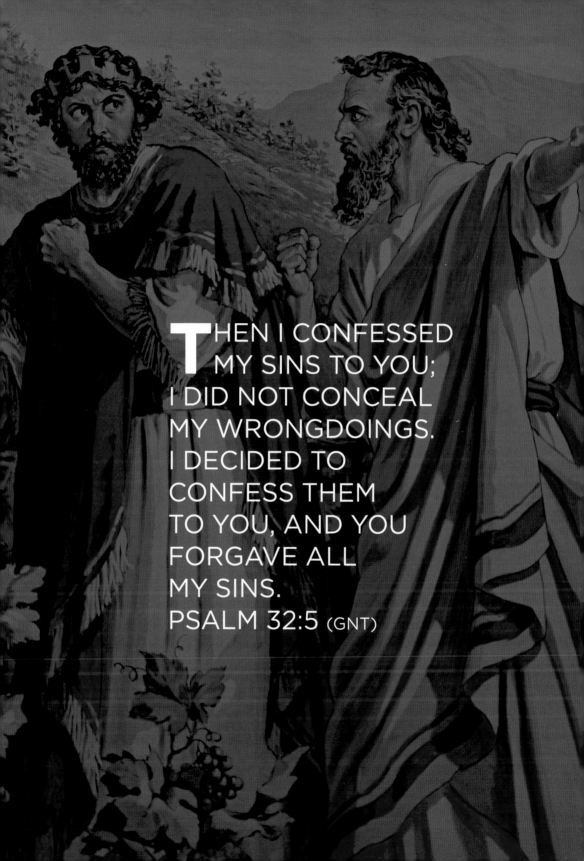

THEN I CONFESSED MY SINS TO YOU; I DID NOT CONCEAL MY WRONGDOINGS. I DECIDED TO CONFESS THEM TO YOU, AND YOU FORGAVE ALL MY SINS. PSALM 32:5 (GNT)

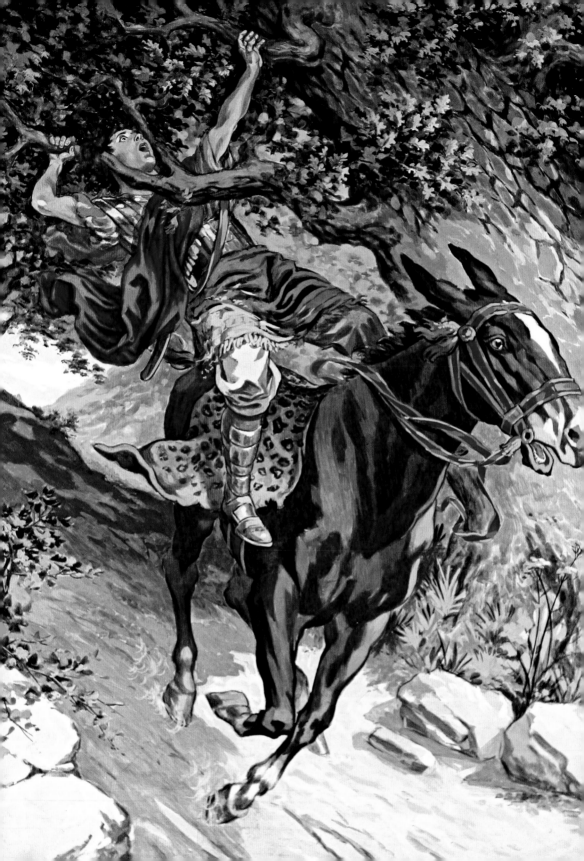

ABSALOM'S REBELLION

SETTING THE SCENE

All was not well in the House of David. Rivalries and palace intrigue dominated the affairs of state. As Nathan had prophesied following David's shameful acts, "Because of what you have done, I will cause your own household to rebel against you" (2 Samuel 12:11).

His moral authority weakened, David took no action when his eldest son, Amnon, raped his own half-sister, Tamar. This wicked act sowed seeds of hatred against Amnon in the heart of Absalom, David's son and Tamar's brother. Biding his time by waiting two years, Absalom exacted his revenge when he killed Amnon. Absalom was temporarily banished from Israel, but he returned to Jerusalem three years later. Though David's heart longed for Absalom, they remained estranged. In the absence of his father's attention, Absalom hatched a bold plot and conspired against his own father to seize the kingdom.

Although Absalom's initial efforts to overthrow his father had put the king on the run, the attempted coup was soon quashed. The tables turned, with Absalom now on the run from the forces loyal to the king.

Tangled

FROM 2 SAMUEL 18

Then David mustered the men who were with him and set over them commanders of thousands and commanders of hundreds. And David sent out the army, one third under the command of Joab, one third under the command of Abishai the son of Zeruiah, Joab's brother, and one third under the command of Ittai the Gittite. And the king ordered Joab and Abishai and Ittai, "Deal gently for my sake with the young man Absalom." And all the people heard when the king gave orders to all the commanders about Absalom.

So the army went out into the field against Israel, and the battle was fought in the forest of Ephraim. And the men of Israel were defeated there by the servants of David, and the loss there was great on that day, twenty thousand men. The battle spread over the face of all the country, and the forest devoured more people that day than the sword.

And Absalom happened to meet the servants of David. Absalom was riding on his mule, and the mule went under the thick branches of a great oak, and his head caught fast in the oak, and he was suspended between heaven and earth, while the mule that was under him went on. And a certain man saw it and told Joab, "Behold, I saw Absalom hanging in an oak." Joab said to the man who told him, "What, you saw him! Why then did you not strike him there to the ground? I would have been glad to give you ten pieces of silver and a belt." But the man said to Joab, "Even if I felt in my hand the weight of a thousand pieces of silver, I would not reach out my hand against the king's son, for in our hearing the king commanded you and Abishai and Ittai, 'For my sake protect the young man Absalom.' On the other hand, if I had dealt treacherously against his life (and there is nothing hidden from the king), then you yourself would have stood aloof." Joab said, "I will not waste time like this with you." And he took three javelins in his hand and thrust them into the heart of Absalom

> For they sow the wind, and they shall reap the whirlwind.
> HOSEA 8:7 (ESV)

while he was still alive in the oak. And ten young men, Joab's armor-bearers, surrounded Absalom and struck him and killed him.

Then Joab said to the Cushite, "Go, tell the king what you have seen." The Cushite bowed before Joab, and ran.

And behold, the Cushite came, and the Cushite said, "Good news for my lord the king! For the LORD has delivered you this day from the hand of all who rose up against you." The king said to the Cushite, "Is it well with the young man Absalom?" And the Cushite answered, "May the enemies of my lord the king and all who rise up against you for evil be like that young man." And the king was deeply moved and went up to the chamber over the gate and wept. And as he went, he said, "O my son Absalom, my son, my son Absalom! Would I had died instead of you, O Absalom, my son, my son!" (ESV).

TRUTH FOR TODAY

Is there anything more heart-breaking than having a child in full-on rebellion against you?

Absalom had risen up against his father, and despite David's order, "For my sake, deal gently with young Absalom" (2 Samuel 18:5), Absalom suffered an ignoble death. Upon hearing of his son's death, David plunged into despair, crying, "O my son Absalom! My son, my son Absalom! If only I had died instead of you! O Absalom, my son, my son" (2 Samuel 18:33). The throne was secure, but David's heart was broken.

While there is still time, foster good relationships with your children. Let them know of your love, and when rifts develop, spur yourself to make the first move toward reconciliation.

For whatsoever a man soweth, that shall he also reap.
Galatians 6:7 (KJV)

FYI

David's intense grief over the loss of his son Absalom blinded him to the needs of those loyal to him and could have cost him the kingdom, save for Joab's bold rebuke of the king:

"You're more loyal to your enemies than to your friends. What you've done today has shown your officers and soldiers that they don't mean a thing to you. You would be happy if Absalom was still alive, even if the rest of us were dead" (2 Samuel 19:6, CEV).

To read the full account of events involving Absalom, leading up to his death, read chapters 13–17 in 2 Samuel.

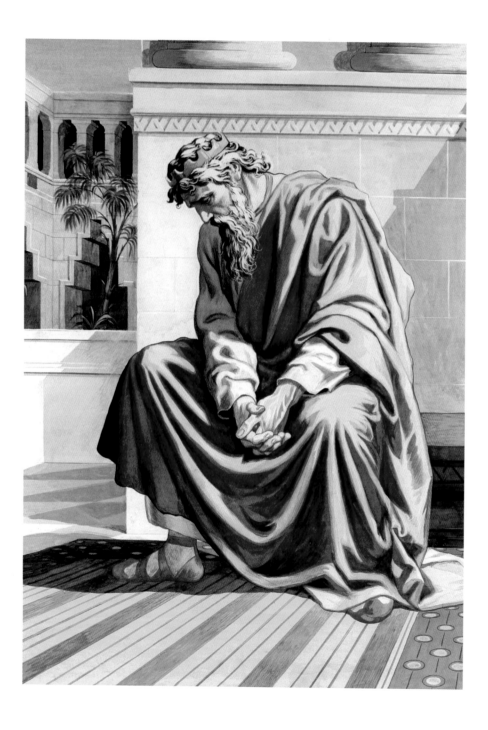

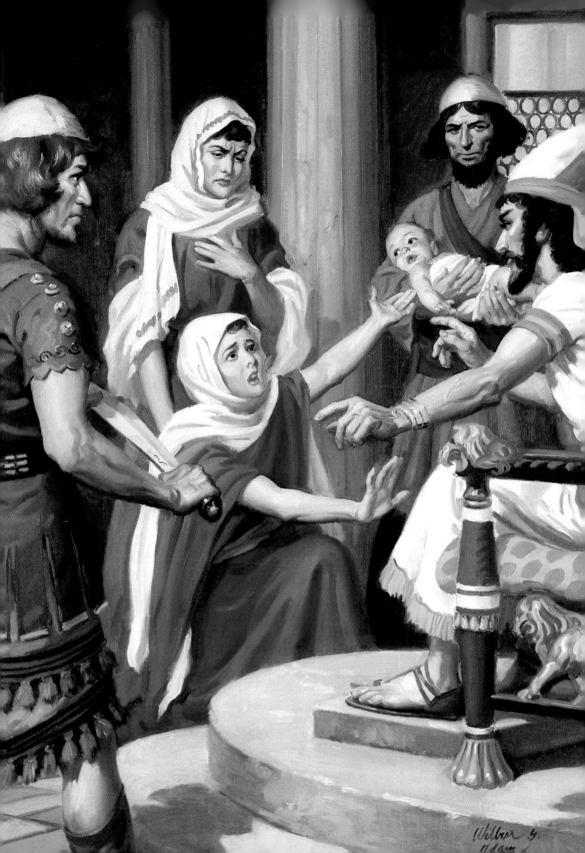

THE WISDOM OF SOLOMON

SETTING THE SCENE

Solomon was selected to succeed his father, David, as king of Israel. He was a young man when he ascended to the throne and faced all of its associated responsibilities and expectations.

Shortly after he had become king, the Lord appeared one night to Solomon in a dream. God asked Solomon to request whatever he would like to have. Uncertain about how best to govern and lead, he astutely asked the Lord for wisdom.

Don't Split the Baby

FROM 1 KINGS 3

The Lord was pleased that Solomon had asked for wisdom. So God replied, "Because you have asked for wisdom in governing my people with justice and have not asked for a long life or wealth or the death of your enemies—I will give you what you asked for!

I will give you a wise and understanding heart such as no one else has had or ever will have! And I will also give you what you did not ask for—riches and fame! No other king in all the world will be compared to you for the rest of your life! And if you follow me and obey my decrees and my commands as your father, David, did, I will give you a long life."

Then Solomon woke up and realized it had been a dream. He returned to Jerusalem and stood before the Ark of the Lord's Covenant, where he sacrificed burnt offerings and peace offerings.

Some time later two prostitutes came to the king to have an argument settled. "Please, my lord," one of them began, "this woman and I live in the same house. I gave birth to a baby while she was with me in the house. Three days later this woman also had a baby. We were alone; there were only two of us in the house.

"But her baby died during the night when she rolled over on it. Then she got up in the night and took my son from beside me while I was asleep. She laid her dead child in my arms and took mine to sleep beside her. And in the morning when I tried to nurse my son, he was dead! But when I looked more closely in the morning light, I saw that it wasn't my son at all."

Then the other woman interrupted, "It certainly was your son, and the living child is mine."

"No," the first woman said, "the living child is mine, and the dead one is yours." And so they argued back and forth before the king.

Then the king said, "Let's get the facts straight. Both of you claim the living child is yours, and each says that the dead one belongs to the other. All right, bring me a sword." So a sword was brought to the king.

Then he said, "Cut the living child in two, and give half to one woman and half to the other!"

Then the woman who was the real mother of the living child, and who loved him very much, cried out, "Oh no, my lord! Give her the child—please do not kill him!"

> **F**ear of the LORD is the foundation of true wisdom. All who obey his commandments will grow in wisdom.
>
> PSALM 111:10

But the other woman said, "All right, he will be neither yours nor mine; divide him between us!"

Then the king said, "Do not kill the child, but give him to the woman who wants him to live, for she is his mother!"

When all Israel heard the king's decision, the people were in awe of the king, for they saw the wisdom God had given him for rendering justice.

> **E**ven fools are thought wise when they keep silent.
> PROVERBS 17:28

TRUTH FOR TODAY

This story has the makings of a special *Law and Order: Jerusalem* episode. Because Solomon had wisdom, he knew how to get to the truth of the matter.

Wisdom is more valuable than wealth or knowledge. Anyone can know or learn something, but wisdom incorporates understanding and discernment and with it one can render good judgment. In the words of Solomon himself:

It's much better to be wise and sensible than to be rich.
Proverbs 16:16 (CEV)

FYI

For a sampling of the wise words of Solomon, read the Old Testament book of Proverbs.

King Solomon oversaw the building of the first temple in Jerusalem (often referred to as Solomon's Temple), which was an architectural wonder of the ancient world.

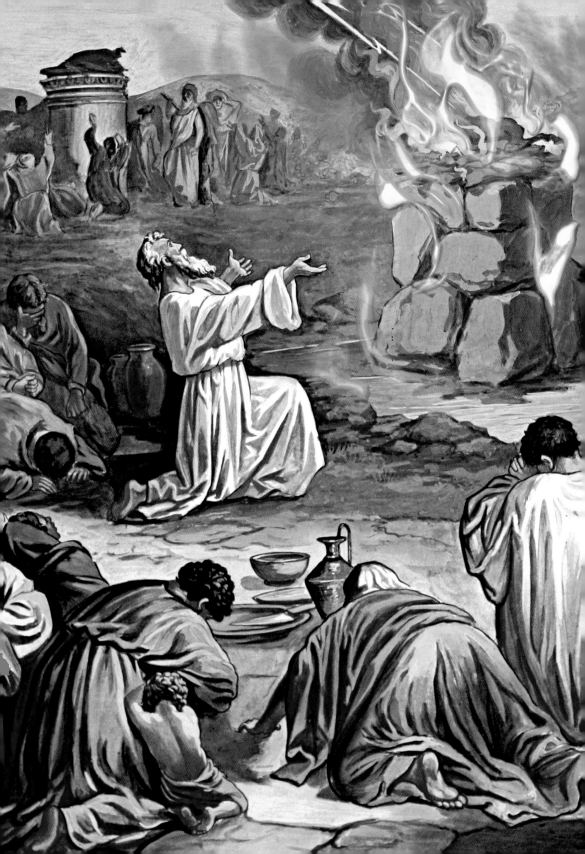

ELIJAH AND THE PROPHETS OF BAAL

SETTING THE SCENE

After the death of King Solomon, Israel fractured into two kingdoms—the southern kingdom, known as Judah, and the northern kingdom, known as Israel.

Elijah was a prophet of God in the northern kingdom during the reign of King Ahab. Out of a long string of morally corrupt kings in the northern kingdom, Ahab was the worst. Along with his wife, the equally wicked Jezebel, they led Israel deep into idolatry and promoted the worship of a false god called Baal.

Despite Jezebel's murderous purge of prophets of the Lord, God spared Elijah, who continued to faithfully confront Ahab as directed by the Lord. This long-running conflict set the stage for an epic showdown.

GOD'S BARBEQUE
FROM 1 KINGS 18

When Ahab saw him [Elijah], he said, "So there you are—the worst troublemaker in Israel!"

"I'm not the troublemaker," Elijah answered. "You are—you and your father. You are disobeying the LORD's commands and worshiping the idols of Baal."

So Ahab summoned all the Israelites and the prophets of Baal to meet at Mount Carmel. Elijah went up to the people and said, "How much longer will it take you to make up your minds? If the LORD is God, worship him; but if Baal is God, worship him!" But the people didn't say a word.

Then Elijah said, "I am the only prophet of the LORD still left, but there are 450 prophets of Baal. Bring two bulls; let the prophets of Baal take one, kill it, cut it in pieces, and put it on the wood—but don't light the fire. I will do the same with the other bull. Then let the prophets of Baal pray to their god, and I will pray to the LORD, and the one who answers by sending fire— he is God."

Then Elijah said to the prophets of Baal, "Since there are so many of you, you take a bull and prepare it first. Pray to your god, but don't set fire to the wood."

At noon Elijah started making fun of them: "Pray louder! He is a god! Maybe he is day-dreaming or relieving himself, or perhaps he's gone off on a trip! Or maybe he's sleeping, and you've got to wake him up!" So the prophets prayed louder and cut themselves with knives and daggers, according to their ritual, until blood flowed. They kept on ranting and raving until the middle of the afternoon; but no answer came, not a sound was heard.

Then Elijah said to the people, "Come closer to me," and they all gathered around him. He set about repairing the altar of the LORD which had been torn down. He took twelve stones, one for each of the twelve tribes named for the sons of Jacob, the man to whom the LORD had given the name Israel. With these stones he rebuilt the altar for the worship of the LORD. He dug a trench

around it, large enough to hold about four gallons of water. Then he placed the wood on the altar, cut the bull in pieces, and laid it on the wood.

He said, "Fill four jars with water and pour it on the offering and the wood." They did so, and he said, "Do it again"—and they did. "Do it once more," he said—and they did. The water ran down around the altar and filled the trench.

At the hour of the afternoon sacrifice the prophet Elijah approached the altar and prayed, "O LORD, the God of Abraham, Isaac, and Jacob, prove now that you are the God of Israel and that I am your servant and have done all this at your command. Answer me, LORD, answer me, so that this people will know that you, the LORD, are God and that you are bringing them back to yourself."

The LORD sent fire down, and it burned up the sacrifice, the wood, and the stones, scorched the earth and dried up the water in the trench. When the people saw this, they threw themselves on the ground and exclaimed, "The LORD is God; the LORD alone is God!" (GNT)

TRUTH FOR TODAY

One prophet of God against 450 prophets of Baal—it was no contest.

While patient and merciful, the Lord does not suffer the foolishness of humanity without limit. This showdown was a tangible example of God's power and a wake-up call to the people who were trying to have it both ways—wavering between idolatry and worship of God.

Elijah's question for the people was simple: "How much longer will it take you to make up your minds?" The time had come to pick a side.

If you're on the fence, choose a side.

FYI

It is said of Ahab that "[he] did evil in the sight of the LORD, more than all who were before him" (1 Kings 16:30, ESV).

Baal was a regional god associated with fertility, whose worship in Israel was championed by King Ahab's wife, Jezebel. Asherah was a related female deity worshipped alongside Baal. Immoral and detestable practices were associated with the cult of Baal.

WHERE IN THE WORLD

It is thought that Mount Carmel is near the city of Haifa in modern-day Israel.

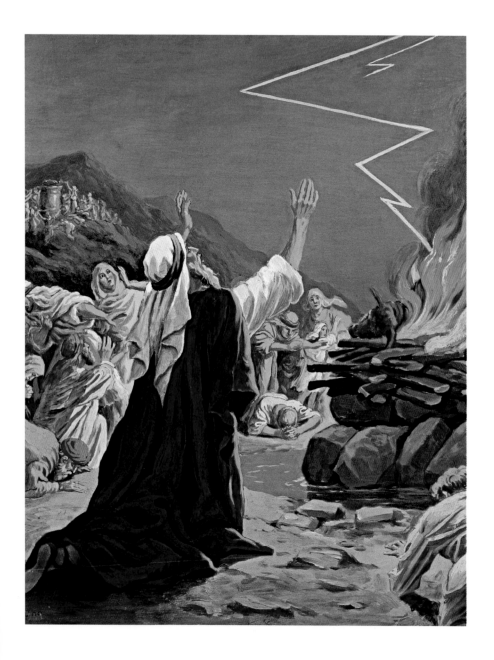

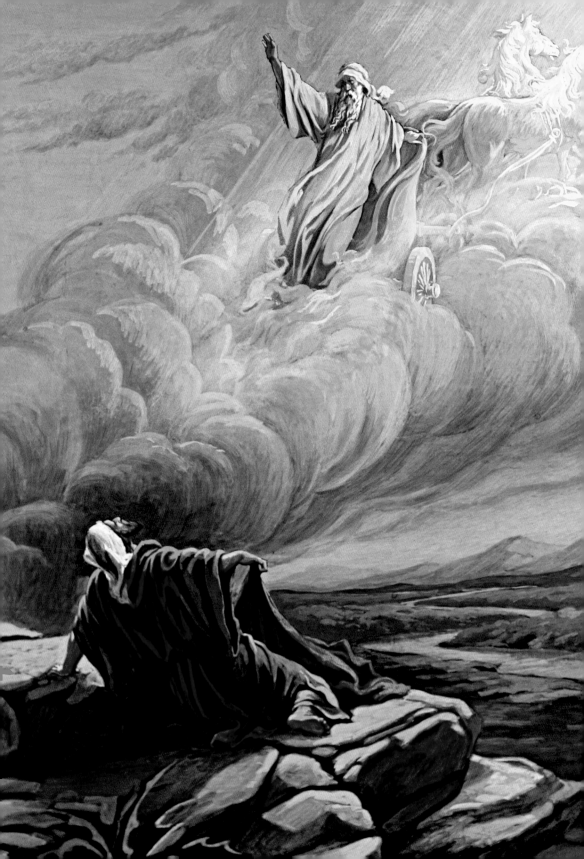

ELIJAH'S CHARIOT OF FIRE

SETTING THE SCENE

The storied ministry of Elijah, the powerful prophet of God, was drawing to a close. Having faithfully served God as a prophet primarily during the reign of King Ahab, and having found an able protégé in his apprentice, Elisha, the end of Elijah's time on earth was near.

Carried Away

FROM 2 KINGS 2

When the LORD was about to take Elijah up to heaven in a whirlwind, Elijah and Elisha were traveling from Gilgal. And Elijah said to Elisha, "Stay here, for the LORD has told me to go to Bethel."

But Elisha replied, "As surely as the LORD lives and you yourself live, I will never leave you!" So they went down together to Bethel.

The group of prophets from Bethel came to Elisha and asked him, "Did you know that the LORD is going to take your master away from you today?"

"Of course I know," Elisha answered. "But be quiet about it."

Then Elijah said to Elisha, "Stay here, for the LORD has told me to go to Jericho."

But Elisha replied again, "As surely as the LORD lives and you yourself live, I will never leave you." So they went on together to Jericho.

Then the group of prophets from Jericho came to Elisha and asked him, "Did you know that the LORD is going to take your master away from you today?"

"Of course I know," Elisha answered. "But be quiet about it."

Then Elijah said to Elisha, "Stay here, for the LORD has told me to go to the Jordan River."

But again Elisha replied, "As surely as the LORD lives and you yourself live, I will never leave you." So they went on together.

Fifty men from the group of prophets also went and watched from a distance as Elijah and Elisha stopped beside the Jordan River. Then Elijah folded his cloak together and struck the water with it. The river divided, and the two of them went across on dry ground!

When they came to the other side, Elijah said to Elisha, "Tell me what I can do for you before I am taken away."

And Elisha replied, "Please let me inherit a double share of your spirit and become your successor."

"You have asked a difficult thing," Elijah replied. "If you see me when I am taken from you, then you will get your request. But if not, then you won't."

As they were walking along and talking, suddenly a chariot of fire appeared, drawn by horses of fire. It drove between the two men, separating them, and Elijah was carried by a whirlwind into heaven. Elisha saw it and cried out, "My father! My father! I see the chariots and charioteers of Israel!" And as they disappeared from sight, Elisha tore his clothes in distress.

Elisha picked up Elijah's cloak, which had fallen when he was taken up. Then Elisha returned to the bank of the Jordan River. He struck the water with

Elijah's cloak and cried out, "Where is the LORD, the God of Elijah?" Then the river divided, and Elisha went across.

When the group of prophets from Jericho saw from a distance what happened, they exclaimed, "Elijah's spirit rests upon Elisha!"

TRUTH FOR TODAY

Talk about going out *in style*. Elisha may not have known exactly what was going to happen, but he knew something was up, and he wasn't going to miss it. Sticking close to his mentor to the end, Elisha witnessed Elijah's miraculous rapture.

It's hard to overstate the importance of having someone in your life who has "been there, done that" and can show you the ropes. Elijah had poured himself into Elisha, leaving him with far more than just a great story to tell.

Find someone worth following and learn from them;
in turn, be someone worth following.

FYI

Elijah is one of two people in the Bible who were taken by God from the earth. The other was Enoch, who "walked with God, and he was not, for God took him" (Genesis 5:24, ESV).

CROSS REFERENCE

In the Gospel of Matthew, we read that Elijah and Moses appeared to Jesus and three of His disciples on the Mount of Transfiguration (Matthew 17:3–4).

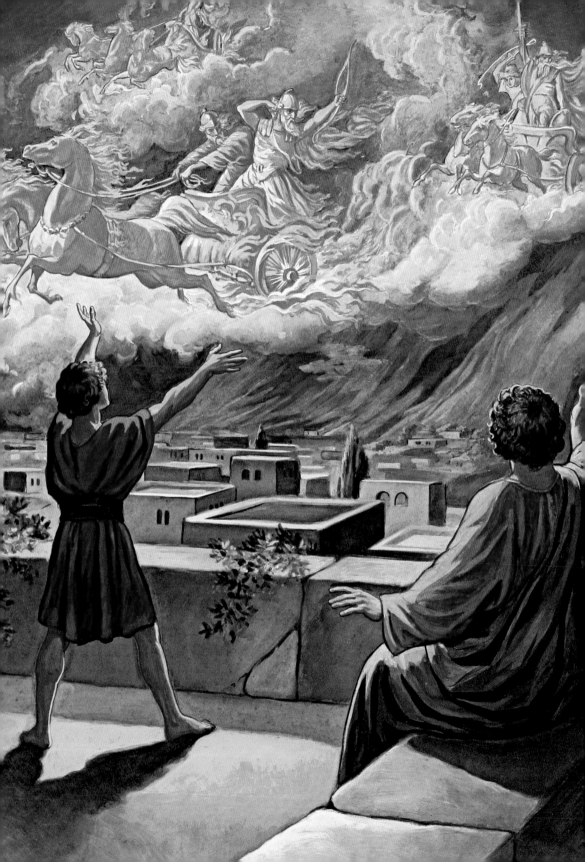

ELISHA'S HEAVENLY DEFENDERS

SETTING THE SCENE

After the prophet Elijah had been taken into heaven, Elisha took up Elijah's mantle, following in his mentor's footsteps as a great prophet of God in Israel. The Lord empowered Elisha to perform a number of amazing miracles and also used him to thwart the plans of the king of Syria, who kept plotting surprise attacks against Israel.

Angel Army

FROM 2 KINGS 6

Once when the king of Syria was warring against Israel, he took counsel with his servants, saying, "At such and such a place shall be my camp." But the man of God [Elisha] sent word to the king of Israel, "Beware that you do not pass this place, for the Syrians are going down there." And the king of Israel sent to the place about which the man of God told him. Thus he used to warn him, so that he saved himself there more than once or twice.

And the mind of the king of Syria was greatly troubled because of this thing, and he called his servants and said to them, "Will you not show me who of us is for the king of Israel?" And one of his servants said, "None, my lord, O king; but Elisha, the prophet who is in Israel, tells the king of Israel the words that you speak in your bedroom." And he said, "Go and see where he is, that I may send and seize him." It was told him, "Behold, he is in Dothan." So he sent there horses and chariots and a great army, and they came by night and surrounded the city.

When the servant of the man of God rose early in the morning and went out, behold, an army with horses and chariots was all around the city. And the servant said, "Alas, my master! What shall we do?" He said, "Do not be afraid, for those who are with us are more than those who are with them." Then Elisha prayed and said, "O LORD, please open his eyes that he may see." So the LORD opened the eyes of the young man, and he saw, and behold, the mountain was full of horses and chariots of fire all around Elisha. And when the Syrians came down against him, Elisha prayed to the LORD and said, "Please strike this people with blindness." So he struck them with blindness in accordance with the prayer of Elisha. And Elisha said to them, "This is not the way, and this is not the city. Follow me, and I will bring you to the man whom you seek." And he led them to Samaria.

As soon as they entered Samaria, Elisha said, "O LORD, open the eyes of these men, that they may see." So the LORD opened their eyes and they saw, and behold, they were in the midst of Samaria. As soon as the king of Israel saw them, he said to Elisha, "My father, shall I strike them down? Shall I strike them down?" He answered, "You shall not strike them down. Would you strike down those whom you have taken captive with your sword and with your bow? Set bread and water before them, that they may eat and drink and go to their master" (ESV).

TRUTH FOR TODAY

The Lord can choose both to reveal and hide things, regardless of the dimension in which they exist. To Elisha, God revealed the king's plans; for Elisha's servant, God allowed him to see the heavenly army he was previously oblivious to. But in the case of the Syrian army, God temporarily blinded them to where they were and where they were being led.

Our ability to discover, know, and see rests with the Lord. The same God who can make blind eyes see can make seeing eyes blind to reality and spiritual truth.

In an era of instant digital and visual information, it can be difficult to separate truth from fiction. Seek to discern truth and to receive knowledge from God, and then use it for the good of others.

God is active and at work—often in ways and dimensions we do not see.

FYI

The idiom "take up the mantle" originated from the Bible—specifically from Elijah and Elisha. A mantle is a type of clothing. When Elijah was taken up to heaven, his cloak (mantle) fell behind and was taken up by Elisha.

The biblical Syrians (also rendered as "Arameans" in some translations) were near relatives of Israel and vied with them for land. Although there had been a tenuous peace between Israel and Syria during Ahab's reign as king of Israel, Syrian hostilities increased when Ahab's son Jehoram (sometimes shortened to Joram) was on the throne.

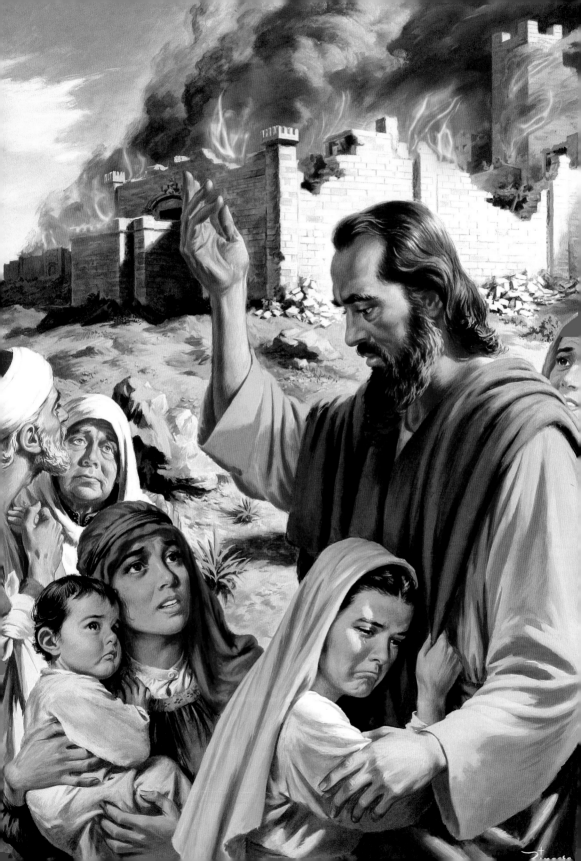

THE FALL OF JERUSALEM

SETTING THE SCENE

The northern kingdom, known as Israel, had fallen to the Assyrians (circa 722 B.C.) following a successful siege of its capital, Samaria. Meanwhile, the southern kingdom known as Judah, with its capital Jerusalem, managed to hold off conquest for approximately 136 years before succumbing to King Nebuchadnezzar the Babylonian (circa 586 B.C.).

O Jerusalem, Jerusalem
FROM 2 CHRONICLES 36

Zedekiah rebelled against King Nebuchadnezzar, who had forced him to swear in God's name that he would be loyal. He stubbornly refused to repent and return to the LORD, the God of Israel. In addition, the leaders of Judah, the priests, and the people followed the sinful example of the nations around them in worshiping

idols, and so they defiled the Temple, which the LORD himself had made holy. The LORD, the God of their ancestors, had continued to send prophets to warn his people, because he wanted to spare them and the Temple. But they made fun of God's messengers, ignoring his words and laughing at his prophets, until at last the LORD's anger against his people was so great that there was no escape.

So the LORD brought the king of Babylonia to attack them. The king killed the young men of Judah even in the Temple. He had no mercy on anyone, young or old, man or woman, sick or healthy. God handed them all over to him. The king of Babylonia looted the Temple, the Temple treasury, and the wealth of the king and his officials, and took everything back to Babylon. He burned down the Temple and the city, with all its palaces and its wealth, and broke down the city wall. He took all the survivors to Babylonia, where they served him and his descendants as slaves until the rise of the Persian Empire. And so what the LORD had foretold through the prophet Jeremiah was fulfilled: "The land will lie desolate for seventy years, to make up for the Sabbath rest that has not been observed" (GNT).

Then Isaiah said to Hezekiah, "Listen to this message from the LORD of Heaven's Armies: 'The time is coming when everything in your palace—all the treasures stored up by your ancestors until now—will be carried off to Babylon. Nothing will be left,' says the LORD."
ISAIAH 39:5-6

TRUTH FOR TODAY

Though sad and tragic, Jerusalem's fall at the hands of the Babylonians had been predicted and was a long time in the making. The temple that David had envisioned and that had been built by his son Solomon was looted and burned. What had once been the vibrant center of Israel's worship of God lay in ruins, which reflected the nation's overall spiritual state.

Not willing that any should perish, God demonstrates patience toward us, even in the midst of apostasy. However, God is also just and brings judgment in the absence of repentance.

God's patience in the face of rebellion provides the opportunity to turn one's heart back to the Lord.

FYI

There is a parallel account of Jerusalem's fall recorded in 2 Kings 25. See also Lamentations 1 for a graphic description of Jerusalem's devastation.

Jerusalem had become the capital city of a united Israel during King David's reign, circa 1000 B.C. It remained a stronghold for the Hebrew people for over four hundred years until it was sacked and burned by the Babylonians circa 586 B.C.

Then this message came to Jeremiah from the LORD: "I am the LORD, the God of all the peoples of the world. Is anything too hard for me? Therefore, this is what the LORD says: I will hand this city over to the Babylonians and to Nebuchadnezzar, king of Babylon, and he will capture it."

JEREMIAH 32:26–28

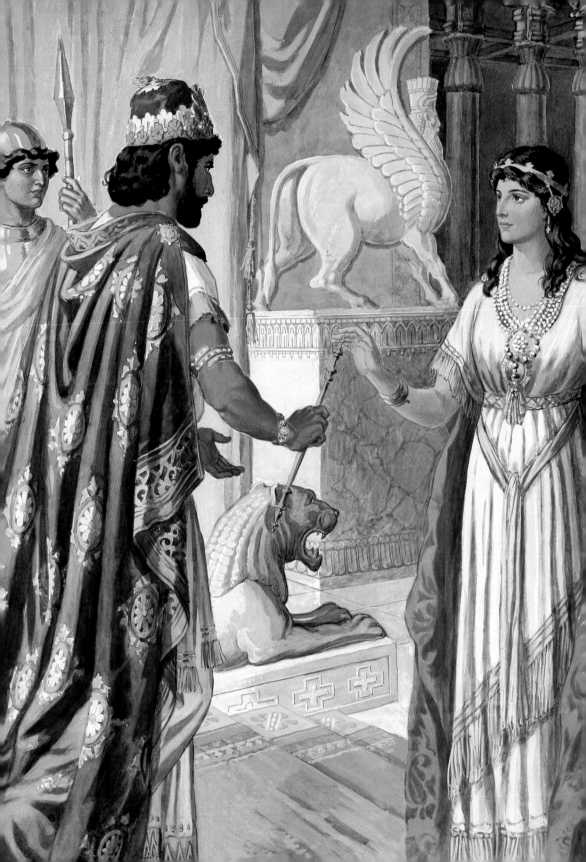

COURAGEOUS
QUEEN ESTHER

SETTING THE SCENE

The book of Esther tells the story of an orphaned Jewish exile who unexpectedly became queen in a foreign kingdom.

Queen Esther, her ethnicity a closely held secret, had arrived in the king's court in Susa after an elaborate national search for a successor to Queen Vashti, who had displeased King Xerxes and had been banished.

Esther found herself in a unique position to intercede on behalf of her people in the face of a sinister plot against them. She prepared to approach the king with a request. However, going before this king without an express invitation meant risking her own life—if he failed to extend his golden scepter.

Look Who's Coming to Dinner

FROM ESTHER 5 AND 7

Three days later, Esther dressed in her royal robes and went to the inner court of the palace in front of the throne. The king was sitting there, facing the open doorway. He was happy to see Esther, and he held out the gold scepter to her.

When Esther came up and touched the tip of the scepter, the king said, "Esther, what brings you here? Just ask, and I will give you as much as half of my kingdom."

Esther answered, "Your Majesty, please come with Haman to a dinner I will prepare for you later today."

The king said to his servants, "Hurry and get Haman, so we can accept Esther's invitation."

The king and Haman went to Esther's dinner, and while they were drinking wine, the king asked her, "What can I do for you?"

Esther replied, "Your Majesty, if you really care for me and are willing to do what I want, please come again tomorrow with Haman to the dinner I will prepare for you. At that time I will answer Your Majesty's question."

When Haman got home, he called together his friends and his wife.... He told them the many ways that the king had honored him and how all the other officials and leaders had to respect him. Haman added, "That's not all! Besides the king himself, I'm the only person Queen Esther invited for dinner. She has also invited the king and me to dinner tomorrow. But none of this makes me happy, as long as I see that Jew Mordecai sitting at the palace gate."

Haman's wife and friends said to him, "Have a tower built about seventy-five feet high, and tomorrow morning ask the king to hang Mordecai there."

The king and Haman were dining with Esther and drinking wine during the second dinner, when the king again said, "Esther, what can I do for you?

Esther answered, "Your Majesty, if you really care for me and are willing to help, you can save me and my people. That's what I really want, because a reward has been promised to anyone who kills my people."

"Who would dare to do such a thing?" the king asked.

Esther replied, "That evil Haman is the one out to get us!"

Haman was terrified, as he looked at the king and the queen.

The king was so angry that he got up, left his wine, and went out into the palace garden.

Haman realized that the king had already decided what to do with him, and he stayed and begged Esther to save his life.

Just as the king came back into the room, Haman got down on his knees beside Esther, who was lying on the couch. The king shouted, "Now you're even trying to rape my queen here in my own palace!"

As soon as the king said this, his servants covered Haman's head. Then Harbona, one of the king's personal servants, said, "Your Majesty, Haman built a tower seventy-five feet high beside his house, so he could hang Mordecai on it. And Mordecai is the very one who spoke up and saved your life."

"Hang Haman from his own tower!" the king commanded (CEV).

TRUTH FOR TODAY

"Who knows if perhaps you were made queen for just such a time as this?" (Esther 4:14b). These words spoken to Esther by her uncle and guardian, Mordecai, helped embolden Esther to act on behalf of her people, which she did in a style and manner all her own.

On the flip side, wicked Haman was hoisted with his own petard.

Such it is in God's economy: at some point in life, you may very well find yourself in a particular place at a particular point for a particular purpose.

God delights in using ordinary people
to accomplish the extraordinary.

FYI

To "hoist with his own petard" is a literary phrase used in Shakespeare's play *Hamlet*. It represents being caught up in or by the device you had intended for someone else's harm.

The Jewish festival Purim, celebrated annually, commemorates the main event in the book of Esther: the deliverance of the Jewish exiles as facilitated by Esther's courage against Haman's execution plot.

WHERE IN THE WORLD

Susa was a city in the ancient Persian Empire. It was located in what is now Iran, near the modern-day city of Shush.

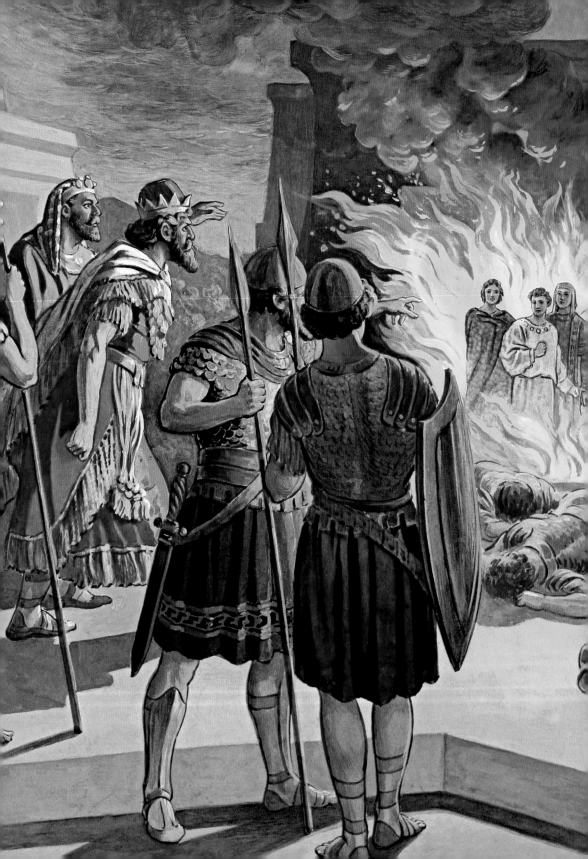

THREE FRIENDS AND
THE FIERY FURNACE

SETTING THE SCENE

King Nebuchadnezzar, ruler of the Babylonian Empire at the time of the fall of Jerusalem, had a ginormous gold statue (ninety feet tall) erected outside Babylon. The king amassed a large gathering to dedicate the statue. Those assembled were instructed to bow down and worship the king's statue when the ceremonial music played. The penalty for not doing so: death.

The music played and three young Jewish exiles, who had been taken to Babylon from Jerusalem, stood while everyone else bowed.

Fire in the Hole

FROM DANIEL 3

Then Nebuchadnezzar flew into a rage and ordered that Shadrach, Meshach, and Abednego be brought before him. When they were brought in, Nebuchadnezzar

said to them, "Is it true, Shadrach, Meshach, and Abednego, that you refuse to serve my gods or to worship the gold statue I have set up? I will give you one more chance to bow down and worship the statue I have made when you hear the sound of the musical instruments. But if you refuse, you will be thrown immediately into the blazing furnace. And then what god will be able to rescue you from my power?"

Shadrach, Meshach, and Abednego replied, "O Nebuchadnezzar, we do not need to defend ourselves before you. If we are thrown into the blazing furnace, the God whom we serve is able to save us. He will rescue us from your power, Your Majesty. But even if he doesn't, we want to make it clear to you, Your Majesty, that we will never serve your gods or worship the gold statue you have set up."

Nebuchadnezzar was so furious with Shadrach, Meshach, and Abednego that his face became distorted with rage. He commanded that the furnace be heated seven times hotter than usual. Then he ordered some of the strongest men of his army to bind Shadrach, Meshach, and Abednego and throw them into the blazing furnace. So they tied them up and threw them into the furnace, fully dressed in their pants, turbans, robes, and other garments. And because the king, in his anger, had demanded such a hot fire in the furnace, the flames killed the soldiers as they threw the three men in. So Shadrach, Meshach, and Abednego, securely tied, fell into the roaring flames.

But suddenly, Nebuchadnezzar jumped up in amazement and exclaimed to his advisers, "Didn't we tie up three men and throw them into the furnace?"

"Yes, Your Majesty, we certainly did," they replied.

"Look!" Nebuchadnezzar shouted. "I see four men, unbound, walking around in the fire unharmed! And the fourth looks like a god!"

Then Nebuchadnezzar came as close as he could to the door of the flaming furnace and shouted: "Shadrach, Meshach, and Abednego, servants of the Most High God, come out! Come here!"

So Shadrach, Meshach, and Abednego stepped out of the fire. Then the high officers, officials, governors, and advisers crowded around them and saw that the fire had not touched them. Not a hair on their heads was singed, and their clothing was not scorched. They didn't even smell of smoke!

Then Nebuchadnezzar said, "Praise to the God of Shadrach, Meshach, and Abednego! He sent his angel to rescue his servants who trusted in him. They defied the king's command and were willing to die rather than serve or worship any god except their own God. Therefore, I make this decree: If any people, whatever their race or nation or language, speak a word against the God of Shadrach, Meshach, and Abednego, they will be torn limb from limb, and their houses will be turned into heaps of rubble. There is no other god who can rescue like this!"

Then the king promoted Shadrach, Meshach, and Abednego to even higher positions in the province of Babylon.

TRUTH FOR TODAY

What courage! What conviction! In the king's own words: "They … were willing to die rather than serve or worship any god except their own God."

Equal to the courage of their convictions, these young men had a faith that was mature enough to trust God—"even if" His plan would have been something other than their physical deliverance from the furnace.

There is plenty of room for compromise on most issues. But there are also certain principles for which it's worth putting yourself on the line.

Stand on the courage of righteous convictions and know that God is able to deliver.

FYI

The word "ginormous" made the Oxford English dictionary in 1989, but it was labeled as slang. However, Merriam-Webster accepted it as a proper word in 2007.

Shadrach, Meshach, and Abednego were names given to these Jewish young men by the Babylonians. Their Jewish names were Hananiah, Mishael, and Azariah.

Neb's gold statue, at ninety feet tall, is similar in height to the iconic Cristo Redentor (Christ the Redeemer) statue overlooking Rio de Janeiro, Brazil. Excluding the base, it stands ninety-eight feet tall.

It's debated among Bible scholars as to whether the fourth figure in the furnace was a pre-incarnation appearance of Jesus or an angel.

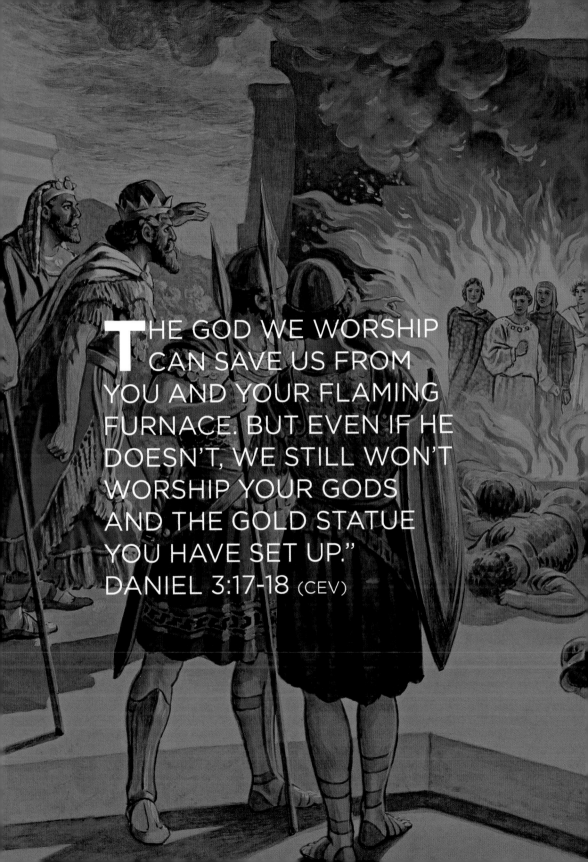

THE GOD WE WORSHIP CAN SAVE US FROM YOU AND YOUR FLAMING FURNACE. BUT EVEN IF HE DOESN'T, WE STILL WON'T WORSHIP YOUR GODS AND THE GOLD STATUE YOU HAVE SET UP." DANIEL 3:17-18 (CEV)

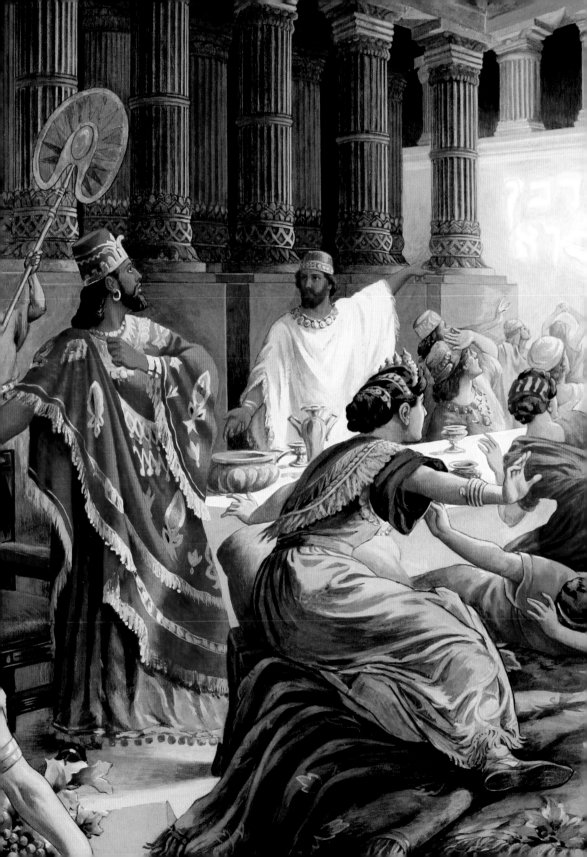

BELSHAZZAR'S FEAST

SETTING THE SCENE

As part of his conquest of Jerusalem, King Nebuchadnezzar exported back to Babylon the vessels used in worship that had been looted from the temple. In addition, he ordered that the best and brightest youths in Israel be sent to Babylon to be trained and enter into the king's service. Daniel, a young Hebrew to whom God had given the unique ability to interpret dreams and visions, was among those exiled, and he loyally served King Neb during his reign.

Many years later, the regent in Babylon, Belshazzar, was preparing for a grand banquet. Due to a mysterious event that would unfold during the feast, Daniel found himself as an unexpected guest at Bel's party.

The Handwriting on the Wall

FROM DANIEL 5

One evening, King Belshazzar gave a great banquet for a thousand of his highest officials, and he drank wine with them. He got drunk and ordered his servants to

bring in the gold and silver cups his father Nebuchadnezzar had taken from the temple in Jerusalem.

When the gold cups were brought in, everyone at the banquet drank from them and praised their idols made of gold, silver, bronze, iron, wood, and stone.

Suddenly a human hand was seen writing on the plaster wall of the palace.

All of King Belshazzar's highest officials came in, but not one of them could read the writing or tell what it meant, and they were completely puzzled. Now the king was more afraid than ever before, and his face turned white as a ghost.

When the queen heard the king and his officials talking, she came in and said:

Your Majesty, I hope you live forever! Don't be afraid or look so pale. In your kingdom there is a man who has been given special powers by the holy gods.... Not only is he wise and intelligent, but he can explain dreams and riddles and solve difficult problems. Send for Daniel, and he will tell you what the writing means.

When Daniel was brought in, the king said:

Neither my advisors nor the men who talk with the spirits of the dead could read this writing or tell me what it means.... Now then, if you can read this writing and tell me what it means, you will become the third most powerful man in my kingdom.

Daniel answered:

Your Majesty, I will read the writing and tell you what it means. But you may keep your gifts or give them to someone else. Sir, the Most High God made your father a great and powerful man and brought him much honor and glory....

But when he became proud and stubborn, his glorious kingdom was taken from him. His mind became like that of an animal, and he was forced to stay away from people and live with wild donkeys. Your father ate grass like an ox, and he slept outside where his body was soaked with dew. He was forced to do this until he learned that the Most High God rules all kingdoms on earth and chooses their kings.

King Belshazzar, you knew all of this, but you still refused to honor the Lord who rules from heaven.... You praised idols made of silver, gold, bronze, iron, wood, and stone, even though they cannot see or hear or think. You refused to worship the God who gives you breath and controls everything you do. That's why he sent the hand to write this message on the wall.

The words written there are mene, which means 'numbered,' tekel, which means 'weighed,' and parsin, which means 'divided.' God has numbered the days of your kingdom and has brought it to an end. He has weighed you on his balance scales, and you fall short of what it takes to be king.

So God has divided your kingdom between the Medes and the Persians. That same night, the king was killed (CEV).

TRUTH FOR TODAY

Case #5702-B: *The Most High God v Belshazzar of Babylon*

The charges:

1. Contempt for the godly goblets
2. Toasting idols with the aforementioned vessels
3. Refusal to acknowledge the God of the Universe

The verdict: weighed in the balance and found wanting.

The sentence: loss of kingdom and life (to be carried out forthwith).

Belshazzar's failure to acknowledge the God Most High came at a steep price. A truth he failed to grasp is this: all earthly sovereigns serve at God's pleasure and can be dispatched as the Lord wills. In today's complex and often bewildering geopolitical climate, this is a truism we would do well to remember.

A focus on temporary and fleeting pleasures will leave one found wanting when weighed by God.

FYI

As a musical retelling of this story, Johnny Cash wrote "Belshazzar." It was recorded in 1957 and released in 1964 as the B-side song of the single "Wide Open Road." It also appears on the 1964 album *The Original Sun Sound of Johnny Cash* and on the *God* CD, released in 2000 as part of the *Love, God, Murder* compilation.

Daniel's Babylonian name was Belteshazzar, not to be confused with Belshazzar.

At the time of this feast, Daniel may have been in Babylon for nearly fifty years (calculated from when Jerusalem fell to when the Medes and Persians conquered Babylon).

Pride goeth before destruction, and an haughty spirit before a fall.
PROVERBS 16:18 (KJV)

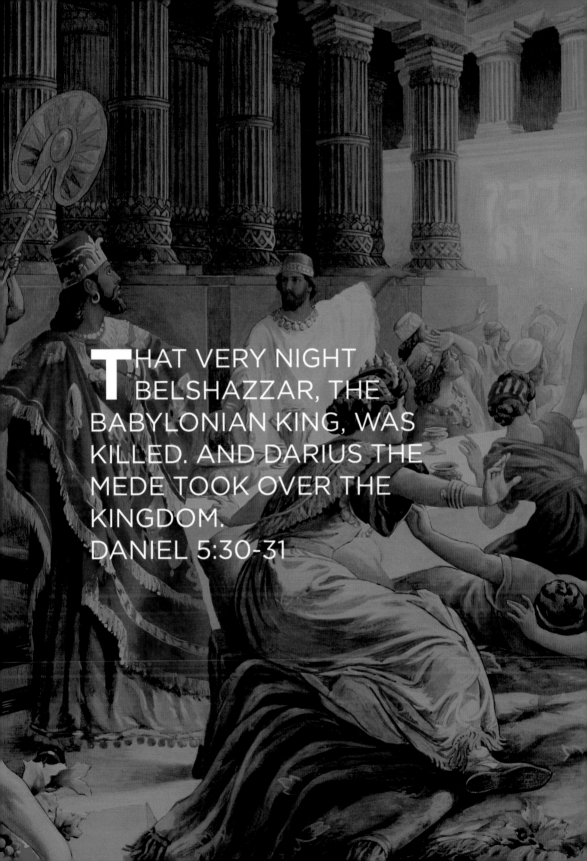

THAT VERY NIGHT BELSHAZZAR, THE BABYLONIAN KING, WAS KILLED. AND DARIUS THE MEDE TOOK OVER THE KINGDOM.
DANIEL 5:30-31

DANIEL IN THE LIONS' DEN

49

SETTING THE SCENE

As one of three supervisors appointed by King Darius over a network of 120 governors, Daniel distinguished himself from his peers and was up for a promotion. In addition to being an exemplary employee and a person of impeccable character, Daniel was a devout follower of God.

His jealous rivals, looking for a way to bring him down, had to resort to tricking the king into signing an irrevocable order. It mandated that if anyone prayed to someone other than the king, they were to be thrown to the lions.

Nice Kitty

FROM DANIEL 6

When Daniel's enemies observed him praying to God, all of them went together to the king to accuse Daniel. They said, "Your Majesty, you signed an order that for

the next thirty days anyone who requested anything from any god or from any human being except you would be thrown into a pit filled with lions."

The king replied, "Yes, that is a strict order, a law of the Medes and Persians, which cannot be changed."

Then they said to the king, "Daniel, one of the exiles from Judah, does not respect Your Majesty or obey the order you issued. He prays regularly, three times a day."

When the king heard this, he was upset and did his best to find some way to rescue Daniel. He kept trying until sunset. Then Daniel's enemies came back to the king and said to him, "Your Majesty knows that according to the laws of the Medes and Persians no order which the king issues can be changed."

> If you set a trap for others, you will get caught in it yourself. If you roll a boulder down on others, it will crush you instead.
> PROVERBS 26:27

So the king gave orders for Daniel to be taken and thrown into the pit filled with lions. He said to Daniel, "May your God, whom you serve so loyally, rescue you." A stone was put over the mouth of the pit, and the king placed his own royal seal and the seal of his noblemen on the stone, so that no one could rescue Daniel. Then the king returned to the palace and spent a sleepless night, without food or any form of entertainment.

At dawn the king got up and hurried to the pit. When he got there, he called out anxiously, "Daniel, servant of the living God! Was the God you serve so loyally able to save you from the lions?"

Daniel answered, "May Your Majesty live forever! God sent his angel to shut the mouths of the lions so that they would not hurt me. He did this because he knew that I was innocent and because I have not wronged you, Your Majesty."

The king was overjoyed and gave orders for Daniel to be pulled up out of the pit. So they pulled him up and saw that he had not been hurt at all, for he trusted God. Then the king gave orders to arrest all those who had accused Daniel, and he had them thrown, together with their wives and children, into the pit filled with lions. Before they even reached the bottom of the pit, the lions pounced on them and broke all their bones (GNT).

TRUTH FOR TODAY

This story is an extreme case of sabotage and entrapment borne out of professional envy. While not always as evident or immediate as in this instance, evil plotted against the innocent boomerangs upon the conspirators.

An important aspect of this story not to be overlooked is Daniel's response to the injustice that was committed against him. He bore no ill will toward the king. Rather, he spoke a word of blessing to him and testified to his deliverance by God's hand.

In the face of injustice, do right, trust God, and guard your heart against bitterness.

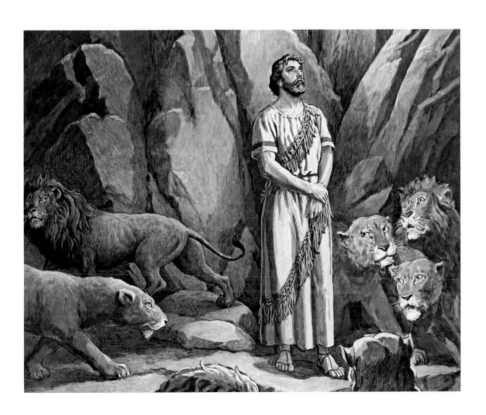

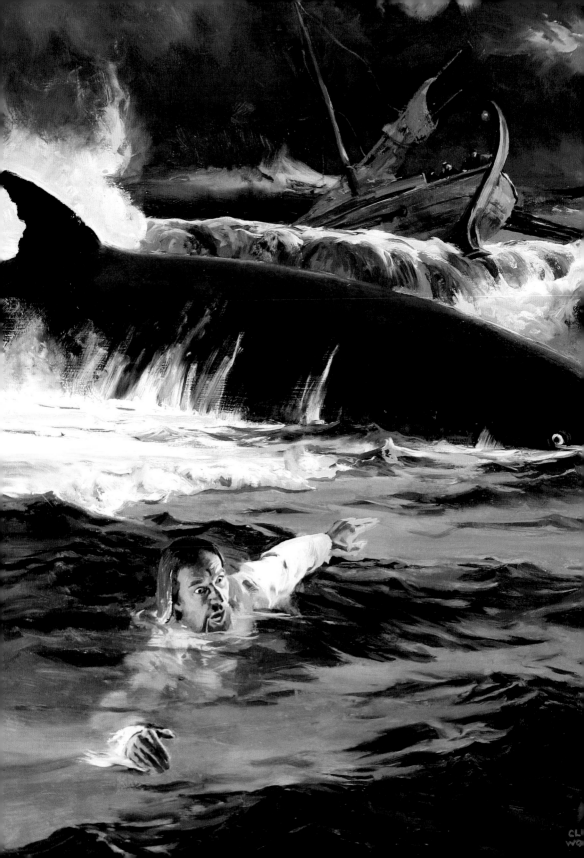

JONAH AND THE BIG FISH

SETTING THE SCENE

Jonah was a prophet of the Lord in the northern kingdom of Israel during the reign of Jeroboam II. To the east of Israel, the Assyrian Empire posed a threat to Israel. Jonah was called by God to go and preach in the great Assyrian city of Nineveh. As we shall see from this story, Jonah was loathe to carry out this assignment.

You Can Run, but You Can't Hide

FROM JONAH 1–3

One day the LORD told Jonah, the son of Amittai, to go to the great city of Nineveh and say to the people, "The LORD has seen your terrible sins. You are doomed!"

Instead, Jonah ran from the LORD. He went to the seaport of Joppa and bought a ticket on a ship that was going to Spain. Then he got on the ship and sailed away to escape.

But the LORD made a strong wind blow, and such a bad storm came up that the ship was about to be broken to pieces. The sailors were frightened, and they all started praying to their gods. They even threw the ship's cargo overboard to make the ship lighter.

All this time, Jonah was down below deck, sound asleep. The ship's captain went to him and said, "How can you sleep at a time like this? Get up and pray to your God! Maybe he will have pity on us and keep us from drowning."

Finally, the sailors got together and said, "Let's ask our gods to show us who caused all this trouble." It turned out to be Jonah.

They started asking him, "Are you the one who brought all this trouble on us? What business are you in? Where do you come from? What is your country? Who are your people?"

Jonah answered, "I'm a Hebrew, and I worship the LORD God of heaven, who made the sea and the dry land."

When the sailors heard this, they were frightened, because Jonah had already told them he was running from the LORD. Then they said, "Do you know what you have done?"

The storm kept getting worse, until finally the sailors asked him, "What should we do with you to make the sea calm down?"

Jonah told them, "Throw me into the sea, and it will calm down. I'm the cause of this terrible storm."

The sailors tried their best to row to the shore. But they could not do it, and the storm kept getting worse every minute. So they prayed to the LORD, "Please don't let us drown for taking this man's life. Don't hold us guilty for killing an innocent man. All of this happened because you wanted it to." Then they threw Jonah overboard, and the sea calmed down. The sailors were so terrified that they offered a sacrifice to the LORD and made all kinds of promises.

The LORD sent a big fish to swallow Jonah, and Jonah was inside the fish for three days and three nights.

From inside the fish, Jonah prayed to the LORD his God:

When I was in trouble, LORD, I prayed to you, and you listened
to me. From deep in the world of the dead, I begged for your
help, and you answered my prayer.

The LORD commanded the fish to vomit up Jonah on the shore. And it did.

Once again the LORD told Jonah to go to that great city of Nineveh and
preach his message of doom.

Jonah obeyed the LORD and went to Nineveh (CEV).

TRUTH FOR TODAY

The rest of the story: Jonah was a reluctant messenger because he suspected
God would show mercy to the enemy of his people instead of wrath and
judgment. When the people of Nineveh heard Jonah's message, they turned
from evil. God was merciful and withheld destruction.

Jonah could not outrun God; the great fish was at God's command, and the
wicked Ninevites were not beyond the Lord's compassion.

Nothing (and no one) is beyond God's reach.

WHERE IN THE WORLD The ancient city of Nineveh was close to the present-day
city of Mosul in northern Iraq.

CROSS REFERENCE

In the Gospel of Matthew, Jesus recounts Jonah's time in the
belly of the great fish—"three days"—which foreshadowed his
impending death and time in the grave (Matthew 12:40).

SCRIPTURE INDEX

This index lists the books of the Bible referenced in their canonical, not chronological, order. The Bible stories in this book follow the standard Bible book order, with one exception: the account of King Saul's death (Chapter 38). (This story appears in both 1 Samuel (31:1-6) and in 1 Chronicles, but the text from 1 Chronicles is used.)

The Bible stories and Scripture quotes utilize several translations (noted on the copyright page) that have been widely published and were primarily selected for readability. As this index shows, and as noted in the Introduction, some stories are abridged. For the full impact and context of the Bible stories, read the complete Bible chapters and books from which they derive.

GENESIS

EXODUS

NUMBERS

ABOUT THE ART

The Standard Publishing company, which incorporated in Cincinnati, Ohio, in 1872, was a pioneer in creating Sunday school materials for all ages. In 1908 Standard invested in color printing. To take advantage of its new color printing capabilities, Standard began an ambitious project to commission paintings of all the major events of the Bible. This endeavor continued over the next fifty years, involving dozens of artists and resulting in one of the largest collections of its kind. Due to the quality and breadth of the collection, the art was a staple in Sunday school materials and other educational resources used throughout much of the twentieth century by a diverse variety of denominations (Disciples of Christ, Church of God in Christ, A.M.E. Church, Independent Christian Churches, and Churches of Christ, to name a few).

The vintage Bible art is a throwback to an era before computer-generated imagery and the proliferation of biblical illustrations in cartoon and comic styles. As with all art, these paintings are a reflection of the period, experiences, and training of the artists. Some of the artists did a credible job of capturing the biblical period they were illustrating, while the work of others is more of an impression of the times and styles in which they painted. Then, as now, the intent of these images is to help illuminate the biblical text and reflect God's glory.

> The aim of art is to represent not the outward appearance of things, but their inward significance.
> —ARISTOTLE

Regardless of individual tastes in art, I hope you enjoy the nostalgic and, at times, campy flavor of these works. In particular, I trust that for those who are fifty and over—an often overlooked age group in the book world—the classic Bible art evokes a fond childhood memory of reading a book with a parent or grandparent or endearing church experience.

Speaking of art, a couple of short notes of appreciation: To my Providence Collection friends, Mark and Scott: thanks. You really are your brother's keeper! And to my long-term publishing pal, Jenette, thank you for applying your mad design skills in helping to take this project to another level. Lastly, if interested in hosting a traveling Bible art exhibit or to inquire about prints, email classicbibleart@outlook.com.

ABOUT THE AUTHOR

Matt Lockhart spent more than twenty-five years serving in a variety of leadership positions for noted Christian educational publishers, including Group, Standard, and David C Cook.

In addition to developing more than a dozen original adult Bible study and church resource series, Matt actively fosters publishing partnerships with numerous ministries and publishers. These have included projects in association with Tyndale, Outreach, FamilyLife, Christ in Youth, Voice of the Martyrs, Summit Ministries, Back2Back, Zondervan, and Christianity Today. He has also worked with a number of bestselling authors, such as Warren Wiersbe, Thom and Joani Schultz, Wendy Pope, Lyman Coleman, J. Warner Wallace, V. Gilbert Beers, Dr. Mary Manz Simon, and Dennis Rainey.

Matt has had the honor of being a part of numerous bestselling adult Bible study publications including the annual *Standard Lesson Commentary*, FamilyLife's *HomeBuilders Couples Series*, and *Serendipity Bible for Groups* (fourth edition).

Presently, Matt enjoys writing, working with the Classic Bible Art collection, and developing and taking on select publishing projects. He and his delightful wife live in Colorado in a newly empty nest with an eye-catching mountain view.

Your feedback regarding this book is welcome. Feel free to drop Matt a note at classicbibleart@outlook.com.

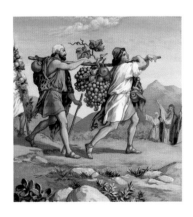

IF YOU ENJOYED

50 Bible Stories Every Adult Should Know

Volume 1: Old Testament

WATCH FOR

50 Bible Stories Every Adult Should Know

Volume 2: New Testament